Synchronization and Title Sequences

Synchronization and Title Sequences proposes a semiotic analysis of the synchronization of image and sound in motion pictures using title sequences. It is the second volume in Michael Betancourt's study of semiotics and cinema using the title sequence as a critical focus, allowing for a consideration of fundamental theoretical issues apart from both the issues of narrative and realism common to commercial media. Through detailed historical close readings of title designs that use either voice-over, an instrumental opening, or title song to organize their visuals—from *Vertigo* (1958) to *The Player* (1990) and *X-Men: First Class* (2011)— author Michael Betancourt develops a foundational framework for the critique and discussion of motion graphics' use of synchronization and sound, as well as a theoretical description of how sound-image relationships develop on-screen. The resulting study of synchronization is both a critical analysis and a theory of visual music in cinema.

Michael Betancourt is an artist/theorist concerned with digital technology and capitalist ideology. His writing has been translated into Chinese, French, Greek, Italian, Japanese, Persian, Portuguese, and Spanish, and been published in magazines such as *The Atlantic, Make Magazine, Millennium Film Journal, Leonardo, Semiotica,* and *CTheory*. He wrote *The _____ Manifesto*, and other books such as *The Critique of Digital Capitalism, The History of Motion Graphics, Glitch Art in Theory and Practice, and Beyond Spatial Montage: Windowing*. These publications complement his movies, which have screened internationally at the Black Maria Film Festival, Art Basel Miami Beach, Contemporary Art Ruhr, Athens Video Art Festival, Festival des Cinemas Differents de Paris, Anthology Film Archives, Millennium Film Workshop, the San Francisco Cinematheque's Crossroads, and Experiments in Cinema, among many others.

Routledge Studies in Media Theory & Practice

1 **Semiotics and Title Sequences**
Text-Image Composites in Motion Graphics
Authored by Michael Betancourt

2 **Synchronization and Title Sequences**
Audio-Visual Semiosis in Motion Graphics
Authored by Michael Betancourt

Synchronization and Title Sequences

Audio-Visual Semiosis in
Motion Graphics

Michael Betancourt

Routledge
Taylor & Francis Group

NEW YORK AND LONDON

First published 2017
by Routledge
711 Third Avenue, New York, NY 10017

and by Routledge
2 Park Square, Milton Park, Abingdon, Oxon OX14 4RN

Routledge is an imprint of the Taylor & Francis Group, an informa business

Some sections of this book were adapted from previously published essays concerned with documenting my studio practice; it emerges from my earlier studio/theoretical work with/on VJ, visual music, and abstract movies:

The typologies of synchronization are adapted from my book *Structuring Time: notes on making movies* published by Wildside Press in 2004.

and from

"Rhythmic Synchronization," and "Visual Music Notes," published in *Canyon Cinemazine* no. 3, March 28, 2015.

Discussion of visual music and abstract film appearing in Chapter 3 was adapted from my Barbara Wilson Memorial Lecture at the University of Nebraska-Omaha in 2006.

and from

"Synchronous Form in Visual Music," *Off Screen*, vol. 11, nos. 8–9 (August/September) 2007.

The periodizing framework for the history of title sequences is adapted from my book *The History of Motion Graphics: From Avant-Garde to Industry in the United States*, published by Wildside Press in 2013.

"Scooby-Doo, Where Are You!" lyrics written by David Mook and Ben Raleigh, copyright 1969 Warner/Chappell Music, Inc.

"Nobody Does It Better" lyrics written by Carole Bayer Sager, copyright 1977 Sony/ATV Music Publishing LLC.

Library of Congress Cataloging in Publication Data
Names: Betancourt, Michael, 1970- author.
Title: Synchronization and title sequences : audio-visual semiosis in motion graphics / Michael Betancourt.Description: New York : Routledge, Taylor & Francis Group, 2018. | Series: Routledge studies in media theory & practice | Includes bibliographical references and index.
Identifiers: LCCN 2017009253 (print) | LCCN 2017010111 (ebook) |
ISBN 9781138085060 (hbk) | ISBN 9781315111551 (ebk)
Subjects: LCSH: Sound in motion pictures. | Motion pictures—Titling. | Sound symbolism. | Motion pictures—Semiotics. | Synchronization. | Credit titles (Motion pictures, television, etc.)
Classification: LCC TR897 .B47 2018 (print) | LCC TR897 (ebook) | DDC 777/.53—dc23
LC record available at https://lccn.loc.gov/2017009253

ISBN: 978-1-138-08506-0 (hbk)
ISBN: 978-1-315-11155-1 (ebk)

Typeset in Times New Roman MT Std
by diacriTech, Chennai

For Leah

Table of Contents

List of Figures ix
Acknowledgments xi

1 Introduction 1

The Development of Title Sequences 8
Primary Recognition 13
Emergent Identification 17

2 Direct Synchronization 24

The Synchronized 27
Naturalistic Synchronization 32
Diegetic and Non-Diegetic Synchronization 36

3 Natural Artifice 46

The "Visual Music" Heritage 49
The Ideology of Synchronization 53
Illustrative Synchronization 59

4 Counterpoint 70

Reservations about the "Talkies" 73
Counterpoint Synchronization 82
Quotational Counterpoint 85

5 Songs and Voice-Over 95

 Music 98
 Title Songs 101
 Narrated Montages 119

6 Conclusions 129

 The Statement *of Synchronization 129*
 The Immanence of Ideology 132
 The Role of Music and Theme Songs 136

 Index 139

Figures

Frontis Illustration of an Auto-Ophicleide playing in "A Steam
Concert" from *Un Autre Monde* (1844) by J.J. Grandville,
page 24 xii
1.1 All the title cards in *Rumba* (1935) 8
1.2 Selected stills from *Lichtspiel: Opus I* (left, 1921) and
Lichtspiel: Opus III (right, 1924) by Walther Ruttmann;
the title sequence to *X-Men: First Class* (2011); *Tarantella*
(1940) by Mary Ellen Bute; and the title sequence to
Ça Ce Soigne? (*Is It Treatable?* 2008) 12
1.3 Album cover for *Les Echanges* (1964) by Rolf Liebermann 19
1.4 *Distinctions between Music and Non-Music* adapted from
Figure 2.6 in *A Theory of Musical Semiosis* by
Eero Tarasti 20
2.1 All the title cards in *The Player* (1992) 26
2.2 Selected stills from the title sequence to
Belle de Jour (1967) 33
2.3 Selected stills from the title sequence to *One
Flew Over the Cuckoo's Nest* (1974) 35
2.4 All the title cards in *The Set-Up* (1949) 37
2.5 All the title cards in *Beat the Devil* (1953) 40
2.6 All the title cards in *The Adventures of Baron
Munchausen* (1988) 43
3.1 Selected stills from the title sequence to *Wimbledon* (2004) 47
3.2 All the title cards in *The Man with the Golden Arm* (1955) 48
3.3 Selected stills from *Heroes* (2009) 54
3.4 All the title cards in *The Trollenberg Terror* (aka
The Crawling Eye, 1958) 60
3.5 All the title cards in *The Seven Year Itch* (1955) 61
3.6 All the title cards in *The Bold Ones* (1970) 62
3.7 All the title cards in *All the President's Men* (1976) 64

4.1	All the title cards in *Arabesque* (1966)	71
4.2	Excerpt from the diagram "A sequence from *Alexander Nevsky.*" Reproduced from *The Film Sense* by Sergei Eisenstein	78
4.3	Selected stills from the title sequence to *Les Bleus de Ramville* (2012)	79
4.4	Selected stills from *Parabola* (1936) by Mary Ellen Bute	84
4.5	All the title cards in *The Dog Problem* (2006)	85
4.6	All the title cards in *Ça Ce Soigne? (Is It Treatable?* 2008)	88
4.7	All the title cards in *Scott Pilgrim vs. the World* (2010)	90
5.1	All the title cards in *The Big Broadcast of 1937* (1936)	96
5.2	Panorama from the title sequence to *My Man Godfrey* (1936)	99
5.3	The title card only opening to *Ghostbusters* (1984)	103
5.4	All the title cards in *The Spy Who Loved Me* (1977)	105
5.5	Selected stills showing identical mask used in *The Spy Who Loved Me* (top, 1977) and *A View to A Kill* (bottom, 1985)	106
5.6	All the title cards in *Scooby-Doo, Where Are You!* (1969)	114
5.7	The first 16 episode title cards for *Scooby-Doo, Where Are You!* (1969–1970)	116
5.8	All the title cards in *The Addams Family* (1964)	117
5.9	All the title cards in *Captain Video* (1949)	120
5.10	All the title cards in *The Six Million Dollar Man* (1974)	121
5.11	Selected stills from the title sequence to *Blade II* (2002)	124
6.1	The range of sync points formally distinguishes direct (*naturalistic* and *illustrative*) from counterpoint synchronization, a reflection of the syntactic function the *statements* created by synchronization have for interpreting motion pictures	130
6.2	Selected stills from the title sequence to *For a Few Dollars More* (1965)	133

Acknowledgments

This book began in talks about the role and potentials for synchronized sound in motion pictures with my friend and fellow artist, Charles Recher. The final form it has taken would not have been possible without the discussions with my graduate students, especially Dominica Jordan, Noël Anderson, and Matt Van Rys; and my colleagues Min Ho Shin and John Colette. Special thanks go to my brother, John Betancourt, for his assistance with locating many of the title sequences that inform this study.

Frontis Illustration of an Auto-Ophicleide playing in "A Steam Concert" from
Un Autre Monde (1844) by J.J. Grandville, page 24.

1 Introduction

Informational structures tend to dominate the analysis of title sequences—the design and aesthetics of the title cards/montage presenting the individual credits (text)—or their function as an introduction to the drama that follows (narrative). However, this focus neglects other, non-lexical aspects of these sequences, in particular the crucial role that synchronized sound and music have for the organization, identification, and interpretation of title designs. This book emerged from the same disparate historical research that informed the analysis in *Semiotics and Title Sequences: Text-Image Composites in Motion Graphics* whose primarily visual engagement with title sequence designs (mostly) produced for feature films and television programs in the United States meant neglecting issues of sound and synchronization. The scope of this study ranges across an international spectrum that nevertheless remains primarily focused on Hollywood productions.[1] These selections reflect their utility for the present analysis. The works discussed are carefully chosen exemplars of form: mainly well-known works whose designs minimize the indeterminacy of their synchronization; the title sequences chosen for this study reinforce their underlying selective criteria—that the examples all provide a clear, coherent presentation of what are more commonly complex, ambivalent, and indistinct approaches that often organize the same design at different levels of its construction. The resulting selection's limitations illuminates the complexity of more ambivalent designs by making their commingled morphologies of synchronization into distinct modes employed together in a composite fashion.

Questions of synchronization have been an ongoing concern related to my research into visual music for more than a decade. Understanding *synchronization* necessitates careful attention to sound::image relationships independent of the more common dramatic narratives of commercial media; title designs are a natural, even logical site for this analysis due to their independence from the constraints and demands

of storytelling: title designs are semi-autonomous structures (typically) created and organized around their synchronization with music, making them ideal sources for the theorization of synchronization. They articulate meaning through the synchronization of audio-visual materials, parallel to the constraints imposed by text on-screen. Avant-garde and commercial films, title designs, and other motion graphic paratexts (such as music videos, commercials, and trailers[2]) have developed and explored this formative role for synchronization, making a semiotic theory of synchronized sound potentially relevant to more than just the title sequence.[3] In spite of this logical connection, discussions of synchronization in title sequences are even rarer than the theoretical consideration of synchronization itself in narrative motion pictures; for example, film historian Rick Altman's pioneering studies of 'lip-sync' in the 1970s and 1980s do not develop a semiotic theory for sound or its synchronization.[4] This nearly complete neglect is surprising given the importance of synchronization to motion pictures generally.

For film theorists and practitioners, how to employ *synchronization* in motion pictures has been a point of theoretical concern guided by the commercial shift to "Talkies" in the 1920s. Heuristic theories of *use* modeled on 'lip-sync' act to hide other theoretical concerns in the decades since its introduction. Elizabeth Weis and John Bolton's authoritative anthology on the role of audio, *Film Sound: Theory and Practice,* provides a range of approaches to film sound, but tends to focus on the innovative work of particular auteurs. There is little consideration given to a general theory; careful and extensive critical consideration of model examples provide insight into the use of sound by film auteurs such as Orson Welles or "sound designers" such as Walter Murch. Their anthology approaches the aesthetics of film sound, but does not address the theoretical issues arising from the basic issue of synchronization except in a historical sense via coverage of the 1920s–30s debates around "Talkies" when sync sound recording was new. And while there is an extensive literature on the avant-garde and its relationship to sound and sound recording, this is a literature that only rarely considers motion pictures, and never touches on the commercial title sequence. That synchronization is rarely theorized is surprising; it is a universally neglected, but also obvious, question.

However, *music* has been theorized extensively, and its theory is often confused with questions of sound and its synchronization, because music has been a part of the cinematic experience since its infancy; thus, analyses and critical approaches to sound and film tend to focus instead on music[5]—questions of scoring and appropriate choices of performance and composition—rather than the specific questions of synchronization

outside the realm of the score.[6] And these theories of film music and histories of sound recording are also almost always concerned with narrative film dramas: sound for fiction films has been discussed and considered extensively, but as with much about the design and structure of title sequences, there has been no consideration of the role and meaning of synchronized sound (rather than music composition) in the title sequence. This emphasis on scoring and composition is the historically dominant approach to theorizing synchronization, since it is one of the very first ways that motion pictures engaged with sound::image relationships—by 1912 the need for curated (if not specifically composed) music was becoming obvious. In his 1951 reminiscence about this shift, film composer Max Winkler describes "The Origin of Film Music," as a necessity:

> More and more musical mishaps began to turn drama and tragedy on-screen into farce and disaster. Exhibitors and theatre managers made frantic efforts to avoid the musical faux pas that made their films appear ridiculous. Carl Fischer's [where Winkler worked] was probably the most famous and certainly the most successful in the field of orchestra music. I began to understand their problems. We gave advice, we helped some of them, and when they described to us a particular scene in a film, we would usually know of a piece that would fit the mood.[7]

As film historian Mervyn Cooke noted in his discussion of Winkler's comments in *The Hollywood Film Music Reader,* Winkler is not entirely reliable in his account.[8] However questionable Winkler's comments may be, he was correct in observing that the music that accompanies what appears on-screen, especially for the early cinema, has a dramatic impact on how the audience understands what they see: it does more than merely set the mood, it can be a determining feature of *how* the audience understands the visual. This impact—what Winkler describes as the difference between tragedy and farce—gives music a central role in the construction and determination of meaning.

A similar neglect is also apparent in studies focused on the well-known field of "visual music" or abstract film. Film historian William Moritz's monograph *Optical Poetry: The Life and Work of Oskar Fischinger* is typical. The immediacy of synchronization is a foundational *given;* it neither receives nor requires a more thorough consideration. Visual music leaves the theorization of audio-visual form as little more than a formal description of potential linkages entangled with the cultural heritage and aesthetic choices that define "visual music" as such. Because Moritz

accepts this cultural idea as a foundation, his study cannot address its organization except *en passant*—the audio-visual linkage described by "visual music" as a construct is not of concern; neither are the semiotics of its organization. These are not criticisms of Moritz's work, nor of "visual music"—the issue of synchronization is a gap in this theory/ history, a critical fallacy that puts the entire construct into question, and so cannot be addressed because it is often seen as the necessary and sufficient condition for "visual music"—the *metaphor* of synaesthesia is typically shown via synchronization.

Considerations of sound and synchronization in motion pictures, beyond some general remarks in studies of "art sound," is not a topic of significant analysis. Douglas Kahn's exemplary history of sound in art and the avant-garde, *Noise, Water, Meat* does not consider it. As in *Film Sound*, Kahn's approach is historical, not theoretical, concerned with the heuristic debate around the "Talkies." He does not develop a consideration of the synchronous linkages between sound::image in motion pictures; neither does Jacques Attali's well known theory of sound proposed in the book *Noise* address motion pictures, being concerned instead with an ideological role and meaning for music.[9]

The only lengthy discussion of film sound in *Noise, Water, Meat* is concerned with Soviet filmmakers of the 1920s and 30s—primarily Dziga Vertov and Sergei Eisenstein. Approaches to synchronization that emerge prior to World War II are focused on the "Talkie," with their analysis addressing only the realist needs of dramatic narratives for synchronized speech and sound effects.[10] But this focus on "Talkies" is not limited to live action films, as Douglas Kahn notes (in passing) about Disney's use of sound in cartoons, what is commonly called "Mickey Mousing":

> Whereas Eisenstein sought to find an auditive equivalent to his visually derived montage, Disney extended the elements of silent cinema into sound under the actuality (not metaphoricity) of music in such a way that the music and sound *performed* the visual elements of the film—its characters, objects and actions. What may have once struggled awkwardly as an implied or otherwise compensatory sound made itself heard with a vengeance through every possible auditive technique. Voices, sounds, and music were spread out over the bodies of both characters and objects in a new form of homologous puppetry, whether a squeaking elbow joint, fly footsteps, flesh ripped off to play a rib-cage xylophone, or a piece of clothing mentioned in the title or verse of a familiar song. The exaggeratedly tight coordination of sound and image in the novel context of sound cinema meant that the visual experience of animated cartoons was itself animated by sound.[11]

Kahn's description of how sound performed the visuals in Disney cartoons makes its synchronization both the central focus of the discussion, and an implicit, unexplored, and unquestionable relationship: the linkage of sound::image is so direct and complete that the need to even consider it as a construct, an artificial assemblage, seems redundant. Understood in these terms, what could a theory of synchronization add? The autonomous connection happens so fully and directly that the "Mickey Mousing" he describes needs only to have the visual part mentioned to invoke the audible. The directness of this connection leaves very little room for other explorations in narrative cinema.[12]

Kahn's discussion is typical: the question of *synchronization* is only engaged as specifically analogous to 'lip-sync' in the "Talkies": the naturalistic connection of voice-to-speaker, extended by "Mickey Mousing" to everything that *could* make a sound. However, some filmmakers working during this transition produce a variety of statements and manifestos arguing for the use of sound in contrast to the imagery. What the Soviet directors Eisenstein, Pudovkin, and Alexandrov call "asynchronism" in their *Statement on Sound* from 1928 is typical of these oppositional arguments for a 'counterpoint relationship' between sound and image, a role that conceives sound directly in opposition to the "Talkies":

A first period of sensations does not injure the development of a new art, but it is the second period that is fearful in this case, a second period that will take the place of the fading virginity and purity of this first perception of new technical possibilities, and will assert an epoch of its automatic utilization for "highly cultured dramas" and other performances of a theatrical sort.

To use sound in this way will destroy the culture of montage, for every ADHESION of sound to a visual montage piece increases its inertia as a montage piece, and increases the independence of its meaning—and this will undoubtedly be to the detriment of montage, operating in the first place not on the montage pieces but on their JUXTAPOSITION.

ONLY A CONTRAPUNTAL USE of sound in relation to the visual montage piece will afford a new potentiality of montage development and perfection.[13]

Written in 1929, this statement on the use of sound resembles a manifesto in its rejection-prescription for its use. These three Soviet directors' films were based in the juxtaposed imagery of montage. The synchronous linkage of sound::image offered by 'lip-sync' are an existential threat to their aesthetics, offering instead of the rupture and collision of thesis and

antithesis in montage editing the convergent and coincident assertion of the film "world" as corresponding to the natural encounter and experience of everyday life. Their concerns about "Talkies" and synchronized sound are typical of arguments *for* counterpoints between imagery and sound—for a "creative" use of sound to challenge and comment upon the apparently inevitable linkage created by 'lip-sync.' The conjoining of sound and image creates a new, decisive form in whose linkage these elements become something entirely different than each on its own. Bela Balazs' observations about how sound becomes a concrete fact when linked to a picture:

> The sound of a wave is different if we see its movement. Just as the shade and value of a color changes according to what other colors are next to it in a painting, so the *timbre* of a sound changes in accordance with the physiognomy or gesture of the visible source of the sound seen together with the sound itself in a sound film in which acoustic and optical impressions are equivalently linked together into a single picture.[14]

The tortured language he employs to specify a simple relationship—synchronization—hints at the novelty of the form and difficulty of its precise analysis. The obtuseness of considering sound::image and synchronization makes the relative scarcity of theory around it less surprising. It is precisely the ambiguity of its description that makes theorization difficult. At the same time, the arbitrary arrangements that produce the synchronization are implicitly linked to the prosaic realism of everyday life, as Eisenstein/Pudovkin/Alexandrov recognized: arguments for a counterpoint relationship necessarily reject the naturalistic alignment of sound::image common to 'lip-sync' where audiences watch characters speak[15] (or sing, as in *The Jazz Singer*) because the naturalness of relations thus presented do not seem to demand any additional attention or theorization beyond the recognition that they exist.

The implication of a naturalistic relationship of sound::image is that there is nothing *to* theorize about it, thus the common shift from synchronized sound to the issues and concerns of film music and its composition-recording, including the considerations and analyses of popular music being used in commercial films, such as Hillary Lapedis' discussion "Popping the Question: The Function and Effect of Popular Music in Cinema" in *Popular Music*,[16] or Julie Brown's critique of the television program "*Ally McBeal's* Postmodern Soundtrack."[17] Analyses/ theories of synchronization appear redundant for the realist approach that renders their naturalistic connection beyond critical consideration.

Aside from those theories proposed by those artists working with "visual music" such as John Whitney, issues of audio-visual synchronization have not been explored with any consistency or regularity. The focus on music in these discussions reflects theorist Jacques Attali's recognition that music demonstrates and invokes an audience's enculturated hierarchies; in motion pictures, this concern with synchronization is tangential (except as it impacts the score)—the functional role of music for composers is enculturation, and they are the primary audience for these studies. Composer Jessica Green's comments in her speech "Understanding the Score: Film Music Communicating to and Influencing the Audience" are typical. She leaves the issue of synchronization—the subservience of the heard to the seen—outside the realm of analysis:

> By distinguishing dialogue, noise, and music—all auditory channels of information—as important pieces of film, Stam, Burgoyne, and Flitterman-Lewis support Metz's assertion "that the cinema possesses various 'dialects,' and that each one of these 'dialects' can become the subject of a specific analysis." Once audiences and critics consider music as one of the fundamental "dialects" of film, it then makes sense to understand music as an essential part of communication and argument in film.[18]

Music, not its synchronization with visuals. The emphasis in her analysis follows the standard approach to discussing audio-visual combinations: it does not address the synchronization—except perhaps *en passant*—as the formal structures of music and its arrangement as part of a motion picture are the primary concern. Her focus is on what 'dialects' means. Critical responses to sound, music, and the "Talkies" demonstrate the fundamental theoretical importance of *naturalistic synchronization*—thus, 'lip-sync'—as a the 'degree zero' for the synchronization of sound::image. Invoked in this audio-visual creation-linkage is the audience's understanding of the "world" shown by the dramatic narrative as an internally consistent reality—that is, the *realism* of the mimesis appearing on-screen—what is sometimes critiqued as a 'photographic fallacy.'[19] The entanglement of this fundamental phenomenal encounter with audience perceptions of that fiction as corresponding to everyday life is the basic opposition between a 'realism of surface appearances' and a 'realism of the mind' that lie in the background to theories of realism itself.

Proposing a semiotic theory of synchronization thus involves developing a framework that enables more complex and robust analysis of audio-visual structures in motion graphics (and motion pictures as a whole); the relationship of semiosis to both the material organization of design and to the

semiotics of text-image composites opens the range of works to consider beyond the scope of "visual music." A semiotic approach to interpreting synchronization of sound::image or image-to-sound requires a consideration of the dynamics and problematics of how these phenomenal encounters are at the same time organized and guided by the established expertise of cultural experience. It is not simply an issue of how well or poorly these relationships correspond to the audience's past experiences with everyday life, but the role that assumptions about the organization and nature of the world in have in constructing audio-visual synchronization.

The Development of Title Sequences

Title sequence designers do not consistently engage with the aesthetics of audio-visual synchronization until their design becomes a source of prestige and critical attention. When sound is considered in the title sequence, the focus is on music and image, but not their synchronization, as Jonathan Gray's discussion in *Show Sold Separately* demonstrates.[20] These discussions also tend to be almost without historical concern, which is not surprising since prior to the 1950s, the arbitrary use of music in a title sequence was uncommon: Universal's reuse of the same recording excerpted from *Swan Lake* as the title music for the uncredited designs in both *Dracula* (1931) and *The Mummy* (1933) demonstrate this early tendency to repeat and adapt existing music, merely attaching it to the titles as an unrelated background. The relationship of sound and image is often less-than considered in these designs. Although the uncredited titles for *Rumba* (Paramount, 1935) *do* play an excerpt from a rumba, the Spanish-dressed dancers do not follow its beat (Figure 1.1). In

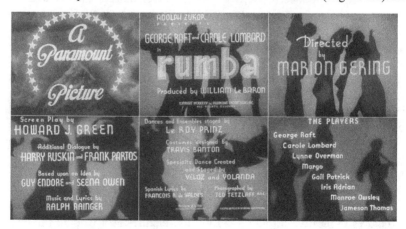

Figure 1.1 All the title cards in *Rumba* (1935)

watching this title sequence, it is uncertain *if* they are even dancing, since their movements are both abstracted by the shadows and distorted with a prismatic lens attachment that splits the screen halfway through the sequence. This ambivalence is common; the syncopation of animation and music in Saul Bass' design for *The Man with the Golden Arm* (1955) is appropriate to a design using jazz; the resulting slippages of audio-visual synchronization are typical of the *almost*-synchronized character common to title designs in the first half of the twentieth century.

The production process employed in the Hollywood studios was primarily responsible for the inability to create a direct and immediately clear synchronous link between image and sound because in the studio's assembly-line production, the recording of the music would normally come *after* all the other production was finished, including the title sequence, making precise synchronization unlikely. These designs have been conceived as pseudo-independent paratexts,[21] mediating the beginning or ending of a dramatic narrative without the proximate demands of storytelling, thus allowing for poetic and abstract approaches to sound::image synchronization normally absent from the realist dramatic itself. My approach to periodization of feature film title sequences in Hollywood productions proposed in my book *The History of Motion Graphics: From Avant-garde to Industry in the United States* provides a framework to consider this development of synchronization in title sequences:

AMERICAN FEATURE FILM TITLE DESIGN PERIODS	
Early (Experimental) Period	(beginning until ~1915)
Silent Period	(until ~1927)
Studio Period	(until ~1955)
Designer Period	(until ~1977)
Logo Period	(until ~1995)
Contemporary Designer Period	(1995 to present)

The development of synchronized titles begin to dominate title production by the end of 1950s during the Designer Period for feature film title design that continues until approximately 1977.[22] This period is broken into distinct sections based on shifts in dominant approach to how the title sequence relates to the dramatic narrative which

follows: these three phases, the Early, Middle and Late, are the starting point for this examination. In the Early Phase the title sequence adapts Modernist approaches to graphic design pioneered in film by Saul Bass. These titles are specifically "signed" by the star-designer who makes them following an earlier model in print design pioneered by Paul Rand and Alvin Lustig. The shifts in priority that begin with the Middle Phase are all connected to changes in *how* the film begins—the organization and pseudo-independence of the title sequence. The historical two-minute title sequence becomes progressively longer, creating an opening "spectacle." The most famous of these designs are those Maurice Binder made for the series of James Bond films starting in the 1960s and continuing until 1989. During the Late Phase these priorities shift again as the "signature" created by the title designer becomes less important. As the Late Phase progresses, the title sequence becomes increasingly integrated into the opening scenes of the film following a model offered by Wayne Fitzgerald's 1958 design for Orson Welles' film *Touch of Evil*. These distinctions within the Designer Period are shifts more than major changes of fundamental conception: throughout all three phases, the title sequence remains a primarily separate 'unit' of construction, typically at the start of the film, whose organization functions as an introduction to the film that follows, an idea promoted by Saul Bass,[23] whose influence remains pervasive throughout this period:

> My initial thoughts about what a title could do was to set the mood and to prime the underlying core of the film's story; to express the story in some metaphorical way. I saw the title as a way of conditioning the audience, so that when the film actually began, viewers would already have an emotional resonance with it.[24]

This "allegorical method" Bass describes to historian Pamela Haskin renders the opening sequence as a paratext: a supplemental text reflecting back on a central text in much the same way that a book cover or film trailer is a descriptive rendition of another, linked primary text.[25] This subordinate position renders the title sequence as a contingent presentation—one that serves to establish what the central text's concerns are, but does so metaphorically or allegorically. The deployment of abstraction during the Early Phase production of abstract, graphic title sequences is the most apparent instance of this freedom from established conventions. These designs, most closely identified with the work of Saul Bass, owe their organization to both abstract painting and the absolute film. They apply the audio-visual approaches of synaesthesia and visual music to the production and design of title sequences. For Bass, the title design is

constructed as a separate "film before the film" that develops its own iconography and subject matter separate from what appears in the fictional drama. It is a commentary on what follows (or in the case of the main-on-end, a reflection back on what happened). This secondary position frees the *paratexts* from a direct or literal presentation of the primary text, giving them a high degree of freedom to innovate and experiment.

The invention of title design as a professional practice deserving recognition comparable to cinematography, screenwriting, and direction in the 1950s has identified particular designs as noteworthy and elevated a select group of designers to prominence —including Saul Bass, Maurice Binder, Pablo Ferro, and Wayne Fitzgerald. However, these recognized works only provide a starting point in this analysis; they are far from comprehensive or fully descriptive of all potentials. As a result of these limitations, the wider range of designs than just those of these well-known designers were examined than just those made by "signature designers" and the examples chosen for this study were identified from within this larger sample. The designs discussed in this book are illustrations of principle, allowing consideration of "idealized" form. In selecting them, what was of concern was each example's capacity to direct attention beyond its own parameters, to help identify general principles rather than serve as models to emulate.

The pseudo-independence of title sequences as separate-from-narrative declines during the Logo Period, and the independent title sequence disappears from many films in the 1980s; this eclipse of the independent title design was short-lived. After the Logo Period, where the title design disappears into the opening scenes of the dramatic narrative, starting in the mid-1990s, the Contemporary Designer Period returned to the production of aesthetically "independent" title sequences. The centrality of audio-visual form to these contemporary designs links them to the earlier Designer Period. While music does have a role and relationship to the visuals in both periods, the distinction between them is more than just an issue of type placement.

Throughout the Designer Period and in the Contemporary Period, the role of synchronization for these opening sequences is crucial to their internal structure; this dependence on sound and music is even more pronounced in titles made for television programs. These approaches to synchronization are heuristics that describe formal potentials for sound in relation to dramatic narratives, or in the avant-garde film, as an independent art—"visual music"—where the meaning of works derives from the abstract relationship of animated graphics to musical form. The development of contemporary motion graphics (and title sequences) originates with these *absolute films*. This heritage remains a clear

organizational reference for contemporary designers. This foundation is more than simply an abstract "influence" (Figure 1.2)—in designs such as Simon Clowes' *X-Men: First Class* (2011) the main-on-end design transforms abstract forms familiar from visual music—both Walther Ruttmann's absolute films and the spiraling forms created by John Whitney's cam-machine for Saul Bass' *Vertigo* title sequence (1958)—into designs that transform abstraction into a representation of genetics and gene sequencing; similar quotations from Mary Ellen Bute's *Tarantella* (1940) appear in *Ça Ce Soigne?* (*Is It Treatable?* 2008). These references draw attention to the *established* character of the historical abstraction developed by Modernist avant-gardes as a language for manipulation. The centrality of visual music to existing theories of audio-visual synchronization provides a historically complex and well-established set of theories that overlap with approaches apparent in commercial title sequences. Synaesthetic conceptions of sound::image synchronization are central to the early development of this foundation, leaving its imprint clearly through the conventions of synchronization that continue to organize

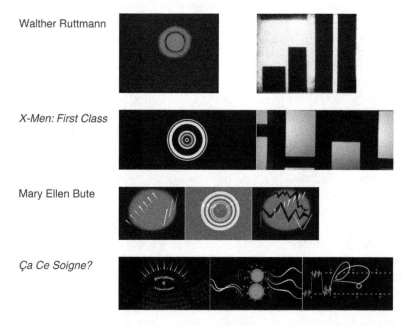

Walther Ruttmann

X-Men: First Class

Mary Ellen Bute

Ça Ce Soigne?

Figure 1.2 Selected stills from *Lichtspiel: Opus I* (left, 1921) and *Lichtspiel: Opus III* (right, 1924) by Walther Ruttmann; the title sequence to *X-Men: First Class* (2011); *Tarantella* (1940) by Mary Ellen Bute; and the title sequence to *Ça Ce Soigne?* (*Is It Treatable?* 2008)

title design, but synaesthetic media is only one site of development and exploration for this analysis of synchronization in title designs.

Primary Recognition

There is no pre-existing semiotic theory of synchronization; sound receives only marginal consideration in texts on semiotics and motion pictures, as with Peter Wollen's pioneering work *Signs and Meaning in the Cinema,* or Christian Metz's book *Film Language: A Semiotics of the Cinema.* The issue of synchronization (much like music) is incidental to their concerns with images and symbolic functions of motion pictures. Wollen's proposal that interpreting visuals is analogous to language leaves the soundtrack as an auxiliary element, of secondary semiotic concern. A convergent discussion of film semiotics proposed by Metz in *Film Language* concludes with a chapter titled "The Saying and the Said" which has nothing to do with sound or 'lip-sync,' but is instead concerned with the proposition that filmmakers "say" things through their films, a metaphoric title. Sound and synchronization only appear in Metz's semiotics as a parallel/supporting the visual. A consideration of "sync sound" in itself is absent. His discussion of denotation that aligns sound with image is typical—sound and its synchronization emerge, only to be elided from consideration as redundant with the visual:

> Among the codes that are extracinematographic by nature, but that nevertheless intervene on the screen under cover of analogy, one must point out as a minimum—without prejudice to more complex and sensitive enumerations—the *iconology* specific to each sociocultural group producing or viewing the films (the more or less institutionalized modalities of object representation, the process of recognition and *identification* of objects in their visual or auditive "reproduction," and, more generally the collective notions of what an image is), and on the other hand, up to a certain point, *perception* itself (visual habits of identification and construction of forms and figures, the spatial representations particular to each culture, various auditory structures, and so on).[26]

Metz implicitly reiterates a hierarchy of language-vision-hearing; the theory of film semiosis he proposes develops and proceeds without concern for the audible—its presence in this list of elements is clearly in the interest of logical completeness, rather than as a focus of attention. Sound is of lesser concern to his theory than proposing a lexical visuality that can substitute for verbal language. What he means by "various auditory

structures" is unknown—there is no further elaboration or development of this element in his list. One can presume he means "music" or perhaps "speech," since both are cultural, but why they would then be listed as *perception* become questionable.

The general lack of *any* theorization around synchronization in film studies is not surprising: *sound* in itself presents unique difficulties for analysis. These problems emerge clearly in an article on sound by Metz where he proposed and discusses "aural objects"—a theory of audible denotation. His analysis reveals the difficulty posed by sound in the simultaneously perceptual-conceptual problematics of identification and recognition that emerge together as the apperceptive encounter:

> How is it possible that we are capable of recognizing the sound of "lapping" on the soundtrack of a travelogue or among the confused rustling sounds heard when walking in a forest? How is this possible when we don't know its source, even if we identify other different sounds as "lapping" at other times? It must be that "lapping" exists as an autonomous aural object, the pertinent traits of its acoustic signifier corresponding to those of a linguistic signified to the semes of the sememe "lapping." [. . .] There is no sense in asking whether they define the French word "lapping" (*clapotis*) or "lapping" as a characteristic noise, since the sound and the word only exist in relation to each other.[27]

Focusing on the sound as an isolated element renders it subservient to the language that describes the sound: there are many varieties of lapping— ocean waves, cats with milk, turgid water in caves, all of them linked to their capacity to produce a realist interpretation of their origins for the listener—each with their own character that renders them entirely different in nature and meaning. Metz's analysis reveals the commingled nature of sound—denotation depends on a specific *recognition* that identifies the sound in question as *mimetically* comparable to a photograph: the recognition that *this* noise is, in fact, "lapping" lies at the foundation of the interpretive process, preceding its identification with language. In attempting to reconcile the "audible event" with specific lexia, to transfer it to the realm of denotative signs, Metz denies the role of his past experience that guides him; this same ambiguity about "perception" is an innate feature of his semiotics, as the discussion from *Film Language* shows. Before any interpretation or naming can occur, the sound must first "fit" within the established knowledge of similar sounds, allowing its primary identification as a *specific*, identifiable event; without this first recognition, the sound is necessarily abstract and mysterious.

This initial linkage between past experience and a particular "noise" reveals the underlying abstract character of sound itself: that the audience's identifications and recognitions lie at the foundation of how we understand what we hear, a fact that becomes especially obvious when considering the range of approaches and techniques developed starting in the 1950s with *musique concrete* that employed the transformative capacities of recording to render recognizable sound alien and unknown: a human voice singing "Mary had a little lamb" recorded at one speed and played back at another may remain recognizable or become an amorphous series of tones that do not resemble their origins at all. "Lapping" can become a rhythmic, drum-like pattern through looping and repetition, changing its character in a fundamental way for the listening audience, shifting it from mere denotation towards the domain of music. These fluid transformations of sound make the audience's immanent recognitions a central part of how we interpret our encounters with sounds. An electronic, 60-cycle tone may be an unrecognizable, and painful to hear, abstract screech when held for a long time, or may become instead a brief and equally abstract "ding" that we immediately recognize as a cell phone announcing the arrival of a text message. Contra Metz, differences in understanding depend on how the sound corresponds to our past experiences and cultural knowledge, not any innate indexical connections between a sound and what produces it.

Linking the *apperception* of sound to an *interpretation* of a specific source gives the audible a similar material foundation to that of photography—as presenting "found" objects the audience responds to as a physical presence even when unseen. The sound of lapping water does not require its visual presentation for it to establish a dark, underground setting as dank; it is sufficient that the imagery and scene establish the setting as dark and "underground" for the lapping water sound to provide this additional meaning. Metz's identification of sound as a characteristic of an object does not negate its potential as a signifier of equal significance to the visual. The argument he develops for sound parallels the realism Bazin proposed for photography: that the audience begins their understanding of sound with its identification as a *trace* of a physical reality—via *denotation* where a sound's origin informs its meaning. This basis in realism is a fallacy.

This primary identification of sounds as being *mimetic* or *non-mimetic* is the initial separation of the sounds that past experience recognizes from those that remain unknown. In this regard, the identification of an abstract "ding" as being a cellphone is a recognition of productive source that is equally mimetic as the identification of "lapping," the dripping of water, or the human voice; even the recognition when listening

to music that it *is* music—not to mention the recognitions of particular instruments playing—is a *mimetic* recognition, literally a recognition that refers to memory and past experience. Once placed within the realm of known sounds, this mimetic connection links the audible within a network of expectations and interpretations that masks this earlier abstraction, hiding it from our consideration. We make the identification of sounds instantly: those we do not recognize or understand, we tend to ignore as "noise"—these other, unrecognized sounds are *non-mimetic,* as Douglas Kahn explained in his history of sound and art, the monograph *Noise, Water, Meat*:

> Noise can be understood in one sense to be that constant grating sound generated by the movement between the abstract and the empirical. It need not be loud, for it can go unheard even in the most intense communication. Imperfections in script, verbal pauses, poor phrasing are regularly passed over in the greater purpose of communication, yet they always threaten to break out into an impassable noise and cause real havoc. [. . .] With respect to sound, noise is an abstraction of sound, and if the "process of abstraction . . . is involved in the elimination of noise," then noise itself is a form of noise reduction, it is something done to sound that most often goes unheard.[28]

By "abstract and empirical" Kahn means the distinctions between the identification of a sound (mimetic) and its remaining unknown, unnamed, unidentified for its audience (non-mimetic). The failure to identify a sound as *other* than "noise" leads to its rejection from conscious consideration—the designation "noise" is nothing less than a labeling of those sounds that are *not relevant* for interpretation and can then be ignored. In being relegated to the realm of "noise," a sound can remain entirely particular, at the same time it is a challenge to those *identifications* productive of meaning that are central to analysis. The separation of sounds into those bearing meaningful relations and those that do not is definitional in organizing perception for higher-level interpretations. Where "noise" challenges the development and progression of interpretations, primary recognition establishes the horizons of interpretation available for any particular sound. Synchronization, as Kahn suggests, acts to reduce the "noise" of those audible sounds that remain steadfastly unidentified for the listener: through its simultaneous presentation with an image, constraining its understanding in specific ways that renders the mimetic/non-mimetic opposition suggested by Metz's isolated analysis of limited value for a consideration of sound::image relationships. The connection

with a visual assigns an identity to the sound, thus rendering it mimetic, whether the audience would recognize the sound by itself or not.

The problem the synchronization presents originates with this immediacy of perception—in a motion picture, everything contained by the soundtrack is presented simultaneously with whatever is shown on-screen. The parsing of this immanent presentation into those elements that are synchronized and those that are not depends on the nature of this primary recognition: hearing a human voice and seeing a person on-screen moving their lips in a way that corresponds to our everyday encounters with people talking (past experience) leads us to believe that the voice we hear is that of the person shown on-screen; the ability to make animated cartoon characters speak depends on precisely this correlation of image and sound—but the connection depends first on the recognition that the "noise" heard is a voice, speaking (no matter the language spoken).[29]

Metz's interpretation-discussion of the "sound of lapping" via the linguistic masks more basic phenomenal identifications of linkage that specifically emerge in motion pictures through a sound's synchronization with an image. All sounds are synchronous with their accompanying images, but not all are identified as being "synchronized." The description of a sound as *sync* is not simply or only the immanent link of sound::image: that apparent connection is emergent, happening over time as past experience mediates both the identification of the sound and the significance of its relationship to the visual. Higher-level interpretations are organized from these lower-level and foundational interpretations. The designation that a sound is diegetic or non-diegetic is at once both a decision about the synchronization of sound to the image, and the product of established narrative and realist conventions of depiction— both interpretations arise from identical structural cues.

Emergent Identification

Applying semiotics to the arrangement and synchronization of sound::image does not delimit their meaning in the same way that the meaning of terms in a verbal or written statement are constrained by their lexical foundations, or even in the ways that the image sequences of montage can be examined in terms of their denotative contents arrayed over time: the mimetic identifications of sound do not necessarily constrain the higher-level interpretations emergent from their organization over time.

The "subjects" contained by the soundtrack are characteristically different from visual forms, being composed from voices, sounds, and

music mixed together and presented simultaneously with visuals. The recognition of synchronization of sound and image parallels the cultural foundations of music as an already-organized experience whose comprehension depends on established knowledge: sound is transformed into symbolic content through the *statement* created in the identification of audio-visual synchronization. In shifting the emphasis in its consideration from the question of *what sound?* to this implied meaning produced through an immanent relationship revealed in the simultaneous phenomenal encounter with other, visual materials—the identification of synchronization is a formal property of the synchronized. Their organization determines the sound::image structures arising from both cultural knowledge and the immanent encounter, a fusion of sound::image into a singular unit of sense-experience, as Attali theorized,[30] expanding the observations Claude Levi-Strauss made about music as a cultural product in *The Raw and the Cooked*:

> Music follows exactly the opposite course [than painting]: culture is already present in it, but in the form of sense-experience, even before it organizes it intellectually by means of nature. It is because the field of operations of music is cultural that music comes into being, free from those representational links that keep painting in a state of subjection to the world of sense experience and its organization in the form of objects.[31]

The identification of sense-experience as "music" renders these results mimetic, whatever the character and audible qualities of the sounds themselves. The Futurist music by composer Luigi Russolo employing his "six families of noises"[32] depends on their rhythmic character—emergent development—for their recognition as belonging to the domain of music. This emergent determination is definitive for interpreting the work. They are immediately apparent in the composition *Les Echanges* (1964) by Rolf Liebermann, whose original performance at the 1964 New York World's Fair, *Expo '64*, by 156 office machines—16 typewriters, 18 calculators, 8 accounting machines, 12 office punchers, 10 cash registers, 8 dry mounters, 8 teleprinters, 2 metronomes, 4 signal bells, 2 door gongs, 10 claxons, 16 telephones, 40 signal receptors, a photocopier, and a forklift—created the music through its rhythmic organization of anti-musical sound: the bells, type strikes and other "noise" (Figure 1.3) machines produce as they operate.[33] As Russolo noted in his Futurist manifesto "The Art of Noises," the identification of sound *as being* music does not depend on its being produced by musical instruments.[34] What transforms the cacophony of the machines' operation into music is *not* a function of an immanent

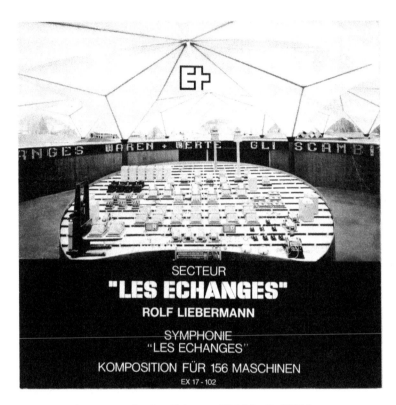

Figure 1.3 Album cover for *Les Échanges* (1964) by Rolf Liebermann

recognition of mimetic or non-mimetic sound, but arises through their emergent structure apprehended by audience listening—the transferal of the sound to the higher-level domain 'music.' The audience must decide that these sounds' arrangement and organization belong to the domain of music, just as they must decide the audible "tuning-up" heard at the start of Walt Disney's *Fantasia* (1940) does not—neither the use of musical instruments nor hearing sounds made by them is enough for the determination 'music.'

Musicologist-semiotician Eero Tarasti's *A Theory of Musical Semiotics* develops these distinctions as differences between signifier and signified, but as he notes, searches for new musical materials enlarges the range of what is and is not musical. These engagements at the level of the "material"—the sensory encounters with the sounds themselves—enables divisions between the domains of music and non-music. Music depends on recognitions of how *musical* and *anti-musical* sound (recognizable as

the concept of "noise") are unstable identifications in music, dependent not on their own innate nature, but on their resemblance to established forms contrasted with their proximate role in a higher-level organization.

Adapting Tarasti's model (Figure 1.4) explains how the noises of *Les Exchanges* remain comprehensible *as* noise—while still identifying the shift to the domain of music as a clear organization at an interpretive level: the bottommost pairing "musical | anti-musical" is a description of the proximate encounter with the sounds themselves; "anti-music" and "noise," as Kahn noted in his study, are generally coupled as synonyms of each other. The higher-level opposition of "music | non-music" is the emergent interpretation of the appropriate domain for understanding the resulting composition as being organized musically or not—as conforming to the shared cultural idea "music" or being simply sound; *Les Echanges* challenges the assumptions of the established category "music" by expanding it.

The primary recognition of the sounds heard—mimetic/non-mimetic, the audience recognition of the sounds—is a lower-level identification than the cultural conventions of music *qua* music. This cultural knowledge is the determinant constraint for the audience interpretation of sound over time—a decision about what "domain" the sounds have when their organization emerges. In making the recognition of a musical organization for the mechanical noises heard in the performance of *Les Exchanges*, the chaos of machines running (anti-music sound) becomes instead an organized and self-organizing progression of percussive rhythms: it becomes *music*. This higher-level interpretation is not a deterministic result of the mimetic recognition of (for example) the sound of "teletype machine," but emerges separately from that recognition; the higher-level identification of the *anti-music* sounds as "music" demonstrates that the recognition of the sounds is not important in marking their independent organization. These are distinct, separate

non-music	music	
	musical (SOUND)	anti-musical (NOISE)

Figure 1.4 Distinctions between Music and Non-Music adapted from Figure 2.6 in A Theory of Musical Semiosis by Eero Tarasti

recognitions—one immanent in the sense-encounter itself, the other emergent over time. The disjunction between one level of identification and another when engaging with sound is absolute: the primary recognition of a sound, and its organization over time by a particular domain (such as "music," and by extension even "speech") are entirely separate interpretations that do not depend on each other. Unlike language where the recognition of lower-level units organizes the higher-level interpretations, for 'pure' sound (sound in itself without vocal or visual accompaniment) this linkage is absent.[35]

Visual aspects of synchronization are consistent, emerging from their immediacy: visuals are understood in the instant. In looking, the sensory encounter that sight provides does not require time for it to develop or become coherent—factors that distinguish the visible from the audible. The identification of linkage between the recognition of a sound and the visuals simultaneously accompanying it emerges from the addition of time—duration—because sound requires temporal development. The immediate recognitions common to the visual are altered by the emergent meanings common to audible form. Even though the connections created by their simultaneous presentation in a motion picture may suggest their synchronization is more than coincidental, the linkage of sound::image specific to synchronization depends on the audience interpreting these experiences through their past experiences and established (lexical) expertise.

The problem posed by sound is not denotative—the ontological basis of the heard—but rather its relational shift into higher-level domains such as music arising from its role in a 'grammatical order.' *Synchronization*—distinguishing the organized from the happenstance—forms the initial interpretation of any significance following from that apperception. No particular arrangement necessarily has any particular meaning; analysis and interpretation follow from the specifics and detail of particular images and sounds, their unique and singular character, rather than their organization into a general and abstract arrangement. The dynamic relationships of sound::image emerging in synchronization fundamentally determines the significance and appeal of individual designs. Synchronization in title sequences depends on both the immediacy of visual form and the emergent meaning of sound, mediated by the interpretation of both elements' relationship to the text on-screen. Unlike the visual relationships of text and image, where the interpretation can focus on the lexical and structural relationship of elements, for sound, the phenomenal encounter is the foundational level of interpretation. How this initial engagement progresses then determines whether any other meanings connected with synchronization are recognized as

appropriate potential ways to engage the *statement* their synchronization creates—such as the correlations of audible and visual that create the synaesthetic effects of visual music. Higher-level understanding of sound::image synchronization (such as 'lip-sync' or visual music) is separate from primary recognition, a product of the organization of these lower-level elements to form the initial *statement*. Only after this definition through its organization into this enunciation can more complex interpretations of sound progress: the audience identification of *synchronization,* is the fundamental interpretation for sound::image relationships in motion pictures—not, as has been commonly theorized, the mimetic/non-mimetic nature of the sound itself.

Notes

1　The focus on primarily Hollywood films is typical of studies of title sequences. Even exhibitions such as the 2009 survey *Vorspannkino: 47 Titel einer Ausstellung* (KW Institute for Contemporary Art, Berlin) reveal the dominance of Hollywood productions internationally.

2　Graine, P. and C. Johnson. *Promotional Screen Industries* (New York: Routledge, 2015).

3　Gray, J. *Show Sold Separately: Promos, Spoilers, and Other Media Paratexts* (New York: NYU Press, 2010).

4　See, for example, Altman, R. "Moving Lips: Cinema as Ventriloquism." *Cinema/Sound,* edited by R. Altman (New Haven, CT: Yale University Press, 1980), or his anthology, *Sound Theory, Sound Practice* (New York: Routledge, 1980).

5　As in the special issue of the journal *Music, Sound, and the Moving Image* (Vol. 8, No. 2, Autumn 2014) that collected papers from a conference on music in "Titles, Teasers, and Trailers" organized by Annette Davidson at the University of Edinburgh in April 2013.

6　David, R. *Complete Guide to Film Scoring: The Art and Business of Writing Music for Movies and TV, Second Edition* (Boston: Berklee Press, 2010).

7　Winkler, M. "The Origin of Film Music." *Films in Review* (Dec. 1951), pp. 35–36.

8　Cooke, M. *The Hollywood Film Music Reader* (New York: Oxford University Press, 2010), pp. 5–6.

9　Attali, J. *Noise: The Political Economy of Music* (Minneapolis: University of Minnesota Press, 2009), p. 26.

10　Betancourt, M. *Beyond Spatial Montage: Windowing, or the Cinematic Displacement of Time, Motion, and Space* (New York: Routledge, 2016), pp. 19–50.

11　Kahn, D. *Noise, Water, Meat* (Cambridge: The MIT Press, 1999), p. 149.

12　Jacobs, L. *Film Rhythm After Sound* (Oakland: University of California Press, 2015), pp. 58–72.

13　Eisenstein, S., V.I. Pudovkin, and G.V. Alexandrov. "A Statement" (Statement on Sound). *Film Sound,* edited by E. Weis and J. Belton (New York: Columbia University Press, 1985), p. 84.

14　Balazs, B. "Theory of the Film: Sound." *Film Sound,* edited by E. Weis and J. Belton (New York: Columbia University Press, 1985), p. 116.

15 Altman, R. "Moving Lips: Cinema as Ventriloquism." *Cinema/Sound,* edited by R. Altman (New Haven, CT: Yale University Press, 1980), pp. 67–79.
16 Lapedis, H. "Popping the Question: The Function and Effect of Popular Music in Cinema." *Popular Music,* Vol. 18, No. 3 (Oct. 1999), pp. 367–379.
17 Brown, J. "*Ally McBeal*'s Postmodern Soundtrack." *Journal of the Royal Musical Association,* Vol. 126, No. 2 (2001), pp. 275–303.
18 Green, J. "Understanding the Score: Film Music Communicating to and Influencing the Audience." *The Journal of Aesthetic Education,* Vol. 44, No. 4 (Winter 2010), p. 82.
19 Rushton, R. *The Reality of Film: Theories of Filmic Reality* (Manchester: University of Manchester Press, 2011), pp. 53, 60–63.
20 Gray, J. *Show Sold Separately: Promos, Spoilers and Other Media Paratexts* (New York: NYU Press, 2010), pp. 72–78.
21 Stanitzek, G. "Texts and Paratexts in Media." *Critical Inquiry*, Vol. 32 (Autumn 2005), pp. 27–42.
22 Betancourt, M. *The History of Motion Graphics: From Avant-Garde to Industry in the United States* (Rockport: Wildside Press, 2013).
23 Horak, J. *Saul Bass: Anatomy of Film Design* (Lexington: University of Kentucky Press, 2014).
24 Haskin, P. "Saul, Can You Make Me a Title?" *Film Quarterly*, Vol. 50, No. 1 (Autumn 1996), pp. 12–13.
25 Picarelli, E. "Aspirational Paratexts: The Case of 'Quality Openers' in TV Promotion." *Frames Cinema Journal* (2013), http://framescinemajournal. com/article/aspirational-paratexts-the-case-of-quality-openers-in-tv-promotion-2/, retrieved September 14, 2016.
26 Metz, C. *Film Language: A Semiotics of the Cinema* (New York: Oxford University Press, 1974), p. 111.
27 Metz, C. "Aural Objects." *Film Sound*, edited by E. Weis and J. Belton (New York: Columbia University Press, 1985), pp. 154–155.
28 Kahn, D. *Noise, Water, Meat* (Cambridge: The MIT Press, 1999), p. 25.
29 Altman, R. "Moving Lips: Cinema as Ventriloquism." *Cinema/Sound*, edited by R. Altman (New Haven, CT: Yale University Press, 1980), pp. 67–79.
30 Attali, J. *Noise: The Political Economy of Music* (Minneapolis: University of Minnesota Press, 2009).
31 Levi-Strauss, C. *The Raw and the Cooked* (Chicago: University of Chicago Press, 1983), p. 22.
32 Russolo, L. "The Art of Noises—Futurist Manifesto." *The Art of Noises* (New York: Pendragon Press, 1986), pp. 23–30.
33 Recording sleeve notes, *Secteur "Les Echanges," Rolf Liebermann, Symphonie "Les Exchanges" Komposition fur 156 maschinen, Ex17-102*, Turicaphone, AG, 1964.
34 Russolo, L. "The Art of Noises—Futurist Manifesto." *The Art of Noises* (New York: Pendragon Press, 1986), pp. 23–30.
35 Tarasti, E. *Theory of Musical Semiotics* (Bloomington: Indiana University Press, 1994), pp. 73–76.

2 Direct Synchronization

"Synchronized" identifies a particular relationship between the soundtrack and the imagetrack that is apparent to the audience as more than simply the coincidence of simultaneous presentation. The audience makes higher-level interpretations of structure and organization emerging over time from convergent events between sound and image. The identification of *direct synchronization* originates with its resemblance to phenomenal encounters in our everyday experience: when someone speaks, we see their lips move and we hear their voice as a conjoined encounter; the recreation of these types of synchronized relationship in motion pictures (unlike lived experience) is an artificial construction. In resembling our everyday experiences, *direct synchronization* of sound and visual appears as an *autonomous* conclusion, its immediacy masking its underlying illusion and artifice. *When* sounds are aligned with visual elements determines the character and nature of synchronization, an issue of timing.

Realist morphologies arise from the tendency to identify the formal structures of both direct and counterpoint synchronizations by their degree of similarity to our everyday phenomenal encounters with the world. Identifying synchronization *through* its resemblance to extracinematic phenomena implicitly advances the proposition that the world revealed by the filmic realism common to both André Bazin and Stanley Cavell depends on what film theorist Richard Rushton termed the "forms of life" approach to realism: "knowledge is about a social understanding of reality, intersubjective acknowledgements about what should or can be decided upon as real."[1] Thus, *realism* reveals a dominant ideology; the particulars of that reality are of less concern to this discussion than the acknowledgement that the cinematic construction is interpreted in relation to them. The conception of "reality" diverges into distinct approaches to realism as film theorist Christopher Williams notes in his book *Realism and the Cinema*: *direct*

synchronization develops from this pair of realist approaches—as *naturalistic synchronization*, a reproduction of surface appearances discussed below; or as *illustrative synchronization*, a demonstration of unseen "truths"[2] that are revealed via intellectual consideration, not mere phenomenal sensation, discussed in Chapter 3; *counterpoint synchronization* is discussed in Chapter 4. Both approaches to *direct synchronization* use the same formal technique—they appear as interchangeable proofs—a linkage of sound::image in an immanent encounter. In contrast, *illustrative synchronization,* apparent in the tradition of "visual music" and its heritage, creates sound::image connections that seem direct and natural, but that reify beliefs about an unseen "true reality" rendered as a literal audio-visuality; *counterpoint synchronization* complicates without challenging this pair of realist modes. Synchronization assumes *realism*—ideological-cultural interpretations about the nature of the world—through the audience's immanent encounter with the simultaneous sound::image presentation, the coincident and analogous relationship of the seen to the heard (especially when *what* is encountered is not a part of everyday experience).

Direct synchronization enables this realist form to appear natural, inevitable, unquestionable, beyond any need for theoretical analysis: the literal connection of a sound to its source resembling everyday phenomenal encounters, as in 'lip-sync,' defines this most basic realism, *naturalistic synchronization.* The "sync points"[3] that provide this identification correspond to the everyday reality of sound::image as unitary events—the most obvious example being the closing of a clapboard at the start of filming, or the seeing lips moving on someone's face as they speak, but can include such purely audible things as the notes heard in the soundtrack as an instrument plays.

Naturalistic synchronization informs Dan Perri's title sequence to *The Player* (1992) that weaves the credits into Robert Altman's 9-minute-long take, itself an opening whose narrative content discusses another long take opening, Orson Welles' *Touch of Evil* (1958). The first image shows a clapboard, clearly marked "Take 10" (Figure 2.1). It closes with a resounding snap, a voice says "Action," and both the title sequence and the film begin. The immediacy of this opening is tempered by its blatant artifice: the opening to this motion picture is an epic 9-minute-long take that moves out into the parking lot and follows characters through the space while Dan Perri's carefully composed titles fade in and out unobtrusively. Characters enter and exit, traffic passes through. Even though the very first image was this clapboard announcing that the entire sequence has been attempted nine *other* times, the mise-en-scène that choreographs

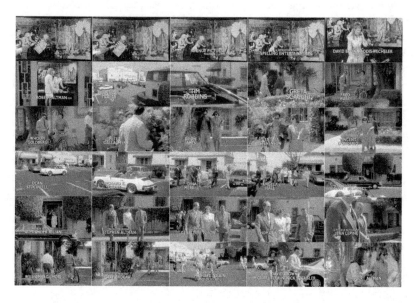

Figure 2.1 All the title cards in *The Player* (1992).

the live action is seductive. While this opening is a title sequence, the presence of text-on-screen is at the same time incidental. The synchronization of sound and music (aside from the clapboard that makes clear the constructed nature of the entire drama that unfolds), make no suggestion that the events apparently happening autonomously in front of a camera are staged to create a realistic appearance. Direct synchronization, aside from the initial snap of clapboard, receives no further consideration: the dialogue reflects on the history of similar openings, but the basic *fact* of its assembly from the synchronized elements of independent soundtrack and imagetrack has become such a natural encounter that is entirely unacknowledged.

The organization of synchronization for title design and motion graphics generally emerge from the more general relationships of sound::image commonly appearing in narrative film; their interpretation and use within title sequences emerges as a specialized, liminal case where the more common constraints of realist form and narrative do not necessarily apply to the liminal form of these designs. The dominant narrative conventions remain constant in the organization and use of synchronization. The fundamental theoretical problems arising from sound and its relationship to images illuminates how their connection *as* synchronization renders

ideological forms as natural phenomena, transforming the cultural into immanent encounter. These dynamics are especially important for the meaning and interpretation of synchronization because title sequences, more than the narratives they accompany, offer the opportunity for considering these interplays of form and meaning through sound::image synchronization without the intervention of fiction, drama, character, or narrative.

The Synchronized

The linked *experiential* basis of audio-visual structures pose *synchronization* as a particular "formal" relation, one that is not structured linguistically, yet does present meaning. The relationships of sound::image employed in title sequences emerge from more basic organizations of audio-visual form. The semiotics that produce the complexity of sound::image in the title sequence are first organized and articulated as particular, discrete *perceptions* of relationship. Interpreting these arrangements coincides with the problematics of the *enunciation* that Michel Foucault describes in *The Archaeology of Knowledge*: a formal unit distinct from the demands of language (*parole*), implied by grammar (*langue*), but formally independent of it. Meaning begins with the grouping-together presented in the *statement*, rather than following from predetermined rules of language, a distinction that is explicitly a feature of audio-visual synchronization:

> The statement is neither a syntagma, nor a rule of construction, nor a canonic form of succession and permutation; it is that which enables such groups of signs to exist, and enables these rules or forms to become manifest. But although it enables them to exist, it does so in a special way—a way that must not be confused with the existence of signs as elements of a language (*langue*), or with the material existence of those marks that occupy a fragment of space or last for a variable length of time.[4]

In this "enunciative function" Foucault describes the action of creating the *statement,* rather than its connections, with whatever meanings may be assigned to its terms; this act of delineation and compartmentalization depends on combinatory effects created by order and arrangement that register *as* the "statement" itself—neither the component parts, nor their meaning—thus 'enunciation.' The initial judgment that a voice heard and an image seen should be understood as a 'singular unit' enables a

unitary interpretation of audio-visual simultaneity, but these structures have been left untheorized by semiotics because they evoke problems not normally considered when examining linguistic statements, issues that Foucault specifically identifies for the enunciative *statement*:

> The relation of the proposition to the referent cannot serve as a model or as a law for the relation of the statement to what it states. The latter relation not only does not belong to the same level as the former, but it is anterior to it. [. . .] The relation of a sentence with its meaning resides within a specific, well-stabilized enunciative relation. Moreover, even if these sentences are taken at an enunciative level at which they are meaningless, they are not, as statements, deprived of correlations.[5]

The recognitions of terms and their meanings do not preclude the construction of valid, grammatical statements without lexical meaning; the elliptical form of rhetorical and poetic statements describe and demonstrate these problematics of meaning posed by/in Noam Chomsky's grammatically correct, but nonsensical statement that Foucault offers as an example whose considered meaning evades easy comprehension: "*Colorless green ideas sleep furiously.*"[6] However, these problems arise not because it is meaningless, but in the uncertainty of how to classify it: as "nonsense statement" it becomes an exemplar of statements without meaning, creating an immanent paradox, since the statement's meaning is that it has none. This organization of meaning apart from the terms contained defines 'enunciation' as process and its functioning in the 'statement.'

Foucault's distinction between *component terms,* the *statement,* and the *meaning* is especially appropriate for considerations of synchronization of sound::image. The classification of sounds encountered—as music, or as voice, or as ambient "noise"—separates distinct modes of analysis and determines the formative dimensions of the encounter. This initial engagement determines the scope of potential meanings that might be assigned to any particular sound—beyond its mere recognition. The addition of synchronized visuals renders even those sounds that might not otherwise be considered meaningful as *potentially* significant. This relation of sound::image elaborates and modifies the meanings that any sound might have: consider how the connotations of Christian Metz's aural object, the 'lapping sound,' changes if hypothetically coupled with the image of a calm sea, a dark cave, a bayou, or an empty office. These transformations originate with the simultaneous sound::image presentation: in each case the combination results in different connotations at the level of enunciation (in each case a product of its simultaneity) that

composes the sound::image unit as a *statement* without even considering the specifics of particular *lapping* sounds or images.

Animations, title sequences, and rhythmic montages cut to music all present determined meaning through synchronizations that are not dependent on lexical structure.[7] Both phenomenal experience (simultaneity) and cultural referents organize these forms as a meaningful construct—as enunciation via the *statement*. These simultaneous presentation of sound-and-image depend on relationships not linked to unmediated, extratextual experience—as with music, even the creation of the instruments before the first note has sounded puts the "musical" inherently into a cultural domain. For cinema, realism denies the artificiality of synchronization, becoming an inherent *demonstration* of cultural ideation itself. The role of synchronization parallels musical compositions. The particular potentials realized as/in the phenomena are set in advance by established cultural hierarchies. In music, this constraint is revealed by the emergent structure and development of Liebermann's composition-performance for 156 office machines, *Les Echanges*. The *statement* (performance) is identified by the audience as "music" rather than as "noise." Synchronization achieves the same apparently inevitable emergence as music, demonstrating the dominance of "realism" for motion pictures.

The structuring and organization of sense-experience into particular phenomena—music, speech, noise—is an autonomously emergent transformation of encounter into coherence. This change is a secondary recognition guided by established knowledge and past experience, independent of the primary recognition that distinguishes or identifies particular sounds as specific phenomena. That these transformations of phenomenal encounters happen continuously without requiring conscious direction renders the world present as a natural, ontological phenomenon; this sensory encounter is mobilized into the identification of synchronization, complicating its theorization.

Although synchronization emerges from sensory encounters as meaningful through a semiotic process, it also remains fundamentally the direct product of a sensory encounter, phenomenological, and so begins at a lower level of interpretation than those typically considered in the theorization and engagement with lexical forms. Making this basic distinction allows for clarity in considering the otherwise entangled encounters of sound::image in motion pictures that includes the mimetic/non-mimetic character of the sound itself, its emergent organization interpreted over time, and the proximate interpretation of its relationship to the visuals. The interpretation that a sound::image pair are *synchronized* is a specific linkage of sound::image that provides the underlying basis for higher-level interpretations. It is this starting point in sense-experience

that renders the problem of synchronization apparent. Unlike parsing written language, where the letterforms themselves only become important in special circumstances (otherwise they remain a secondary element to the significance they present), in the synchronization of sound::image in motion pictures, the sounds and images are important in their initial, phenomenal engagements—a material basis that is typically ignored in theorizing the formalized lexia of language. Synchronized works emerge in an encounter that comes *before* signification: the recognitions that for lexia happen invisibly in the linguistic encounter—the visual recognition and identification of letters, the distinction of *which* sounds are language and which aren't—for sounds are independent of any emergent pattern (such as "music") that provide the central interpretation for the work. This experiential element's primacy distinguishes these works from the linguistic; their analysis and interpretation can begin only through a process of identification and fragmentation that separates the continuities of experience for semiotic consideration.

Understanding synchronization as foundationally constructive of signification reveals that enunciation is never confined to only the first level of what the component elements might signify in themselves. A formulated *statement* requires the identification of its elements as a self-contained arrangement of "terms" organized and delimited in advance of their presentation, not simply as singular elements, but as a group placed into a particular configuration that is productive of meaning. Their organization demonstrates the audio-visual relations described by synchronization in motion pictures are dependent on the interpreting mind of the audience to recognize these formal associations and understand them as a singular unit independent of the character or nature of the individual elements; their meaning develops on contradictory levels, as the constitutive elements and their organization are independent of each other. The distinction between the noise produced by Liebermann's office machines and the music emergent from/through its organization precisely illustrates the independence/separation of the signs composing the *statement* from the new signification arising from/through that composition (i.e., the meaning of the *statement* itself). This progression is contingent on the audience and how they choose to engage the statement, but their interpretations are also constrained by the statement itself. For Foucault, this limiting factor defines enunciation as such:

> The referential of the statement forms the place, the condition, the field of emergence, the authority to differentiate between individuals or objects, states of things and relations that are brought into play by the statement itself; it defines the possibilities of appearance and delimitation of that which gives meaning to the sentence, a value as truth

to the proposition. It is this group that characterizes the *enunciative* level
of the formulation, in contrast to the grammatical and logical levels.[8]

For non-linguistic statements without distinct grammars and whose
denotative form—both images literally shown by photography, and the
aural objects synchronized with them in the soundtrack—are always
entangled with their potential connotative meanings, this enunciative
level dominates the entire interpretive process. Synchronization becomes
the *material* form of the audio-visual statement. Its formulation as the
"statement" requires an imposition of ordering schema, the identifica-
tion of potential signifiers and their arrangement that is constitutive of
the parameters that make interpretation possible; the particular image
always anchors the meaning of sound.

By assuming that the title sequence is a self-contained construction,
as Jonathan Gray explains in *Show Sold Separately*, renders it as tangen-
tial to the central drama—a paratext[9]—allowing these designs a higher
degree of stylization and experiment with the conventions of realism
than might otherwise appear in the main narrative. But this status for the
title sequence—its marginality in relation to the dramas that typically fol-
low it—also means that while there is abundant theorization of realism
within narrative dramas, the role of realism within the title sequence itself
is unconsidered. Gérard Genette, the theorist who proposed the paratext
as a specific part of analysis, views this separation and direction-away is
a contradiction of function. He concludes his book *Paratexts: Thresholds
of Interpretation* by challenging these redirections and the resulting focus
on the paratextual elements as pseudo-independent entities:

> The paratext is only an assistant, only an accessory of the text. And
> if the text without its paratext is sometimes like an elephant without
> a mahout, a power disabled, the paratext without its text is a mahout
> without an elephant, a silly show.[10]

Cinema complicates this conception borrowed from literature: title
sequences rely on their motion picture not only for their existence, but
for their becoming coherent. They are integral, not peripheral, making
their role as paratexts problematic.[11] The conflicted relationship with
the dominant constraints of the primary film-text (the very thing pro-
ductive of its *paratextual* status) that makes it possible to refer to these
"openings" as having a "paratextual function" because the credits refer
simultaneously to the production, and indirectly to the narrative itself.[12]
These roles are of great importance for questions of synchronization in
title sequences, while simultaneously rendering their consideration prob-
lematic: to what extent, if at all, are the concerns with continuity and

naturalistic action even relevant for the organization of the imagery in a title design? Answering this question coincides with theorizing synchronization in title sequences.

Naturalistic Synchronization

The *naturalistic synchronization* of sound and image is so common as to appear inevitable—a demonstration of how realism dominates synchronization. The importance of realism in the organization and conceptualization of audio-visual relationships should not be underestimated when considering narrative dramas, but it also imposes constraints on the title sequence. The development of *naturalistic synchronization* in title sequences depends on the audience's recognition that the sound and image are correlated in a way the resembles their phenomenal encounters in everyday life. The relationship of voice-heard to speaker-seen lies at the foundation of these recognitions—that this person shown on-screen is speaking, and not the others, mobilizes a network of past experience and knowledge derived from everyday life; the linkage of voice speaking to image shown—as in a voice-over for a documentary about penguins—becomes synchronous through the same use of past experience, but plays on the audiences lexical and intertextual knowledge in making the connections. The audience comprehends these synchronized relations of sound::image both through immanent primary recognitions *and* as an emergent product of their simultaneous presentation. The apparent directness of linkage that produces 'lip-sync' as a naturalistic phenomena where characters shown and voices heard correlate as "the speaker shown" is a dramatic effect in itself, even if it has become banal through repeated use. The entire narrative in *The Jazz Singer* (Warner Brothers, 1927), with its focus on songs performed on camera, reveals the emotive power of this connection when it was first introduced. Its opening introduces 'lip-sync' in a dramatic fashion, preceded by an extended musical overture, synchronized speech appears on-screen only after a lengthy camera move whose mise-en-scène renders the encounter with 'lip-sync' specifically as a discovery for the audience. It is precisely this encounter (and its novelty) that was the attraction when the film initially premiered; as Rick Altman noted in "Moving Lips: Cinema as Ventriloquism," the speaker holds the audience's gaze, is the locus of viewer attention in cinema.[13]

In the voice-text-image unity presented by title sequences, they cease to be a coordinated series of *separate* phenomena when the audience recognizes their synchronization: sound is instead "grounded" by its linkage with an image.[14] This subordination of sound::image created by synchronization specifically attaches the audible to a particular subject. In *Belle de Jour* (1967) the titles appear superimposed over a long take

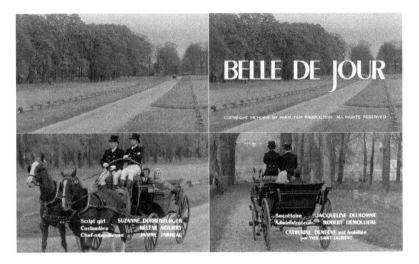

Figure 2.2 Selected stills from the title sequence to *Belle de Jour* (1967).

of a carriage drawn by two horses (Figure 2.2). As it approaches, the shot pans, following it past to reveal a man and woman riding inside, having an inaudible conversation. The soundtrack contains the jingle of metal, the flat trumpet of a fog horn, hooves on pavement—their loudness varies, suggesting the steady approach of the carriage and the ambient noise of the environment. In watching this sequence, the immediacy and literalness of the connection between sound and image is never in question: this is what the audience might hear if they were sitting in the vantage point of the camera. While the sound supports the image, if heard on its own, it would be difficult to identify the particular nature of what is heard. In being synchronized, the direct and natural connection that emerges renders the *realist* claim made through this *statement* quite explicit: that what appears on-screen has the mundane reality of things encountered in the world. The foundation for these associations is the apparent naturalism of 'lip-sync' and its similarity to the past experiences of everyday life—the audiences' phenomenal encounters with the world. This dimension of synchronization brings the role of realism into focus, not only within the title sequence, but in general, by suggesting the same connections of sound to source that André Bazin offers in his discussion of photography:

> The automatic way in which photographs are produced has radically transformed the psychology of the image. Photography's

objectivity confers upon it a degree of credibility absent from any painting. Whatever the objections of our critical faculties, we are obliged to believe in the existence of the object represented: it is truly re-presented, made present in time and space. Photography transfers reality from the object depicted to its reproduction. [. . .] Photography's aesthetic potential resides in the way it reveals reality. A reflection on a rain-swept sidewalk, a child's gesture—these are things that do not depend upon me to perceive them in the fabric of the outside world.[15]

Naturalistic synchronization aids in the assertion of resemblance that Bazin finds as the demonstrative character of photographs. The familiarity of this ontological assumption about the photograph is repeated by the audible through the *statement* created by synchronization—it is not an issue of a literal linkage between sound and image that corresponds to the phenomenal world, but of the association it produces.[16] This distinction between the naturalism of synchronization and the innate connections of everyday life is important because hearing and seeing both happen as continuous, simultaneous events, but only become synchronized in motion pictures following specific codified arrangements[17] such as the realism Bazin clearly invokes. The linkages and associations of what we expect the sound to be like—what and how we expect it to sound—reinforces the apparent reality of the image we see. Many of the sounds heard in the *Belle de Jour* title do not appear on-screen at all, yet their presence passes without concern: there do not appear to be any sleigh bells on this carriage, yet we can hear them clearly. It is not foggy, but there is a fog horn. There is other traffic easily visible in the distance, but it passes silently. The naturalism of 'lip-sync,' while foundational for the *conception* of *naturalistic synchronization,* does not describe the synchronized relationships emergent in motion pictures—while the sound::image link is artificial, the realist effect it accentuates hides this artificiality through the immediacy of its appearance.

These titles for *Belle de Jour* proceed without the addition of music. The assertion of an austere, immanent realism thus ensues: the addition of music to the titles separates the sounds heard in them from their proximate relation to the image, as Wayne Fitzgerald's title sequence design for *One Flew Over the Cuckoo's Nest* (1975) demonstrates (Figure 2.3). As with *Belle de Jour,* at first the soundtrack converges with the images, providing an audible reinforcement of the imagetrack: bird calls and wind; the title music only begins when the first credit fades in, superimposed over a desolate landscape. The *naturalistic synchronization* of the sound::image has a radically different character once the music

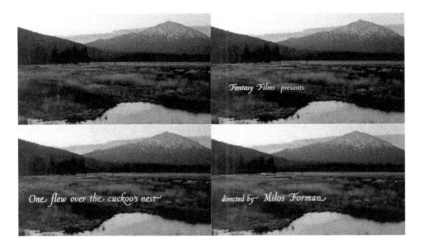

Figure 2.3 Selected stills from the title sequence to *One Flew Over the Cuckoo's Nest* (1974).

begins in Fitzgerald's design, marking the artifice of the title sequence as a separate 'unit' from the ambient sound-space of the landscape. For *Belle de Jour* this distinction never arises. The titles and the background imagery of carriage are organized together, the compositions of the text on-screen placed so they don't overlap the subject matter of the shots. Because there is no ambient music, the sound of the approaching the carriage and horses invite an engagement with this (apparent) background photography rather than redirecting attention to the superimposed titles and away from its realist presentation to a consideration of the text-on-screen as *One Flew Over the Cuckoo's Nest* does. The continuity of this long take affirms the unity of the title sequence: the duration of the titles corresponds to the time it takes for the carriage to approach and pass by. The nature of the narrative can be intuited from this construction—that it is concerned with a moment in the lives of these particular people riding in the carriage.

Because everything on the soundtrack is *technically* synchronized with the visual field, "synchronization" is an interpretation that means more than simply a "happening simultaneously." The parameters of this correlation that creates higher-level meanings are what is of interest to theories of synchronization, not the merely technical fact of sounds being played at the same time as the visuals in a motion picture, but their organization that leads the audience to parse their experience into a *statement* of sound::image linkage. The synchronization emergent in any particular

design becomes a site for the development of meaning. This connection of sound and image recreates the natural linkage of lived phenomenal experience, transforming synchronized images and music into an illustration of that score. Establishing sound::image relationships beyond the mere coincidence of being presented at the same moment is not only what is of interest about "synchronization," it is also the everyday understanding of the term. However, these linkages render their association seemingly inevitable, hiding their artificial and arbitrary foundation; the transformation of ideology into immanent demonstration by this naturalness of synchronization reveals what realism serves to hide through the immanent *statement* of synchronization: a subservience to established hierarchies that dominate audience engagements with the visual, and render the mediating role of lexical interpretation as the supreme model for understanding.

Diegetic and Non-Diegetic Synchronization

What the distinction between *Belle de Jour* and *One Flew Over the Cuckoo's Nest* reveals is the distinction between those sounds the audience identifies as belonging to the narrative "world" suggested by the images—the diegetic sound—and the other sounds that are additions to that depiction—non-diegetic. Even though both recognitions emerge together with the same images, *synchronization* renders them as distinct *statements.* Distinguishing those statements viewers understand as about the content and nature of the world from those added by the filmmakers as descriptors of that world marks the difference between the diegetic and non-diegetic roles for synchronization in these title designs. It is precisely the audience recognition of music in *One Flew Over the Cuckoo's Nest* that identifies it as *external* to the naturalism of this opening shot. That difference arises from the synchronization of music with the initial fade-in of the first title card.

Diegetic sound is a conclusion about the *character* of a soundtrack, its anticipated and expected organization, rather than the proximate or necessarily apparent connection of 'lip-sync,' even though it behaves in the same way. This distinction informs the title sequence for *The Set-Up* (RKO, 1949). It begins with a shot of a man holding a hammer next to a boxing ring, then tilts up to follow the legs of the men as they fight (Figure 2.4). We hear (but do not see) the man ring the bell. Their fight is accompanied by inchoate voices, their words ambiguous—the "murmuring and roar" of the crowd watching the match. Even though no particular people speaking appear in the sequence, the abstract presence of the calls is important not for what they say, but for the ambiance they produce.

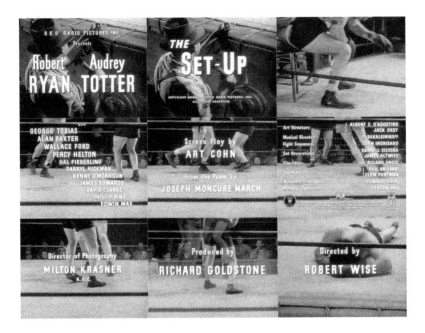

Figure 2.4 All the title cards in *The Set-Up* (1949).

The sounds heard are those we expect to hear—they are the diegetic noises of this scene—there is no music playing. When one boxer finally knocks the other down, his body hits the canvas with a muted thud; the synchronization of his fall is final, but not dramatic: the sound is muted. In being *naturalistic* it appears to lack commentary, a mere presentation of objective fact. This sound's demonstrative character aligns the audible with the realism described by Bazin—the diegetic nature of the sound is confirmed by the image's apparent recording of the fall.

A more complex relationship of diegetic sound appears in the title sequence to *The Big Chill* (1984), as historian Hilary Lapedis explained in her discussion of how popular music plays a dual role in dramatic narratives. Her article "Popping the Question: The Function and Effect of Popular Music in Cinema" marks the distinction between familiar music and that composed specifically for the film. The use of well-known songs in *The Big Chill*, coupled with the initial introduction, establishes the ambivalence of their presence in the soundtrack:

> The title sequence of *The Big Chill* comprises a montage cut to "I Heard It Through The Grapevine." Shots include a variety of

big close-ups of isolated aspects of the prime players: Chloe's (the dancer) legs, Nick's (the junkie) pills—anything that symbolizes the character in visual shorthand. While the song is a long one, the title sequence still manages to use some five minutes of it as an aural trigger for the audience. Whilst the musical genre is blues/soul and hence associated with melancholy and trauma, the lyrics are conveying the power of rumor in relationships and the sadness associated with their loss. [. . .] The cinematography of the title sequence is redolent of a narrative music-video montage sequence. The shots are short and tight and are cut to the rhythm of the song. [. . .] The presence of rock music is so much a part of the diegesis that even in those scenes, such as the title sequence, where there is no real source for the music, it does not become non-diegetic. It is true that we do see record players turned on and music being played by Wolfman Jack, but, even in the non-sourced scenes, rock music is so integral to the diegesis that it is perceived as 'real.'[18]

The relationship of the music to the scenes appearing in the title sequence is initially explicit: the first credits appear as white text over a black background accompanied by sounds of splashing that fade in to a small child who is singing "I Heard It Through the Grapevine" while being given a bath by Kevin Klein. While clearly diegetic, the only sound heard is the child splashing and singing, it is also artificial: only the sounds of the child in the bath are on the soundtrack as a woman answers a telephone in the background—the sound of her conversation or even the telephone ringing are absent—when the shift to recorded music comes, it marks a transition from the diegetic space of the bath to the non-diegetic title montage. It is clearly artificial: shots of a woman dressing a man in formal wear alternate with shots of each of the principal characters responding to the "news" of their friend's death. Only occasionally do the superimposed texts align with the actors appearing in the sequence—these paired text::image combinations do not form calligrams (only "Jeff Goldblum" is clearly linked to his name, which appears directly over his image).

The shift from diegetic to non-diegetic—a child singing to the recorded song that marks the start of the title sequence and ends it when the music fades out over a shot of Kevin Klein standing outside—is not rendered "ambivalent" by the convergence of performance-recording as Lapedis claims. The shift from diegetic sound to non-diegetic identifies the shift to title sequence that begins with the (silent) telephone call; the change to recording signifies the transition *into* the montage, establishing the distinction between narrative and title sequence. The end of the music and return of diegetic sound at its conclusion establish the titles as a self-contained entity.

However, if the characters within the story are playing music more-or-less continuously, as Lapedis' comments suggest, when is this music *not* diegetic? These uncertainties are innate to the use of popular music with an established identity apart from that of the film. The encounter in the title sequence, as with anywhere else, comes with an automatic and familiar—*déjà entendu*—that gives its inclusion additional qualities not otherwise present in the music.

A similar integration of music and diegetic performance appears in the title sequence for John Houston's *Beat the Devil* (1953). The music is diegetic, the performance of a brass band shown on-screen at the start, but the organization and progression of the sequence stretches that identification dramatically by mixing montage of Italian shoreline with footage of an Italian fishing village where the brass band plays (Figure 2.5). The entire sequence is synchronized: the shots where the band plays at the start and finish of the credits invoke the direct connection of 'lip-sync,' while cuts that change shots come both on the beat and at appropriate places in the musical phrasing, exploiting the natural changes in the music as sync points for the change of shot. Unlike in *The Big Chill*, where the distinction of child singing and recording is accompanied by a clear transition between diegetic and non-diegetic, in *Beat the Devil*, the musical montage suggests a continuity of spaces across the array of images shown. For the small Italian fishing village appearing in this title montage, the music is immanent, an audible part of the diegetic space itself. This recognition depends on the opening and closing shots—there is nothing about the music or the scenes shown that otherwise would render this connection of music heard to environment shown. The identification of diegetic sound is always a function of audience recognition and interpretation, quite apart from any identifications of synchronization: the opening and closing shots in the montage render the sequence diegetic; its synchronization is independent of this narrative relationship. In cutting based on the rhythmic structure of the music, the synchronization presented via the montage forms an additional *statement* to that of the diegetic relationship introduced through the naturalistic synchronization of band and performance at the start of the sequence. Foucault's observations about the distinctions between semblance and resemblance in *This is Not a Pipe* are instructive in considering this emerging distinction between diegetic and non-diegetic in the audience's engagement and interpretation of what they encounter in the *statement* produced by synchronization:

> Resemblance has a "model," an original element that orders and hierarchizes the increasingly less faithful copies that can be struck from it.

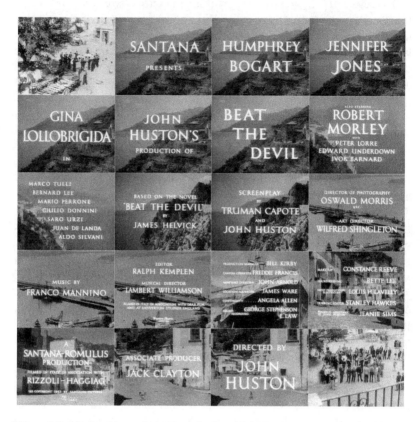

Figure 2.5 All the title cards in *Beat the Devil* (1953).

Resemblance presupposes a primary reference that prescribed and classes. The similar develops in series that have neither beginning nor end, that can be followed in one direction as easily as another, that obey no hierarchy, but propagate themselves from small differences among small differences. Resemblance serves representation, which rules over it; similitude serves repetition, which ranges across it.[19]

The diegetic belongs to this order of resemblance, a product that requires an indexical connection to its a priori source in past experience and expectation. The association of immanence and performance that renders naturalistic synchronization as a realist narrative "space" must always return to the "model" of phenomenal experience: that in a very small fishing village we might hear the music played by a band everywhere in town allows the music in *Beat the Devil* to be an immanent

feature of this fictional environment. In contrast, the independent identity of "I Heard It Through the Grapevine" marks it as non-diegetic in *The Big Chill*, even its initial presence (via the child's performance) functions within the film as an intertextual artifact contained in the narrative. Even when sung by a child, the song retains its independence, identified as a quotation that directs audience attention to prior knowledge of the pop song, rather than to lived, phenomenal experience: there always is a non-diegetic component to independent, known music such as pop songs or the well-known compositions such as Richard Wagner's *Die Walküre* or Gioachino Rossini's *William Tell Overture.*

In contrast to this intertextual identification, the directness of the realist connection to lived experience in *Beat the Devil* makes the diegetic association of music-montage possible—the resemblance between the audience understanding of its diegetic character for those shots seen even when the band is no longer visible on-screen. The realist expectations invoked by this identification are the same ones that anticipate the carriage sounds in *Belle de Jour,* or the boxing match heard in *The Set-Up.* The statement offered by these apparently naturalistic synchronizations all produce a diegetic claim of immanence that is recognizable as the definitive affect of Bazin's realism—that what is encountered in cinema resembles what could be encountered in life, a demonstration through media of the same phenomenal encounters possible in the world.

The identification of sound as "internal" to the film 'narrative space,' as being diegetic/non-diegetic, forms as a surplus of meaning, not based in the naturalistic connection of sound::image. The audience's interpretation of the sound in relation to the image—even when no clear connection appears—is the determinant of this narrative association, guided by its anticipated realist organization. These identifications are not an immanent feature of synchronization (although they are implied in its organization). They are instead a product of conventions and expectations produced by past experience. The development of the title sequence makes the distinctions of diegetic/non-diegetic clearly a product of how and what the audience identifies as significant, rather than an immanent affect of synchronization.

Audience understanding of title sequences as commenting and reflecting upon the narrative is not simply a product of non-diegetic sound—it also requires an identification of the visuals as also being non-diegetic: the *statements* formed by the title design must be separate (outside) the narrative space, even when they play a narrative role for the drama. This distinction emerges specifically through the synchronization of non-diegetic sound with the equally non-diegetic title cards superimposed over the background in *One Flew Over the Cuckoo's Nest.* By connecting the start of the music

with the appearance of the first superimposed figure-ground mode title card (in which the audience recognizes the typography and photography are separate, distinct "fields" on-screen where there is no link between text and image), the synchronization of music-text creates a statement of non-diegetic status. They are mutually reinforcing demonstrations that render the separation of title sequence from narrative, in a recognition of titles as a self-contained unit, in/dependent of the narrative. This identification of the titles as a higher-level *statement* renders them as 'paratext,' as Georg Stanitzek explains in his discussion, "Texts and Paratexts in Media":

> The paratextuality theorem, which was first developed in literary studies is thought to be particularly useful for determining what kind of text or, as it should now be expressed more precisely, what kind of textual unity one is dealing with.[20]

The term, borrowed from literary studies, describes peripheral aspects of the work that are identified as separate from it, but remain a crucial element in its interpretation-identification by its audience. Its application to film is problematic, but has utility in describing the title sequence: invoking this model acknowledges the audience recognition of the title sequence as a peripheral element, created as a quasi-independent form that is indexically connected to the main work.[21] This recognition of the titles as a higher-level non-diegetic statement often originates in the synchronization of music-text, distinguishing the titles in *One Flew Over the Cuckoo's Nest* from the rest of the film. The statement it forms marks the division between *title sequence* and *narrative* explicitly, preventing a collapse of distinction between opening titles and film narrative. The "textual unity" that Stanitzek describes as definitive for the paratext arises for the *One Flew Over the Cuckoo's Nest* title sequence through this distinction between the paired, audible statements: the naturalistic synchronization that defines the diegetic sound at the opening and separates it from the illustrative synchronization of the non-diegetic music-text of the credits themselves. The unity emerging from these statements *is* the opening sequence, readily identified by the audience watching it.

The constitution of the statements that form the opening become a paratext specifically through this non-diegetic identification; without it the opening *becomes* part of the narrative, and the paratextual interpretation cannot emerge. The start of *The Adventures of Baron Munchausen* (1988) demonstrates the importance of this non-diegetic recognition: while there are several intertitles that follow the Columbia Pictures logo graphic identifying the production company ("A Prominent Features & Laura-Film Production") then director ("A Terry Gilliam Film") before

cutting to live action shot of a city surrounded and under siege. The superimposed title "Late 18th Century" is replaced by "Wednesday" before cutting to a canon firing that is the start of a montage of the assault. The sound is directly synchronized and clearly diegetic: canons roar, explosions, yelling. There is also non-diegetic music, but no other superimposed titles or credit sequence appear; the film's title card is embedded diegetically in the live action of the sequence, as part of a tracking shot down a collection of proclamations and bills posted around the base of a ruined statue (Figure 2.6). The only reference made to the film title during the opening has been integrated into the progression of the narrative—the recognition that this poster for a play within the diegesis is at the same time the title of the film being watched is a self-referential interpretation of a different character entirely than the identification of the title sequence as such.

The distinctions between titles and narrative are a reflection of the ability to mark the title sequence as a self-contained unit within the film as a whole. Audio-visual synchronization, as with music-text in *One Flew Over the Cuckoo's Nest,* is the most common, but not the only method producing this identification. In *The Set-Up* the coincidence of duration

Figure 2.6 All the title cards in *The Adventures of Baron Munchausen* (1988).

between the boxing match and the extent of the titles renders it a singular unit where the diegetic sound of the boxer falling to the mat marks the conclusion of the sequence itself. The continuous long take of *The Player* serves the same function: the duration of the title sequence coincides with the length of the long take, approximately nine minutes, again rendering it as a singular unit. In both cases the formal identification of the titles as such depends on visual, not audible, cues to distinguish it from the rest of the film. The interpretation of diegetic and non-diegetic serve to distinguish the title sequence, a recognition commonly produced via a combination of audio-visual cues that provide punctuation to separate one statement from another. This function of synchronization enables the paratextual recognition of the title sequence as a self-contained unit even within a continuously-running narrative (as in *The Player*).

Notes

1 Rushton, R. *The Reality of Film: Theories of Filmic Reality* (Manchester: Manchester University Press, 2011), p. 63.
2 Williams, C. *Realism and the Cinema: A Reader* (London: Routledge, 1980), p. 11.
3 David, R. *Complete Guide to Film Scoring: The Art and Business of Writing Music for Movies and TV, Second Edition* (Boston: Berklee Press, 2010), p. 152.
4 Foucault, M. *The Archaeology of Knowledge* (New York: Pantheon, 1972), p. 88.
5 Foucault, M. *The Archaeology of Knowledge* (New York: Pantheon, 1972), p. 90.
6 Chomsky, N. *Syntactic Structures* (The Hague/Paris: Mouton, 1957), p. 15.
7 Barthes, R. *The Responsibility of Forms* (Berkeley: University of California Press, 1991).
8 Foucault, M. *The Archaeology of Knowledge* (New York: Pantheon, 1972), p. 91.
9 Gray, J. *Show Sold Separately: Promos, Spoilers and Other Media Paratexts* (New York: NYU Press, 2010).
10 Genette, G. *Paratexts: Thresholds of Interpretation* (New York: Cambridge University Press, 1987), p. 410.
11 Cecchi, A. "Creative Titles: Audiovisual Experimentation and Self-Reflexivity in Italian Industrial Films of the Economix Miracle and After." *Music, Sound, and the Moving Image*, Vol. 8, No. 2 (Autumn 2014), pp. 180–181.
12 Re, V. "L'ingresso, l'effrazione. Proposte per lo studio di inizi e fini." *Liminal le soglie del film: Film's Thresholds*, edited by V. Innocenti and V. Re (Udine: Forum, 2004), pp. 105–120.
13 Altman, R. "Moving Lips: Cinema as Ventriloquism." *Cinema/Sound*, edited by R. Altman (New Haven, CT: Yale University Press, 1980), pp. 67–68.
14 Altman, R. "Moving Lips: Cinema as Ventriloquism." *Cinema/Sound*, edited by R. Altman (New Haven, CT: Yale University Press, 1980), pp. 66–70.
15 Bazin, A. *What is Cinema?* Translated by T. Barnard (Montreal: Caboose, 2009), pp. 7–9.
16 Rushton, R. *The Reality of Film: Theories of Filmic Reality* (Manchester: University of Manchester Press, 2011), p. 53.

17 Rushton, R. *The Reality of Film: Theories of Filmic Reality* (Manchester: University of Manchester Press, 2011), pp. 60–63.
18 Lapedis, H. "Popping the Question: The Function and Effect of Popular Music in Cinema." *Popular Music*, Vol. 18, No. 3 (Oct., 1999), pp. 375–376.
19 Foucault, M. *This is Not a Pipe* (Berkeley: University of California Press, 1982), p. 44.
20 Stanitzek, G. "Texts and Paratexts in Media." *Critical Inquiry,* No. 32 (Autumn 2005), p. 29.
21 Gray, J. *Show Sold Separately: Promos, Spoilers and Other Media Paratexts* (New York: NYU Press, 2010), pp. 23–46.

3 Natural Artifice

Illustrative synchronization renders cultural beliefs as an audio-visual "fact," created by an immediate and direct connection of sound::image in an imitation of the phenomenal appeal of 'lip-sync.' The apparently autonomous linkage of sound::image posed by this *statement* of synchronization makes their association appear natural, even inevitable. It creates an audible 'space' comparable to the visual space of the image by meeting audience expectations and anticipations: recognizing the synchronization in the simultaneous presentation of 'crowd noises' and the image of 'stadium filled with people' is a combination whose relationship depends on past experience; the expectation of what it *might* sound like determines what can be heard in the soundtrack. This identification of sounds as belonging to the narrative/dramatic world on-screen—as being instances of 'diegetic sound'—depends on audience expectations about their cinematic encounter matching those of their everyday life; *illustrative synchronization* thus reflects and requires this "associative realism" to cohere its *statement*. Unlike naturalistic synchronization, the source of the sounds heard is only implied by the imagery, rather than actually shown as in the case of 'lip-sync' or "Mickey Mousing."

The "natural" linkages created by *illustrative synchronization* rely on audience assumptions about the nature of the world, changing them into an immanent, real phenomenal encounter: it organizes sound::image according to an implicit realist ideology, rendering an innate, unseen 'nature of the world' tangible. From the very start of the title sequence designed by Kyle Cooper for *Wimbledon* (2004) (Figure 3.1), the *statement* posed by the synchronization connects sound to typography, evoking *naturalistic synchronization*; however, although the sound of a tennis ball being hit with a racket has been synchronized to each credit's appearance, it is an example of *illustrative synchronization*: typography does not make noise.

Figure 3.1 Selected stills from the title sequence to *Wimbledon* (2004).

The addition of live action shots later in the sequence depend on audience expectations to integrate this sound into the narrative space—to become a 'diegetic' element requires a recognition of what

the sound in the visible space might be—the title sequence doesn't show a tennis match being played. The shots focus on the spectators, judge, and press—but the *sound of playing the game* is clearly heard. The editing and motion in each shot replaces the game with the text of the titles, a substitution that associates the subject of the film (the tennis Championships at Wimbledon) with the formal design of the credits. In the live action footage in the *Wimbledon* title sequence, connecting the sound to image is superficially direct—understanding the tennis match as a public spectacle requires a recognition of what is happening; it uses the mimetic identification of the sound to link the actions that are shown in the titles to the tennis match that is not shown. Only the audience's past experiences and knowledge can make the arrangement of typography-sound presented in the design coherent: what is going on—a "simple" question—requires a complex answer that originates with established knowledge of the world that is invoked in the *statement* through the film title, "WIMBLEDON," the distinctive sound of the tennis ball being hit in the tennis match itself, and the various views of the surroundings of those games. This apparent "realism" is an illusion, one that is assembled from fragments that are themselves partial, requiring established knowledge to interpret. That the audience makes these connections fluidly and without pause is what renders them "natural" and makes this soundscape diegetic.

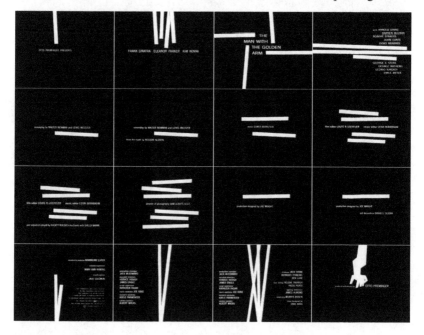

Figure 3.2 All the title cards in *The Man with the Golden Arm* (1955).

Illustrative synchronization never moves beyond the framework of correlating visuals to established expectations. When synchronized with music it remains directly connected to the score: *The Man with the Golden Arm* (1955) designed by Saul Bass is a notable early example of this linkage (Figure 3.2). It contrasts with his later designs using the same formal idiom derived from the Modernist International Style in graphic design. The sequence runs approximately two minutes, which was the most common length for title sequences since the 1920s; his later designs have a longer running time that allows for more complex audio-visual relations and additional imagery not connected to individual credits. This sequence was Bass' first graphic animated title, composed from 16 static title cards with animated transitions. It begins with a clear *statement* of illustrative synchronization that gradually drifts into syncopation; the sounds come slightly before or slightly after the visual sync-point in a reiteration of the syncopation common to jazz music. The syncopated drift and approximate synchronization returns to illustrative synchronization only for the final animorph into graphic arm at the conclusion of the sequence; this arm also appears prominently in the film posters and other advertising. The connection of narrative subject, graphic arm icon, and illustrative synchronization invites an acknowledgement of the *drift* as the impact of intoxication and addiction expressed through the design—the narrative of the film concerns the disastrous consequences that heroin has for a jazz musician (Frank Sinatra). This syncopation of music-credits can be understood as a literal rendition of his addiction, made apparent as the *in*ability of these elements to remain precisely synchronized in the title sequence. This is the "natural" effect of addiction shown during the narrative itself playing out in *The Man with the Golden Arm* title design, transforming this narrative information into both the formal logo/decoration, and the displacements of sound::image, an interpretation that returns the ambivalences of the design to an interpretation informed by the narrative that follows.

The "Visual Music" Heritage

Historians and theorists of "visual music" treat its foundations with using pre-existing music (either the score or a recording) to create and synchronize the visual composition as a given; a brief digression into this history is thus warranted. The formal arrangement, timing, and design of sound::image, what art criticism and history term *synaesthesia*,[1] is pre-planned; borrowed from psychology, this term is the technical description for the simultaneous linkage of two otherwise distinct senses (such as hearing and sight) into a singular "cross-modal sensory experience." Before World War II, the historical avant-garde was closely engaged

with issues of synaesthesia, both as an abstract reference and as a literal *material* to explore through new technologies of sound recording, such as the optical soundtrack.[2] The history of the abstract or "absolute" film's technical-aesthetic development during the two decades prior to the general embrace of synchronous sound recording by the film industry in 1927[3] transfers avant-garde experiments in painting that were explicitly synaesthetic to motion pictures; musical analogies[4] are common in all the "silent" films that provide the sources for the abstract film titles of the 1950s such as *The Man with the Golden Arm*.

The range of artists impacted by "visual music" cuts across the boundaries between movements, media, and decades of time to reveal a consistent interplay of abstract form, synaesthesia, and synchronization.[5] The visual music film uses synaesthesia to produce *statements* of *illustrative synchronization* that mask their cultural/ideological meanings as physical phenomena comparable in their immediacy of recognizable link to 'lip-sync.' Considering this heritage of "visual music" illuminates the complexity and aesthetics of synaesthetic form in title sequences—in the twin formal approaches of *illustrative* and *counterpoint synchronization*—as well as acknowledges its ideological dimensions.

While visual music has informed a variety of aesthetic proposals, these approaches are historically limited in scope and application to particular types of musical composition and only to visual imagery evoking a synaesthetic experience (i.e., a phenomenal encounter that has the character of synaesthesia). The network of relationships between abstraction, synaesthesia, and visual music reveal more than just a set of congruencies—it is a "fine art approach" to sound::image synchronization that motion graphics have adapted for commercial use. In art, abstract forms synchronized with music make these connections more readily apparent, but no less artificial, than in the title design for *Wimbledon*.

Some aspects of this history are well known and described elsewhere, most notably in the history of avant-garde film and the origins of abstract art: the number of artists working with one form of abstraction, only to also create color/visual music and/or abstract film, is striking. The histories of abstraction on film and in avant-garde art are more than simply parallel evolutions—visual music, abstract painting, and motion graphics intersect, overlap, and often share artists. This idea of a visual art that has the same emotional and aesthetic independence as music plays a central role in the early development of abstract painting and informs the entire history of abstract film; the desire to create kinetic abstract/synaesthetic visuals is apparent in its interdisciplinary scope. The *synaesthetic* functions metaphorically as a descriptor for the organization and development of visual works that follow the prerogative and formal structures of musical form—a

reflection of how the musical develops as a cultural phenomenon, itself detached and free-floating, independent of the visual—however, the issue is not about *voice, sound,* or even *music* but about its *synchronization*: the *statement* created through the relationship of sound (which may and often does include music) to visual materials is a simultaneous alignment of immanent sensory encounters and ideological content. The movement between making art engaged with synaesthesia and creating films was common: at the start of the 1910s, the Futurists Bruno Corra and Arnolda Ginna began as painters, abandoned painting to make abstract films, then abandoned film to build a color organ.[6] During these same years, abstract painter/theorist Vassily Kandinsky experimented with visual music in his play, *Der Gelbe Klang*[7], and his theories about color, art, and spirituality in *Concerning the Spiritual in Art* are specifically synaesthetic.[8] The first abstract animations were all variously innovations, inventions, and experiments with producing a kinetic analogue to then-recent developments in avant-garde painting[9]; motion pictures were the only technology suited for these experiments in form and meaning, as historian William Moritz noted in one of his discussions of visual music:

> Indeed, visual music has a history that parallels that of cinema itself. For centuries artists and philosophers theorized that there should be a visual art form as subtle, supple, and dynamic as auditory music—an abstract art form, since auditory music is basically an art of abstract sounds. As early as 1730, the Jesuit priest Father Louis-Bertrand Castel invented an Ocular Harpsichord, which linked each note on the keyboard with a corresponding flash of colored light. Many other mechanical light-projection inventions followed, but none could capture the nuanced fluidity of auditory music, since light cannot be modulated as easily as "air." The best instrument for modulating light took the form of the motion picture projector.[10]

The aesthetic and formal linking of sound::image correspondence requires a technologically produced art such as motion pictures. The earliest attempts to create an abstract art of color focused on light alone, without imagery; however, these experiments with "color music" lead to a general conclusion by the end of the nineteenth century that an art of light is not just an amorphous play of color, but must include form as well—"visual music." The role of Theosophy in this development of synaesthetic visuals in painting and the abstract/absolute film is a well-documented history.[11] These movements between different media reveal how synaesthesia and visual music converged at the start of the twentieth century.[12] The influence of Theosophy on early abstraction,

particularly the imagery of Anne Besant and Charles Leadbetter's book *Thought Forms* first published in 1901,[13] that assigned mystical and esoteric meaning to the "synaesthetic form constants" psychologist Heinrich Klüver would document in the 1930s[14] is a common thread between these experiments and innovations. Understanding synaesthetic arrangements of sound::image as presenting spiritual states of consciousness is the common heritage of visual music shared by later abstract filmmakers.[15]

The invention of motion pictures in the 1890s enabled the creation of abstract films precisely because the various technologies invented to modulate and compose light itself were clumsy and imprecise compared to the projected imagery of film. The surviving abstract films made in Germany in the early 1920s reveal the Theosophical influence. Abstract animations[16] by Walther Ruttmann[17] and Oskar Fischinger[18] both employ the same 'language' of abstract forms, while the work of Viking Eggeling[19] and Hans Richter[20] (whose *Universelle Sprache* employed the same synaesthetic forms as found in Kandinsky's paintings, and was explained using explicitly musical terms[21]) drew their forms and approaches directly from painterly abstraction.[22] The visual shapes appearing in all these visual music films/art works recreate those described by Besant and Leadbetter's text[23]—the works of Len Lye, Norman McLaren, and Mary Ellen Bute are exceptions to this tendency to employ imagery from Theosophy in their motion pictures.

The history of abstraction, spirituality, and a musical analogy for visual art begins in Romanticism and Symbolism. The transformation of earlier "color music" into the abstract films made by Walther Ruttmann, Viking Eggeling, Hans Richter, and Oskar Fischinger, as well as American Mary Ellen Bute, realize synaesthesia as an immanent phenomenon, either through a direct analogy to music or by creating a counterpoint demonstrating "visuals comparable to music." How abstraction departed from this originary context in the twentieth century confuses contemporary examinations of this early heritage and hides its ideological role in the structure and morphology of motion graphics. Art historian Jeffrey T. Schnapp explained how early "abstraction" differs from the concept at the end of the twentieth century in his article "Bad Dada (Evola)" that was concerned with these changes:

> [. . .] "abstraction" rarely meant *abstract* in any pure, rigorously formal, non-referential, and non-representational visual sense, accommodating instead a wide array of hybrid formulations. [. . .] At once pictorial, poetic, and philosophical, it is embedded within a genre whose history can be traced back to romanticism, but whose moment of triumph comes at the end of the nineteenth century in the context of symbolism, decadentism, and the avant-gardes: the

interior landscape. [. . .] As initially employed in twentieth-century cultural debates, "abstraction" signifies less a distinctive pictorial practice that disrupts naturalism in the name of autonomy of art than a mode of unfettered exploration of the world—hence the referential trace embedded in the word "landscape"—closely allied with visionary states: meditation, dreaming, delirium, hallucination. [. . .] So understood, "abstraction" opens up the prospect of an art that, following in the footsteps of pure philosophical inquiry, symphonic music and certain expressions of spirituality, finds in geometry not only the new vernacular of the era of industry but also the secret language of the psyche or of the world, or of the psyche as world; an art that is "abstract" inasmuch as it has withdrawn from the realm of appearances in the pursuit of something anticipating the noumenal.[24]

Implicit in Schnapp's description of the "abstract" is the concept of "synaesthesia": it reiterates Foucault's recognition of the dominance of vision as an arbiter of knowledge that demands the "true nature" of the world become visible. The first abstract animations produced in the 1910s and 1920s all belong to this same ideological revelation; their meaning comes from their foundations in visual music. Their influence on title sequences and motion graphics is obvious from how the soundtrack (especially music) becomes an essential formal part of the work. The centrality of the abstract white lines synchronized with music in *The Man with the Golden Arm* demonstrates this "fine art" tradition in action.

The Ideology of Synchronization

The shift from the invocation of a phenomenal encounter to one constructed from ideological belief can be subtle: the links between *illustrative synchronization* and realism are constants, even when the connections are as simple as the alignment of verbalized and written language. This transformation, an equally direct and automatic linkage as naturalistic synchronization, returns the audible to the realm of signs, assigning particular meaning otherwise absent *outside* the motion picture. *Illustrative synchronization* is complementary to the realist approach of *naturalistic* synchronization that creates an appearance of the everyday phenomenal world, but in place of re-producing the everyday experiential/phenomenal encounter with that world, what illustrative synchronization produces is a "more true" depiction. In Cooper's design, this "more true" depiction is the audience and other spectacle surrounding the tennis matches at the Wimbledon competition shown by the association of hit ball with credit—thus revealing an ideological foundation masquerading as a natural link of sound::image not different in character or degree from the lapping of water.

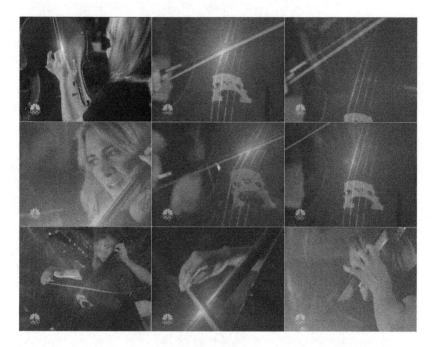

Figure 3.3 Selected stills from *Heroes* (2009).

The centrality of vision in this history of abstraction-as-synaesthesia reveals Foucault's identification of *sight* as an integral ordering of the world, as the primary vehicle for knowledge of that world, a history of ideological reification that includes both visual music and illustrative synchronization generally. The apparent immediacy of connection presented by direct synchronization—the invocation of realism—conclusively brings cultural beliefs into these constructions: ideology becomes an immanent presentation, illustrated "empirically" by synchronizing sound::image. Considering these dynamics apart from the title sequence makes the role of visual music in realizing commingled ideological-cultural content readily apparent: the convergence of *naturalistic* ("objective") and *illustrative* ("subjective") *synchronization* appears in an effects shot from an episode in season 3 of the television program *Heroes* (Figure 3.3). This brief sequence begins with a woman's hand plucking the string of a cello: a note sounds while colored shapes simultaneously rise off the string and float into the air. It is a simple image, a direct synchronization of sound and graphic imagery immediately connecting three distinct elements: *note-string-colored forms*. The association of these three things depends on the mimetic recognition of the sound heard as the *product* of plucking a cello's strings, a connection the audience

makes instantly. The abstract light pattern then becomes a visualization of that sound (realism), rendered comprehensible by its synchronization with the already-known mimetic relationship of *note-string*. Because the sound, the plucked string, and the abstract colored forms all appear simultaneously on-screen, they offer the *statement* that all three phenomena are a mutually reinforcing correspondence, transforming the *naturalistic synchronization* of note-string into the *illustrative synchronization* of note-string-colored forms. The abstract visual *is* the sound, in the same way that the plucked string is; they are both a visible *equivalent* to the audible note through their relationship/demonstration of the concept "synaesthesia."

Michel Foucault's "gaze" identifies how this ordering emerges. It describes the visualization process clearly revealed in *Heroes* as more than simply a demonstration: the assertion of knowledge through vision is an ordering of the world that implicitly demands specifically *visual* proof, provided through the motion picture:

> The breadth of the experiment seems to be identified with the domain of the careful gaze, and of an empirical vigilance receptive only to the evidence of visible contents. The eye becomes the depositary and source of clarity; it has the power to bring a truth to light that it receives only to the extent that it has brought it to light; as it opens, the eye first opens the truth: [...] light, anterior to every gaze, was the element of ideality—the unassignable place of origin where things were adequate to their essence—and the form by which things reached it through the geometry of bodies; according to them, the act of seeing, having attained perfection, was absorbed back into the unbending, unending figure of light.[25]

The realism of the presentation becomes the demonstration of its reality; this integral link between sound::image affirms the ideo-cultural appearance of order. This emphasis on 'light'—nothing more or less than the enlightenment on view—is an absolute dominion of visualized knowledge. The synaesthetic serves this order through the translation of non-visual into visual—in the link of sound::image into the *statement*. Synchronous sound and its demonstrative organization of audio-visual phenomena as an apparently *neutral* phenomenal encounter masks the cultural construction Foucault describes. The dominance of vision as the ideological organization of the world finds an immediate ally in the motion picture's orchestration of sound::image in the *statement*.

Visual music reified ideo-cultural beliefs about the unseen "true nature of reality" in an equally realist approach to sound::image::text synchronization—both *The Man with the Movie Camera* and *Wimbledon* employ

the same formal sync-points in their construction. For both *naturalistic* and *illustrative* synchronization, these simultaneous connections are immanent, a product of an instantly apparent *statement* of direct linkage. This proximate association of audio-visual elements renders their distinction—*naturalistic* or *illustrative*—a discernment of what specifically seem to be subtle shifts in articulation. The directness of both these connections makes the ideo-cultural dimensions of *illustrative* synchronization seem "natural" and "inevitable," rendering its ideological content precisely beyond challenge, a simple demonstration of a "truth" that cannot be perceived. In *Heroes,* the consistency of the synchronization creates meaning: as with historical visual music, synchronization constrains the potential meanings for the effects shot in *Heroes* to being a visionary demonstration ("synaesthetic"[26]) of the association of visual forms and audible sounds. In the process, hearing becomes secondary to seeing, affirming the visual through its synchronization; the *statement* thus created informs the audience about the nature and meaning of their encounter: the sounds heard become the sounds *of* whatever is being shown on-screen, a superficially autonomous relationship that is precisely arranged to copy the mimetic naturalism of 'lip-sync.'

By recognizing ideology as an instrumental force demonstrated through *illustrative synchronization,* it becomes clear how these *statements* serve to validate cultural belief through their demonstration-presentation as "natural" phenomena: in *Heroes,* the simultaneous, immanent encounter that connects the abstract forms shown rising from the string with the sound they make as it vibrates affirms an ideo-cultural belief that "Sound and Light are Similar," an ancient concept articulated by Renaissance author Athanasius Kircher as the direct equivalence of color and sound/music that continues through the nineteenth century with concerns about synaesthesia.[27] This claim, common to mediaeval European thought, assumes literal form in Kircher's explanation of the relationship between sound and color:

> This premise, for sound to be similar to light, sound must be like light in all ways, it must spread out because it has the same source. [...] Just as the light from a fire spreads different colored bodies in different directions around itself, so is sound spread through the air by moving bodies that carry its qualities. [...] When a musical instrument sounds, if someone were to perceive the finest movements of the air, they would see nothing but a painting with an extraordinary variety of colors.[28]

Kircher's ideas have proved remarkably durable—in spite of centuries of scientific evidence and demonstration of their falsity, they persist, a testament to how even well-known fallacies continue to inform

cultural production.[29] The apparent immediacy and directness of note-string-colored forms produced by their synchronization reanimate this cultural idea by way of its immanent presentation. The synchronization of note-string creates a natural correlation that also renders the cultural idea Kircher articulates as being an equally natural, inevitable event. The *statement* thus produced is one where the naturalism that makes one synchronization (note-string) seem autonomous renders the additional, culturally originating relationship (note-string-colored forms) seem equally inevitable. This association is effected by the *statement* (the self-contained nature of synchronization as empirical demonstration), employing the phenomenological encounter to mask its lexical construction. This entanglement makes meaning invisible, an assertion of the linked relations of ideological and "natural" phenomenon in the specific formal structure on view. Once the audience interprets this simultaneous presentation as being *"synchronized,"* the transformation of artifice into natural fact—Rushton's "forms of life" approach to realism—necessarily follow how an illustration of the language-vision-hearing hierarchy imposes order onto our perceptions.

The naturalism offered by synchronization hides the cultural and ideological dimensions of the artifice imposed by this correspondence. While the natural connection of note-string is recognizable from everyday experiences with objects making noise (as well as experiences with live musical performance), the visual music presentation of colored forms in *Heroes* is foreign, even alien to these common experiences for most audiences. The unification of 'objective' and 'subjective' conceptions of "true reality" through visual music evokes the description of early abstraction proposed by Schnapp, as film historian William C. Wees explains in his book on abstract film *Light Moving in Time*:

Similarly, one may call inner imagery "abstract," but the perception of it can be as concrete as the perception of the outer world. In matters of visual perception, it is best to avoid making hard and fast distinctions between inner and outer, abstract and concrete— and for that matter, East and West, except in the sense that the West has been more inclined to insist on these distinctions than the East has been.

By collapsing these distinctions, one can begin to understand how inner vision can be a literal and communicable "increased ability to see." In addition to the physical light of the exterior world, there is a perceived light produced by the central nervous system. Equivalences of the colors, forms, and movements of this inner light appear in many kinds of visual art. Therefore, there is no reason they could not be translated into the art of light moving in time.[30]

The presentation of an "unseen truth" (subjective) through the phenomenal encounter (objective) of motion pictures renders their synaesthesia and the spirituality ascribed to them as a presentation of "inner visions." This externalization of interior 'sight' answers to the necessity for visualization described by Foucault's gaze. The need for a specifically visual proof makes the synaesthetic construction and its formal basis in the synaesthetic "form constants" of hallucinations[31] inevitable. The empirical rendering demonstrates antithetical realisms: the "reality of the mind" ("subjective") through the "mere appearances" of the phenomenal encounter ("objective"). For both Moritz and Wees,[32] the *statement* serves to seemingly reconcile these opposed realisms, an immanent meaning connected to metaphysical claims (the Theosophical heritage) about synaesthetic abstraction revealing "hidden truth" in the visual music film,[33] a product of the historical meanings attached to synaesthesia.

Synaesthesia is commonly understood to present an elemental 'purity' superior to the 'fallen' state of our typically discrete sense perceptions— it was understood as a recovery of primal experiences, thus a more "accurate" depiction of reality. *Bright Colors, Falsely Seen* by historian Kevin Dann explains how synaesthesia, abstraction, and synaesthetic art evolved from earlier Romantic interests with merging "objective" and "subjective" interpretations of the world:

> The triumph of behaviorists' view of the human mind and body as reacting machines only served to intensify the Romantic quest for art forms and theories of knowledge that de-emphasized the world of material causes. Romantics held fast to the ideal of the primacy of the imagination, and synaesthetes would continue in their eyes to offer proof positive of the possibility of attaining new ways of knowing.[34]

Those nineteenth-century cultural groups disenchanted with the rigorous, rational world of normative scientific and psychological theory understood synaesthesia as a means to challenge it; both synaesthetic art and the physiological phenomenon of synaesthesia were viewed by the Romantics as escapes from the predetermined, mechanical world being described by the empirical methods and logical procedures of materialist science. Behaviorist psychology was seen as reducing humans to predictable, machine-like entities—the fusion of senses in synaesthesia appeared to be counter to this predictability. It is an iconic demonstration of this ideology reified in visual music. The embrace of synaesthesia at the end of the nineteenth century leads to both abstract painting and abstract film. These claims to demonstrate a "hidden truth" to non-synaesthetes through the contemplation of art is explicitly cultural/ideological; a realism of the mind, not a phenomenal encounter.

Synaesthesia's "purity" comes from the *failure* to be separate and independent—originating in cultural claims of recovering a lost, primal state of innocence. The initial meaning of "abstraction" as *the* mode of "unfettered exploration of the world" originates in synaesthetic visions understood as unbiased encounters with a normally invisible *actuality*— a revelation of a deeper, unseen "truth." The design and development of the sequence of shots in *Heroes* makes this *actuality* an immanent feature of their direct presentation on-screen. Understanding abstraction in title sequences as descended from these synaesthetic experiments extends those spiritual meanings assigned to abstract films by historians such as Kevin Dann, William Moritz, or William Wees into the realism of commercial cinema. Synaesthetic abstraction provides a tradition for title design; visual music is a convergent history. The application of these approaches to title sequences renders the meaning created by *illustrative synchronization* contingent, since unlike the textual statements whose signs are readily available *a priori* to their composition *into* statements, for motion pictures—even with Metz's *aural objects*—the separation of individual signs from within the undifferentiated parts of a continuous sequence depends on their emergent organization via the *statement*.

The regime of signification created by these *statements* formalizes the connection of disparate sensory encounters that can be separated from each other only in a very relative way because they are two sides of a single assemblage. As Foucault suggests, this relationship is enunciation; in becoming a particular *statement,* the result constructs the reality it demonstrates—*it becomes tautology*—an immanent presentation whose arrangement provides the proof for its own construction; in being arranged it justifies the associations and linkages used for its arrangement. The initial moment of encounter renders the beliefs that organize it as being beyond question, as fact, rather than ideology. Ideo-cultural belief offered is affirmed in that offering. There is no need to consider Groucho Marx's comment,[35] "Who are you going to believe, me or your lying eyes?" as an opposition of two distinct positions—there is no long any distinction between "true reality" and "perception"—the *statement* produced by illustrative synchronization reifies ideology as apparent form, making the unseen visible.

Illustrative Synchronization

Illustrative synchronization employs connections of sound::image that are *not* phenomenally naturalistic, but rather depend on cultural associations for their particular form and intelligibility—that this cultural basis is rendered apparently 'natural' and 'inevitable' is what connects the it to the *realism* of 'lip-sync.' The role of musical composition—instrumental or lyric—in organizing sound::image

synchronization in title sequences consistently reveals the importance of
"visual music." The concern with audio-visual and synaesthetic relation-
ships in art criticism and art historical analyses is a common feature of
these early experiments with film scoring and composition, even before the
use of recorded sound. Modernist composers in Europe collaborated with
their friends who were making avant-garde films to explore audio-visual
form in the new medium: this is why George Antheil, who would later
compose for Hollywood films, also scored *Ballet Mécanique*; *Entr'acte* was
produced for Eric Satie and used his music; Walther Ruttmann's *Lichtspiel*
films also had avant-garde scores composed for them. The music was cre-
ated following the timing and orchestration of the visuals. This conver-
gence of kinetic abstraction and music lead to screenings of 'absolute
films' at the *International Music Festival at Baden-Baden* in 1927.[36]

Figure 3.4 All the title cards in *The Trollenberg Terror* (aka *The Crawling
Eye*, 1958).

This synaesthetic heritage first becomes obvious in motion graphics with the title designs made in the 1950s. The Early Phase of the Designer Period adapted the established approaches of International (or Swiss Style) graphic design[37] and combined it with aesthetics pioneered by the abstract film[38]; the visual music film's formal 'language' of geometric shapes provide the graphic foundations for the abstract animated title sequences of the 1950s such as *The Man with the Golden Arm*, linking the title sequence directly to this earlier visual music tradition. Both the work of well-known designers such as Saul Bass or Maurice Binder, as well as uncredited title designs, such as the title sequence for *The Trollenberg Terror* (1958) (Figure 3.4), reveal the importance of the continuity between visual music, synaesthesia, and abstract art for the graphic animated title that emerged after 1955. Both graphic arrows and text in *The Trollenberg Terror* appear simultaneously with the trumpets' dramatic fanfare, an immediate link between the dramatic music on the soundtrack and the graphic animations that appear in the imagetrack.

Saul Bass makes the synchronization of animated motion and music immediately apparent in his title design for *The Seven Year Itch* (1955), but unlike *The Man with the Golden Arm*, it does not drift into syncopation between the musical sync-points and the graphic animation/transitions between title cards (Figure 3.5). The "windows" that fold open and closed to present each credit in this design move simultaneously to musical cues provided by the score. When the audience hears a note, they see a simultaneously corresponding motion appear on-screen, creating an apparently "natural" connection that masks the arbitrary nature of their construction. Abstraction and visual music present the ideo-cultural belief in a "spiritual" reality through a combination of

Figure 3.5 All the title cards in *The Seven Year Itch* (1955).

 62 *Natural Artifice*

visual form—whether graphic or typographics is irrelevant—creating a synaesthetic experience[39] through their synchronization with sound. This appearance of connection is an inherent character of the *statements* thus produced. These linkages encourage the ideo-cultural belief that the only appropriate relationship between sound and image is one where they are locked into an absolute, synchronized relationship.

Figure 3.6 All the title cards in *The Bold Ones* (1970).

This illustrational linkage appears in the title card for *The Big Broadcast of 1937* where each word of the film's title appears as the announcer's voice says it: the immediacy of this connection functions analogously to 'lip-sync,' but without the apparent naturalism that imitates everyday phenomenal experiences. Wayne Fitzgerald's design for the television program *The Bold Ones* (1970) (Figure 3.6) follows the taxonomy that Solange Landau's article "Das Intro als eigenständige Erzählform. Eine Typologie" from the *Journal of Serial Narration on Television* identified as "Mosaik-Intro" (Mosaic Intro): a title sequence that introduces the lead actors/characters showing them "in action" via "cut-scenes" extracted from the episodes that follow.[40] The synchronization develops these same immediate connections of sound-to-text, but without the additional element of speech contained by *The Big Broadcast of 1937*.

Individual title cards in *The Bold Ones* produce an illustrational linkage of an actor's name to their image, each presentation encapsulated by its own set of musical cues that define them as separate title cards. This punctuating effect is created by the music, revealing internal distinctions within the title sequence as a whole that allow the isolation of each title card as such. These separations are important for this design in particular because the layering process complicates the distinctions between the title cards based on solely visual distinctions. The organization and composition of the typography in this design presents the overlapping and stacked type as an abstract graphic that recalls the dense stacks and piles of letter forms in the work of Fluxus artists such as George Brecht. Fitzgerald's design employs illustrative synchronization in the synaesthetic linkage of music to colored layers of overlapping text and in-set windowed live action. The relationship created is as direct as 'lip-sync'; however, the construction reveals its aesthetic foundation. The organization of text-music does not mirror our everyday experiences of the world. But the *statement* created by this illustrative synchronization of text-music encourages the audience to accept the cultural linkages as if they were the product of a natural connection—giving the text-music linkage the appearance of a mundane reality, necessary and inevitable, rather than contingent and arbitrary. The artificiality of their construction is masked by the directness of their appeal to the senses.

The title sequence to *All the President's Men* (1976) designed by Dan Perri creates a specifically 'documentary effect' by integrating the type placement into the opening montage to set the stage for the docudrama that follows (Figure 3.7). The claims of being *factual* that emerge from direct synchronizations—both naturalistic and illustrative—more than just simply the assertion of resemblance to 'reality' that is realism inherently claim a relationship to the 'real world' outside the confines

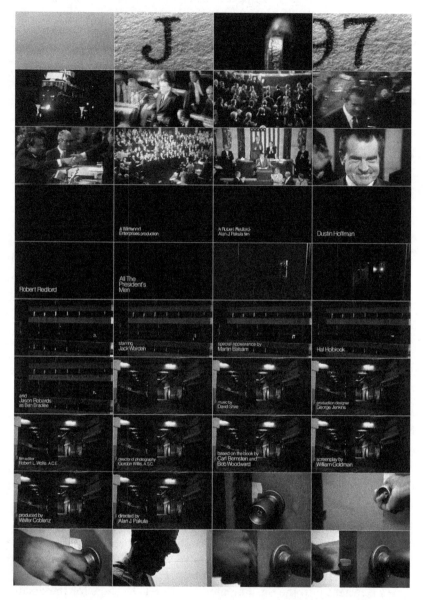

Figure 3.7 All the title cards in *All the President's Men* (1976).

of the fictional one presented on-screen. The mixture of *naturalistic* and *illustrative synchronization* in this sequence creates its realist effect: the opening shot of the film shows a white, slightly textured field filling

the screen held in silence for several seconds. When the typewriter's typebar slams into the page sounding like a gunshot, it often makes the audience jump in shock. This opening reflects the coverage by *Washington Post* reporters Bob Woodward and Carl Bernstein, whose book on their investigation provides the foundation for the film. The story dramatically recreates the central feature of the scandal that ended Richard Nixon's presidency at the start of the film: Nixon's 1972 State of the Union address followed by the break-in to wiretap the Democratic National Headquarters in the Watergate hotel in Washington D.C. on June 17, 1972. Nixon's agents Bernard L. Barker, Virgilio R. Gonzales, Eugenio R. Martinez, James W. McCord, and Frank A. Sturgis were arrested for the burglary. Frank Wills, the security guard who discovered the break-in, appears in the film playing himself; the title sequence concludes with his discovery of the three strips of masking tape the burglars used to keep their exit from locking behind them.

Perri's title sequence consists of three distinct sections: the typewriter that begins the sequence by pausing, then typing out the words "June 17, 1972"; followed by archival footage of a television showing Nixon's arrival, the scan lines clearly visible; four shots depicting the burglary itself. The middle section shows the president's landing in the Air Force One helicopter outside Capital Hill and his entrance into a joint session of Congress to deliver his State of the Union address while a voice-over narrates the scene, describing and expanding on the significance of the images shown. The information conveyed by this news announcer's moment-by-moment commentary on what's happening on-screen shifts between being a description of visible events ("a happy president") and explaining what is about to happen ("address the Congress and the people of the United States"). The directness of the audio-visual *statement* in this assertion of factuality emerges for voice-over with the immediate equivalence of what is said to what is shown—it renders the speech and images as illustrations of each other. This section of the titles ends with a close-up of Nixon's smiling face.

The section of that includes the superimposed title cards consists of only five shots, three of which are long takes. The first long take begins when the screen goes completely black and the first title fades up in the lower left corner. Even though there is nothing to see except the type, soft voices mumble and clicking sounds can be heard in the soundtrack. It is uncertain what is happening from the audio; there is no theme music. This withholding of visuals gives the soundtrack an unusual prominence: it is like listening to a tape recording rather than watching a movie, appropriate for a story in which audio recording plays a central role. After the main title "All the President's Men" fades out, a back-lit doorway opens on the right and dark silhouettes shine their flashlights around the darkened room, pointing them into the camera. A cut to the exterior

of the building shows the men entering the room; the Watergate hotel in Washington, D.C. is instantly recognizable. Their progress into the dark rooms can be followed by the motion of the flashlights once they are inside while the credits continue to be superimposed in the bottom left corner. The exterior shot is followed by a shot of the ramp into a parking garage as the security guard, Frank Willis, who plays himself, walks down and crosses to a green door as the last title card stating "Directed by Alan J. Pakula" fades out. Cut to a close-up of the doorknob—clearly visible next to it are three strips of beige masking tape; Willis' hand opens the door, peels the tape off, letting the mechanism glide out with a loud click; cut to his puzzled reaction. Willis has just restaged his discovery of the break-in for the docudrama, the event that sets in motion Nixon's fall from power.

Throughout this whole sequence the soundtrack contains only the audio that might be anticipated as *diegetic sound*: even the television announcer is expected, his narration mixed into the ambient sounds of Congress. This focus on *only* the "real" sound that would accompany what is shown on-screen asserts the documentary character of those images—that they are an "unmediated" portrayal. The news anchor's voice-over synchronized with the news footage is as "natural" as the diegetic sounds of the burglars entering the office—both correspond to the conventional assumptions about what sound accompanies each presentation. Their realism is the highly restrained reproduction of reality for the hypothetical "fly on the wall" granted the privileged opportunity to witness these events directly. The soundtrack is instrumental in making these assertions, since they suggest that the narrative contents of the film are not a political statement, interpreted and partisan, but simply a reportage of what happened. Because the docudrama presents one of the most serious political scandals in the United States' history, this veil of objectivity must be carefully created and maintained or the film risks being accused of being a political statement (as it necessarily, inherently, is).

The documentary interpretation of this opening sequence renders the titles as secondary to the events being presented; it is typical of title designs from the Late Phase of the Designer Period—the independent title sequence has been replaced by a title sequence where the narrative preamble and the superimposed credits combine with the opening scenes of the film in a way that parallels the convergence of narrative and preamble in Wayne Fitzgerald's design for *Touch of Evil* (1958). In *All the President's Men* this disappearance, complete with the elision of any theme music, establishes the 'reality' of the events shown. The assertion of their *un*mediated nature gives the presentation the superficial appearance of being unplanned—however, the doorway that the burglars enter,

their movement into the offices, and the green door in the garage are all positioned in the same place on-screen, visually linking them to each other through this consistent placement.

Ideology informs all claims of "truthful" depiction, an invisible structuring that makes the documentary a form that always has a partisan dimension—not just in those cases when the subject matter of the narrative is *overtly* political in nature, but *always* and *inherently*. The problem for motion pictures and motion graphics equally is the distinction between what seems "reasonable" and what *actually* occurs. Human life tends to behave irrationally at times, making it fundamentally different from the culturally accepted range (i.e., dependent on reason) of what is *allowed* to happen in realist fiction. Acknowledging these problematics allows a recognition that a presentation the audience will accept as provisionally *factual* depends on that audience being willing to accept the presentation as an unbiased (or if not "unbiased," as biased in a way that converges with what they already accept) series of claims about the world. This recognition means that the truth/falsity of the information conveyed must be considered as an independent issue from its morphology—*how it's presented*. The complex dynamics of these distinctions are beyond the scope of the present consideration, but they do inform the *statements* created for documentary works, and should be acknowledged as a fundamental part of their construction. By arranging sound::image synchronization to produce a particular 'reality effect' that aligns the events shown to match the culturally accepted range of possibilities reiterates the realism of direct synchronization. These manipulative and ideological dimensions of that ideo-cultural construct are masked in/by its apparent realism; thus, the construction of "documentary" has the realism of its audio-visual relationships as a consistent refrain. To challenge them is to put the entire nature of the 'document' itself in question.

Notes

1 Galeyev, B. "Open Letter on Synaesthesia." *Leonardo*, Vol. 34, No. 4 (2001), pp. 362–363.
2 Donguy, J. "Machine Head: Raoul Hausmann and the Optophone." *Leonardo*, Vol. 34, No. 3 (2001), pp. 217–220.
3 Betancourt, M. *The History of Motion Graphics: From Avant-Garde to Industry in the United States* (Rockville: Wildside Press, 2013).
4 There are multiple sources for this history. See Tuchman, M. *The Spiritual in Art: Abstract Painting 1890–1985* (New York: Abbeville Press, 1985) or Brougher, K. *Visual Music: Synaesthesia in Art and Music Since 1900* (New York: Thames & Hudson, 2005).
5 Tuchman, M. (Ed.) *The Spiritual in Art: Abstract Painting 1890–1985* (Los Angeles: LACMA, 1985).

6 Corra, B. "Abstract Cinema—Chromatic Music." *Futurist Manifestos*, edited by U. Apollonio, translated by R. Brain, R.W. Fline, J.C. Higgitt, and C. Tisdal (Boston: MFA Publications, 1970), pp. 66–69.

7 Originally published in *Der Blaue Reiter,* 1912. Held in The Thomas de Hartman Papers, Irving S. Gilmore Music Library, Yale University, Series II.A.1, folders 22/192, 22/193, 22/195.

8 Kandinsky, V. *Concerning the Spiritual in Art* (New York: Dover, 1977).

9 Lawder, S. *The Cubist Cinema* (New York: Anthology Film Archives, 1980).

10 Moritz, W. "Visual Music and Film-as-an-Art Before 1950." *On the Edge of America: California Modernist Art, 1900–1950,* edited by P. J. Karlstrom (Berkeley: University of California Press, 1996), p. 224.

11 Betancourt, M. "A Taxonomy of Abstract Form Using Studies of Synaesthesia and Hallucinations." *Leonardo,* Vol. 40, No. 1 (2007), pp. 59–65.

12 Kemp, M. *The Science of Art: Optical Themes in Western Art from Brunelleschi to Seurat* (New Haven: Yale, 1992).

13 Besant, A. and C. W. Leadbeater. *Thought-Forms* (Wheaton: Quest, 1925).

14 Klüver, H. *Mescal and Mechanisms of Hallucinations* (Chicago: University of Chicago Press, 1966).

15 Wees, W. *Light Moving in Time: Studies in the Visual Aesthetics of Avant-Garde Film* (Berkeley: University of California Press, 1992), pp. 137–146.

16 Norden, M.F. "The Avant-Garde Cinema of the 1920s: Connections to Futurism, Precisionism and Suprematism." *Leonardo*, Vol. 17, No. 2 (1984), p. 112. See also de Haas, P. "Cinema: The Manipulation of Materials." *Dada-Constructivism*, exhibition catalog, Annely Juda Fine Art (London: December 1984), n.p.

17 Ruttmann, W. "Painting with the Medium of Light." *The German Avant-Garde Film of the 1920s*, edited by A. Leitner and U. Nitschke (Munich: Goethe Institute, 1989), p. 104. See also Bock, H.-M. and T. Bergfelder (Eds.), *The Concise Cinegraph: The Encyclopaedia of German Cinema* (Berghahn Books, 2009), pp. 405–406.

18 Moritz, W. *Optical Poetry: The Life and Work of Oscar Fischinger* (Eastleigh: John Libbey Publishing, 2004).

19 Werner, G. and B. Edlund. *Viking Eggeling Diagonalsymfonin: Spjutspets I Återvändsgränd* (Lund: Novapress, 1997). See also Werner, G. "Spearhead in a Blind Alley: Viking Eggeling's *Diagonal Symphony*." *Nordic Explorations: Film Before 1930* (Sydney: John Libbey & Co., 1999), pp. 232–235.

20 Richter, H. "My Experience with Movement in Painting and in Film." *The Nature and Art of Motion*, edited by G. Kepes (New York: George Braziller, 1965), p. 144. See also Gray, C. (Ed.), *Hans Richter by Hans Richter* (New York: Holt, Rinehart and Winston, 1971), p. 85.

21 Richter, H. "Demonstration of the Universal Language." *Hans Richter: Activism, Modernism and the Avant-Garde*, edited by S. C. Foster (Cambridge: MIT Press, 1998), p. 208.

22 Le Grice, M. *Abstract Film and Beyond* (Cambridge: MIT Press, 1981), pp. 19–31. See also Schobert, W. *The German Avant-Garde Film of the 1920s* (Munich: Deutsches Filmmuseum, 1989).

23 Alderton, Z. "Colour, Shape, and Music: The Presence of Thought Forms in Abstract Art." *Literature & Aesthetics,* Vol. 21, No. 1 (June 2011), pp. 236–258.

24 Schnapp, J. "Bad Dada (Evola)." *The Dada Seminars*, edited by Leah Dickerman with Matthew S. Witkowski (Washington DC: National Gallery of Art/DAP: 2005), pp. 50–51.

25 Foucault, M. *The Birth of the Clinic* (New York: Routledge, 1976), p. xiii.
26 Galeyev, B. "Open Letter on Synaesthesia." *Leonardo*, Vol. 34, No. 4 (2001), pp. 362–363.
27 Franssen, M. "The Ocular Harpsichord of Louis-Bertrand Castel: The Science and Aesthetics of an Eighteenth-Century *Cause Celebre*." *Tractrix: Yearbook for the History of Science, Medicine, Technology, and Mathematics*, Vol. 3 (1991), pp. 19–22.
28 Kircher, A. *Musurgia Universalis*, facsimile edition (New York: George Olms Verlag, 1970), p. 240.
29 Dann, K. *Bright Colors Falsely Seen* (New Haven: Yale, 1998).
30 Wees, W. *Light Moving in Time: Studies in the Visual Aesthetics of Avant-Garde Film* (Berkeley: University of California Press, 1992), p. 130.
31 Betancourt, M. "A Taxonomy of Abstract Form Using Studies of Synesthesia and Hallucinations." *Leonardo*, Vol. 40, No. 1 (2007), pp. 59–65.
32 Dann, K. *Bright Colors Falsely Seen* (New Haven: Yale, 1998), pp. 94–119.
33 Some of these spiritual claims were codified in religious terms by theosophists Annie Besant and C. W. Leadbeater in *Thought-Forms* (Wheaton: Quest, 1925).
34 Dann, K. *Bright Colors Falsely Seen* (New Haven: Yale, 1998), pp. 94–95.
35 This comment was relayed by Richard Pryor in his performance *Live on the Sunset Strip* (1982).
36 Thompson, O. "The Baden-Baden Festival: Music for Wireless and Films." *The Musical Times*, Vol. 70, No. 1039 (September 1, 1929), pp. 799–802.
37 Spigel, L. "Back to the Drawing Board: Graphic Design and the Visual Environment of Television at Midcentury." *Cinema Journal*, Vol. 55, No. 4 (Summer 2016), pp. 28–54.
38 Betancourt, M. *The History of Motion Graphics: From Avant-Garde to Industry in the United States* (Rockport: Wildside Press, 2013).
39 Moritz, W. "Jordan Belson: Last of the Great Masters." *Animation Journal*, Vol. 7, No. 2 (1999), pp. 4–16.
40 Landau, S. "Das Intro als eigenständige Erzählform. Eine Typologie." *Journal of Serial Narration on Television*, Vol. 1, No. 1 (Spring 2013), pp. 33–36.

4 Counterpoint

Counterpoint synchronization emerges from the same cultural identifications used for the domain of music, but applied to correlations of sound and image: "counterpoint" is a higher-level interpretation that emerges over time. In being dependent on the progression of the sequence this variable connection becomes coherent following the conventions of *musical form*—a "visual music"—thus employing the audience's past experience and cultural expertise, i.e. reifying the same ideological basis as *illustrative synchronization*. It is not always an immediate or obvious linkage. In place of the directness of 'lip-sync,' the model for how counterpoint proceeds is "choreography/dance"—this *statement* is a linkage/conjunction of otherwise disparate events that the audience identifies as *indirectly* aligned via a limited number of *emergent* audible sync-points (the beat, musical phrasing, and/or instrumental performance) that complement the visual ones used by direct synchronization (motion, duration, and/or chiaroscuro), allowing sound::image to converge in the development of either the shot or the edited sequence; rhythmic montage, as employed in the title designs for *Arabesque* and *Les Bleus de Ramville,* is the most common type of *counterpoint synchronization*.

Melodic statements distinguish each title card in Maurice Binder's design for *Arabesque* (1966), creating a *counterpoint synchronization* through their conjunction with the musical form. The use of video feedback for the background creates a counterpoint synchronization where the composite of sound::image::text generates graphic repetitions and spiraling patterns that match the rhythm of the music (Figure 4.1). The clarity of these associations reflects the high degree of control exercised over the video feedback by Ben Palmer, the BBC-TV engineer who generated these patterns from the same kodaliths (for the typography and logo graphics) employed to make the HiCon masks for the optical printer. Palmer explained his production process for this footage in his self-published memoir, *Ben at the Beeb*:

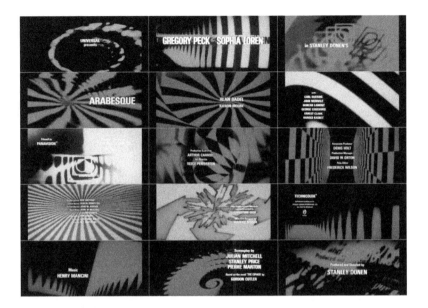

Figure 4.1 All the title cards in *Arabesque* (1966).

Another way to initiate the oscillation was to feed a separate picture to the monitor, as well as that from the camera. This picture then provided the trigger points for the feedback effect and all these patterns and blobs of light then appeared to emanate from the bright parts of the picture. If this picture was of an actor's face then this would distend and distort more and more as the feedback was increased. [. . .] [Binder] chose the stark black and white effects of phase reversal. The BBC gave permission for their equipment to be used for a commercial film—a very great novelty in those days! Se we shot it on 35mm telerecording and Maurice took it away, amazed at how little the BBC had charged him for this facility.[1]

The distortion and repetition of video feedback (what Palmer called "howlaround") combines-repeats the superimposed text, rendering the connection between foreground (white) text and kinetic background as a dynamic shift from legibility into illegibility: the text transforms into the video-feedback ground. The suggestion of moment-to-moment audio-visual alignment *within* the individual title cards creates an illustrative synchronization where the motion of alternating dark and light bands seemingly link to the musical repetitions; however, this visual

music-based connection is subjective. The counterpoint synchronizes with musical changes using the cut from one title card to another as sync-point. In place of the metaphoric connection suggested by its resemblance to visual music, this design employs the changes of music/shot as punctuation to separate the individual title cards. This division is necessary because the text does not simply appear on-screen with the cut, it gradually fades in, making the transformations of text-into-feedback their particular focus. The emergence of these title cards often corresponds to similar revelations of the typographic nature of the feedback imagery, making their emergence a contrapuntal redefinition of the imagery as textual; the emergent counterpoint synchronization comes as a reiteration of this formal organization of the title card designs.

The sync-points revealed by this design transform the 'visual music' heritage apparent in each title card, moving this connection away from the literal association of color/form to sound, and instead developing a structural equivalent to the compositional forms and emergent identification of music itself: Binder's title design employs these same approaches first implemented in the 1920s in the abstract films made *before* the development of commercial sound recording. The sync-points employed in these earliest visual music films needed a "looser" connection of sound::image to allow the musicians playing the score to self-correct if their performance slipped out-of-sync with the images. There is more flexibility for synchronization if the sync-points are less frequent than the direct note-form connection that becomes common starting in the 1930s (and which imitates 'lip-sync' in its literalness of linkage). The *Lichtspiel* animations by Walther Ruttmann in particular developed counterpoint synchronization as an emergent property of how the musical performance and the sequences of imagery come into and out of alignment over time.[2] The graphic notations accompanying Max Butting's score for *Lichtspiel: Opus I* (1921) provide instructions for the synchronization of the live performance of the music with the visuals appearing on-screen. This score reveals the counterpoint is organized around the *duration* of musical measures, rather than aligned with particular notes. One short motion sequence would be accompanied by a sequence of notes, the duration of the measure providing the sync-point for this melodic association of motion::music.

The issue of *sync-points*—which parts of the audio-visual combination provide the identifiable markers for the audience to recognize synchronization—is not important with any type of *direct synchronization* precisely because the connection that is created offers an immediate link of sound::image. All synchronization employs the same sets of *visual sync-points:* motion on-screen, duration of the shot/music, chiaroscuro

dynamics within the frame, *or a combination of all three*—that are then linked to the appearance of a sound. *Counterpoint synchronization* uses a different set of *audible sync-points:* the beat, musical phrasing, and/or instrumental performance. In the emergent *statement,* the audience links these audible sync-points with the same visual sync-points employed by direct synchronization, rendering the audible subservient to the visual in the same hierarchy of language-vision-sound apparent in both *naturalistic* and *illustrative modes.*

Reservations about the "Talkies"

The dominance of synchronized sound in the 1930s came as a repudiation of the earlier aesthetics of silent pantomime and the visual *implication* of sound. This transformation of established aesthetics by new technology prompted significant theorization and analysis by filmmakers and critics of the period. Their arguments generally direct attention away from *naturalistic synchronization,* towards both *illustrative* and *counterpoint* approaches equally; these ideas shaped the development and conception of counterpoint synchronization as an alternative to direct synchronization. The different theories proposed in the 1920s and 30s about how to avoid the literal connections offered by "Talkies" are all arguments in favor of particular sync-points. Uncertainty and rejection of the "Talkies" are not limited to the early years of its adoption, but reappear throughout the twentieth century—French director Robert Bresson's aphoristic instruction "What is for the eye must not duplicate what is for the ear"[3] is a typical response to *direct synchronization* and what is often regarded as its redundancy of sound::image. These criticisms remain remarkably consistent throughout this history.

Sound recording was specifically developed to be an adjunct to the motion picture at the Vitaphone studio in Flatbush, Brooklyn by Warner Brothers in the 1920s. Their work to perfect the recording and replication of human voices in simultaneity with their images for use in commercial films[4] meant that duplicating the visual in/by sound recording was specifically the goal when the technology was being invented, making the various rejections of "Talkies" a response to the new aesthetic this technical foundation produced. Director Rene Clair's reservations, written in 1929, two years after the premiere and commercial success of *The Jazz Singer,* reveal then-current debates about the impact of sound recording on film aesthetics and production:

> The talking film is not everything. There is also the sound film—on which the hopes of the of the advocates of the silent film are pinned.

They count on the sound film to ward off the danger represented by the advent of Talkies, in an effort to convince themselves that the sounds and noises accompanying the moving picture may prove sufficiently entertaining for the audience to prevent it from demanding dialogue, and may create an illusion of "reality" less harmful for the art than the talking film. [. . .] We do not need to *hear* the sound of clapping if we can see the clapping hands. When the time of these obvious and unnecessary effects will have passed, the more gifted filmmakers will probably apply to sound films the lesson Chaplin taught in the silent films, when, for example, he suggested the arrival of a train by the shadows of carriages passing across a face. [. . .] It is the *alternate*, not the simultaneous, use of the visual subject and of the sound produced by it that creates the best effects.[5]

What Clair calls "alternate" is a disjuncture of sound and image; *counterpoint synchronization* is one variant of this relationship, *illustrative synchronization* is another. The direct, naturalistic connection—'lip-sync,' the definitional feature of "Talkies"—renders the association of sound::image without the need to interpret the connection. For Clair and his fellow objectors to "Talkies," the literal connection is also one that eliminates the associative potentials so commonly developed in the "silent film." Their concern about the literalness of the realism promoted by *naturalistic synchronization* originates with the immanence that the apparently autonomous linkage of mimetic sound and expected source has: an affirmation of what appears on-screen as a 'mere appearance' of reality, rather than an aesthetic object shaped to reveal deeper, 'unseen truths' that the silent cinema was necessarily forced to address through the absence of sound. The attention to nuance of performance, lighting, camera work, and editing that provided the narrative cues in the absence of sound were rapidly replaced by dialogue and recorded narration; the novelty of 'lip-sync' as a spectacle (as well as the cumbersome booths used to silence the cameras) acted to eliminate the aesthetic developments of the silent era, replacing them with almost static cameras, lengthy songs, and declarative speeches.

Clair's concerns are typical of the transitional period following the commercial introduction of sync sound. Soviet film director Sergei Eisenstein makes a similar observation about the need to reject the literal connections of 'lip-sync' in his discussion of "chromo-phonic montage." In describing the different elements of music and imagery, his proposal is to create visual analogues to the audible as a new type of montage:

Musical and visual imagery are not actually commensurable through narrowly "representational" elements. If one speaks of a genuine

and profound relations and proportions between music and picture, it can only be in reference to the relations between the *fundamental movements* of the music and the picture, i.e. compositional and structural elements.[6]

The specific focus on musical form in Eisenstein's proposal assumes the structural organization of music can be directly applied to the visual composition and development of shots seen on-screen, but he does not identify what the sync-points would be in such a relationship. This approach, in the abstract, resembles the same solution proposed by Ruttmann's 1921 *Lichtspiel: Opus I* where the fundamental unit was the measure contained by the score. Eisenstein and Clair both argue for counterpoint presupposing an audible equivalent to the visual, much like Christian Metz's "aural object," that in being heard can produce the same direct identification as the "shadows of carriages passing across a face."

However, the issue of primary recognition of a sound is not ontology (indexical nature of sound) but epistemology—the "sounds like" character of sounds and noises. Contra-Metz, audience interpretations are guided by context and synchronization, not an underlying "ontological footprint." This reliance on the synchronized image to define the audible sound demonstrates the ordering that Foucault's gaze imposes: the visual dominates, giving meaning and form to the 'formless' abstraction of sound. The practice of "Foley sound" is based on this abstract character of noises, that in being heard what is identified and what actually produces the sound can be entirely different phenomena; in being synchronized, it is the image that defines the audible. The dominance of sight as knowledge, which Foucault's gaze describes, also emerges through counterpoint synchronization. Unlike the direct sound::image association created in both naturalistic and illustrative synchronization, counterpoint is always emergent, a product of the development and recognition of relationships by the audience, rather than produced in their phenomenal encounter with the motion picture.

Understanding counterpoint as an emergent, variable phenomenon of linkage for sound::image was not immediately clear; of the initial theorizations of counterpoint, many followed Clair's presupposition that sound would have the same indexical character as image, developing the counterpoint systematically as a visual equivalent to the audible. This assumption even informs some of the theorizations for sound, such as Christian Metz's theoretical "aural objects." Sergei Eisenstein's proposal of "chromo-phonic montage" makes these literal transfers an explicit feature of his expansion of the *contrapuntal use of sound* called for in the statement made with Pudovkin and Alexandrov in 1929, the

same year as Clair's observations. The system he proposes for montage with a synchronized soundtrack is analogous to his earlier proposition of a "silent" montage for the primarily visual cinema of the pre-"Talkie" 1920s. His theory of counterpoint parallels that of established musical counterpoint as a *simultaneous* encounter:

> Everyone is familiar with the appearance of an orchestral score. There are several staffs, each containing the part for one instrument or a group of like instruments. Each part is developed horizontally. But the vertical structure plays no less important a role, interrelating as it does all the elements of the orchestra within each given unit of time. Through the progression of the *vertical* line, pervading the entire orchestra, and interwoven horizontally, the intricate harmonic musical movement of the whole orchestra moves forward.
>
> When we turn from this image of the orchestral score to that of the audio-visual score, we find it necessary to add a new part to the instrumental parts: this new part is a "staff" of visuals, succeeding each other and corresponding, according to their own laws, with the movement of the music—and vice versa.[7]

Eisenstein's description of audio-visual synchronization is premised on the recognition that both happen simultaneously; the potential for counterpoint is already contained by their presentation. Creating counterpoint is then simply a question of how to organize these relationships to produce the desired *montage* effects that are the refrain in all his theorizations. His theory is of particular note because he recognized the different nature of sound from image. In developing the visual correspondence to this conception of audio-visual counterpoint, Eisenstein borrows concepts from visual music:

> The decisive role is played by the *image structure* of the work, not so much by *employing* generally accepted correlations [of color to sound], but by establishing in our images of *specific creative work* whatever correlations (of sound and picture, sound and color, etc.) are dictated by the *idea and theme of the particular work.*[8]

How these correlations are to be created he demonstrates with a discussion of "Vertical Montage" from the "Battle on the Ice" in his film *Alexander Nevsky* (Figure 4.2). The counterpoint he creates is meant to be understood as a visual dramatization/literalization of what happens audibly in the music. These images "read" left-to-right as graphic statements of the score; as film historian Kia Afra notes in his discussion of

this sequence, "combinations should therefore proceed from the trace of movement in a given musical or visual piece, where that work's line and shape can become the foundation for a corresponding visual or musical composition."[9] Eisenstein's diagram presents a graphic translation of the music into shots appearing in the film—these are static compositions where neither actors nor camera move—his proposed counterpoint, what he terms "Vertical Montage," can be recognized in this arrangement of live action elements. He offers a graphic interpretation-translation of what happens in the corresponding music:

It was exactly this kind of "welding" [of what was actually filmed with the initial plan], further complicated (or perhaps further simplified?) by another line—the sound-track—that we tried to achieve in *Alexander Nevsky*, especially in the sequence of the German knights advancing across the ice. Here the lines of *the sky's tonality—clouded or clear*, of the accelerated *pace* of the riders, of their *direction*, of *the cutting back and forth* from Russians to knights, of the faces in close-up and the *total* long-shots, the *tonal* structure of the music, its *themes*, its *tempi*, its *rhythm*, etc.—created a task no less difficult than that of [a] silent sequence.[10]

His counterpoint is somewhat less-than-synchronous precisely because the music is more dynamic than the very static visuals: their simultaneous presentation on-screen does not guarantee the creation of a *statement*. The difficulty in identifying the counterpoint relationship throughout this sequence lies with the ambiguity of the sync-points employed for the organization of the whole, as Eisenstein suggests when he describes the process as "welding": two disparate elements are forced into contact—an appropriate metaphor for a theorist concerned with conflicts and dialectical contrasts—but not a metaphor for the enunciation of simultaneity commonly understood as "audio-visual counterpoint."[11] The approach to counterpoint developed theoretically and advanced via his films is premised on a *rupture* between sound::image, not *fusion*.

"Counterpoint" developed in the framework of Eisenstein's montage theory employs a radically different model than what is familiar from other types of visual music. In avoiding the organization of emergent *statements* of synchronization, the counterpoint he offers is one where the audible and the visual do not coincide, their relations remain conflicted. This rejection of "simultaneous" effects involves a systematic montage against the sync-points available in the "*tonal* structure of the music, its *themes*, its *tempi*, its *rhythm.*" This counterpoint is composed of contrasts rather then convergences. His response to synchronized

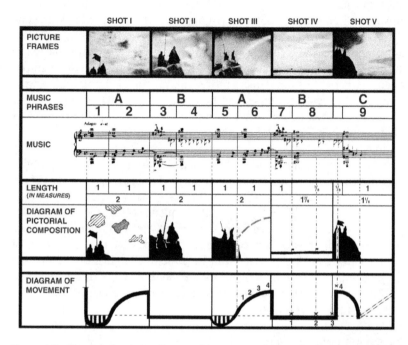

Figure 4.2 Excerpt from the diagram "A sequence from *Alexander Nevsky*."
Reproduced from *The Film Sense* by Sergei Eisenstein.

sound is fundamentally an attempt to *negate* its associative properties, to diminish the realist dimensions of audio-visual linkage.

Eisenstein's approach is recognizably the logical conclusion to the response to 'lip-sync' revealed in Clair's 1929 comments. The rejection of *naturalistic synchronization* becomes in an arrangement of oppositions for Soviet montage. The relative structure of the score determines the composition of his image, and then the simultaneous relationship between the notes heard and the particular image determines its degree of counterpoint. By rejecting the proposition of direct synchronization, the resulting montage sequence is designed to produce the same **thesis + antithesis = synthesis** dialectic as his earlier, purely visual montage theory: the juxtaposition of two elements to create a new meaning not present in either by itself. This alternative to the realist linkage of sound::image was the focus of these responses to the "Talkie" film. The "counterpoint" emergent from this approach rendered the final work as an aggregate of parts, not an entity organized to produce a singular whole.

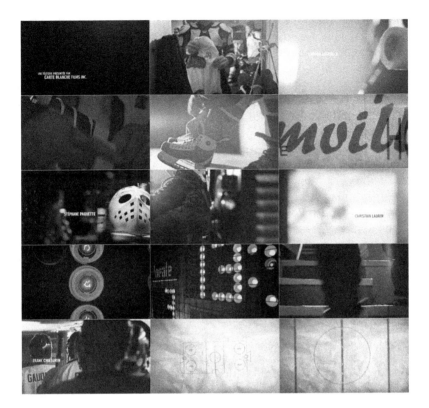

Figure 4.3 Selected stills from the title sequence to *Les Bleus de Ramville* (2012).

The development of counterpoint in title sequences followed a different approach than the avant-garde model proposed by montage. In place of a disjunctive opposition that even Clair's comments suggest, the counterpoint developed in title design produced an emergent alignment of sound::image. This approach is apparent in the fusion of music, sound and editing in Jay Bond's design for *Les Bleus de Ramville* (2012) (Figure 4.3). This 60-second title sequence contains 42 shots of varying duration, the editing often linking these shots together visually either through a graphic match cut, by screen position, or by clearing the frame using the flares common to light leaks in celluloid film. Some of them employ naturalistic synchronization, while others are illustrative, yet the combined effect with the music that runs continuously is to render all these direct synchronizations subservient to the emergent counterpoint. The momentary uses of naturalistic

synchronization within this visual music montage do not function as mimetic reproductions: instead of being momentary pieces of familiar, recognizable sound, their position within the musically structured montage renders their mimetic character as an audio-visual variant of musique concrète—the transformation-subordination of recognizable sounds/noises into the domain of music. The counterpoint that ensues makes audience identifications of mimetic sound a validation of the emergent, realist meaning of the sequence: that the game play flows and develops as a kind of dance, orchestrated via these recognized sounds. The counterpoint organization—realized as the visual music montage (as synaesthetic construction[12])—is a 'revelation' of this hidden "reality."

This meaning emerges from matches between sound, image, and editing creating and following the rhythms of the music—as in a typical rhythmic montage—except that the materials edited create a *statement* where the direct synchronization becomes instrumental to identifying *music*. Much like the transformation of noise (anti-musical sound) into the domain of music in Rolf Liebermann's *Les Echanges*, the counterpoint synchronization in this title sequence enters the domain of visual music. It depends on audience recognitions of the arrangement of both musical and anti-musical sounds.

While there are credits spread across the images, few of them are explicitly title cards: instead, the credits appear as superimposed texts, interspersed with shots of animation and live action. Motion is constant. Every shot of *Les Bleus de Ramville* is assembled to suggest a singular movement across the edits and around the screen, where the crescendos in the music are synchronized to definite actions: scoreboard lights changing, one skater checking another, the crowd leaping up in applause. Each shot in the rhythmic montage has a clear relationship to its accompanying measures of music. This *counterpoint synchronization* is dramatic because of how it emerges from the editing.

Counterpoint synchronizations for sound::image enter into a cultural dialogue with the more common naturalistic synchronizations of realist film productions, a common feature of counterpoint employed in title designs such as *Les Bleus de Ramville*. This fusion of phenomenal appearances and ideo-cultural beliefs reiterates the effects of the gaze for visual music; as Foucault notes in *The Birth of the Clinic*, the gaze is the vehicle for this imposition of realist form:

> So it is not the gaze itself that has the power of analysis and synthesis, but the synthetic truth of language, which is added from the outside,

as a reward for the vigilant gaze of the student. In this clinical method, in which the density (*épaisseur*) of the perceived hides only the imperious and laconic truth that names, it is a question not of an *examination,* but of a *deciphering.*[13]

The transformation of this arrangement of audio-visual elements into the particular *demonstration* that is visual music asserts the unity of the unseen reality and the phenomenal encounter. It is a reconciliation of oppositions through the material form of synchronization that makes these otherwise opposed approaches to realism into a singular *statement* through counterpoint synchronization. The same underlying techniques of realism transfer to the abstract film through synchronization—linking the abstract forms on-screen to the already-abstracted tones of music—become for counterpoint synchronization in the motion picture a synthetic resolution to these incompatible visualizations of knowledge. Their superficial basis in the phenomenal encounter masks the lexical dimensions of this interpretation—their composition as the enunciation, the *statement*—that allows their identification in/as the singularity of "visual music."

From the start of the title sequence for *Les Bleus de Ramville,* the rhythmic pace (every four beats) and alignment of cuts to the music establishes the counterpoint. These opening images are effectively "silent," as their only audio is the music heard; they appear before there are shots with clearly naturalistic synchronization. These first actions "resemble" the music—all the visible motions mirror the pace of the music. By cutting every four beats, this start to the sequence demonstrates the counterpoint of motion to music: every shot contains movement that repeats in a cyclic fashion—the spinning roll of tape, wrapping the hockey stick handle—serve to assert the connections of musical repetition and visual form. The energetic movement of the sequence depends on the audience recognition of convergence in these otherwise independent elements to create the counterpoint relationship. The *statement* formed by this relationship is clearly synchronized, but does not produce the effect of realism common to both types of direct synchronizations. In being a construct, its emergent relationship renders the combination of elements as belonging to a higher-level domain ("visual music"). The occasional moment of direct synchronization is rendered subordinate by this higher-level organization of elements. The emergent recognition of counterpoint subsumes these more immediate connections of sound::image into a more complex *statement* about the synchronization of the title design as a whole.

Counterpoint Synchronization

The introduction of recorded, synchronized sound in 1927 resulted in a broad range of theories around the use and aesthetics of this new technology. However, these concerns with "Talkies" all address sound in relation to a dramatic narrative, with the singular exception of those few visual music artists such as the Whitney brothers and Mary Ellen Bute who were concerned with *counterpoint synchronization*. Bute is especially of interest since her first films were made and released commercially during the early years of sound production—the 1930s. Her approach to counterpoint synchronization is an early instance where the design of a "visual music" film and the commercial demands for ease of comprehension successfully converged. While her visual music films are *not* title sequences, and her short films were not well known on the west coast of the United States prior to 1946[14] (only *Rhythm in Light* [1936] was programmed in the first *Art In Cinema* program curated by Frank Stauffacher at the San Francisco Museum of Art and the University of California, Berkeley; *Escape* [1938] and *Tarantella* [1940] were included in *Series Two* in 1947[15]), works such as her nine-minute abstract film *Parabola* (1937) provide an opportunity to consider the formal connections created in counterpoint synchronization.

The *statements* created by counterpoint emerge both within and between different shots in *Parabola*—the lexical function immanent in the apparent connection of sound::image through on-screen motion and how shots arc edited into sequences. Individual sync-points provide the grammatical punctuation required to define the particular, individual arrangements into specific *statements* of audio-visual relationship: the audience recognition and interpretation of their function is central to their comprehension. *Parabola* reveals that counterpoint synchronization evolves from the more basic identification of elements such as melody, phrasing, and musical structure. The syntactic organization of counterpoint emerges at higher levels of complexity—the momentary alignments that appear as shifts between simultaneous, but unrelated audio-visual presentations (apparently asynchronous) and the momentary, but direct (both naturalistic and illustrative) synchronization of sound::image. The recognition of counterpoint is a revaluation of the apparently asynchronous parts as *in*directly linked to the simultaneously heard music through sync-points based on motion, duration, chiaroscuro, or a combination of all three. Audio-visual counterpoint depends on the particularity of the *formal* and aesthetic development within the composition rather than a mechanical

translation from one system of notation to a visual presentation; it is a cultural interpretation imposed on the visual organization based on an analysis of the signification within the composition's performance— not the score's *a priori* description of the music. The cultural basis of these formal arrangements is self-evident: in selecting *how* to synchro- nize, the interpretation of musical form becomes a constraint on the elaboration and development of visuals. The audience's intertextual (lexical) expertise with both musical form and filmic montage links sound to image through motion, duration, and/or chiaroscuro, all of which are immanent sync-points in any single image.

Darius Milhaud's composition *La Creation Du Monde,* used as the soundtrack for *Parabola,* is immediately recognizable as music, yet understanding its role in this film emerges from the phenomenal encoun- ter with the imagery of Rutherford Boyd's parabolic sculptures made from Plexiglas, wood, and plaster that provide the visual source mate- rial organized by the musical phrasing. The length of shots matches the length of the melodic statements, creating an easily recognized structural correspondence of sound and image. This counterpoint *statement* fol- lows a progression from shorter, simple *statements* into greater complex- ity, apparent in *how* each shot-sequence (in both motion, chiaroscuro, and editing) can be identified as aligned with a melodic statement of varying length, rather than being linked to either the beat or the particu- lar notes played; it is the most common approach to counterpoint after rhythmic montage.

A typical shot from the beginning of *Parabola* demonstrates the sync- points it uses for counterpoint synchronization (Figure 4.4). A short leitmotif is accompanied by a shot showing a series of Plexiglas parabo- las rotating in front of a lamp, creating a repeating shadow pattern on the white wall that dominates the shot. As the notes repeat, gradually ascending the scale, the repeated visual forms/shadows follow a curved path down and then back up the screen, the speed of their motion and its timing align with the musical tempo, drawing attention to the progres- sion of forms as an equivalent to the progression of notes. In being set up as a succession of distinct changes—most of which do not directly align with any particular note—the counterpoint synchronization in *Parabola* initially emerges from editing the shots to match the musical phrases. These sync-points transform the audible into a supplement of the visual—even as the visual *accompanies* the sound. It is an organiza- tion that attempts to redefine the sound::image relationship as an imma- nent counterpoint where what we see and hear mutually correspond

Figure 4.4 Selected stills from *Parabola* (1936) by Mary Ellen Bute.

in a structural fashion. Their reversible connections demonstrate the synchronization in this shot, but are fundamentally a subordination of sound to the materiality and *form* provided by the image—both understandings, as illustration or as dominating the sound, prioritize vision in comprehending the music: the *informe*, ambivalent qualities of hearing are eliminated by the particular character of vision—the hierarchy of visual-over-audio.

Editorial selection allows screen-motion to become a correlation to the metaphoric "motion" of note-sequences in the music. Using the musical phrase as the sync-point for counterpoint creates an immediate *statement* that is readily understood and equally apparent in the formal structure of the film. The title sequence for *The Dog Problem* (2006) designed by Howard Nourmand (Figure 4.5) makes this connection an explicit part of the design: each title card is literally presented as an ink blot test that animorphs into recognizable imagery before advancing; the black areas of each card fill the screen, providing the transition to the next card. The sequence plays as a continuous motion *through* the cards, but the organization offers each motion sequence as an independent "shot," creating a self-contained *statement* via counterpoint. The resulting sync-point in each *statement* is the crescendo of the corresponding musical phrase that marks the transition to the next motion sequence. Structuring counterpoint through an equivalence of "shots" and melodic statements is typical for title sequences. This approach is immediately apparent in the morphology and structure of *Parabola,* and both *The Dog Problem* and *Les Bleus de Ramville* title sequences. This alignment of title cards with musical phrases enables the encapsulation of them as singular *statements* whose cumulative, holistic effect creates an emergent order that is immediately apparent to its audience. The audible cue provided by this counterpoint synchronization allows the clear distinction between individual 'title cards' even when they are composed from several images, or only display their text for a short time.

Figure 4.5 All the title cards in *The Dog Problem* (2006).

Quotational Counterpoint

As Foucault's theory of the gaze recognizes, vision dominates hearing, and for the emergent nature of counterpoint synchronization, this subservience of audition to sight can render the connections between these elements effectively "invisible"—beneath recognition. This pseudo-independence elides the *independent* aspects of title sequences—a paratext is subordinate to the main narrative production, but distinguished from it formally[16]—while simultaneously using their distinction from the drama as a definitional. By grouping smaller *statements* into

an emergent order at higher levels of interpretation—the same approach to counterpoint synchronization used in *Parabola*—synchronization thus distinguishes between title sequence and the narrative.

For Genette, this recognition of a paratext as both integral and separate posed a serious conceptual problem for its definition, yet for the title sequence this separation may be precisely the point: title sequences figure prominently in commercial film and television productions as an indicator not only of the *nature* of the film to follow, but as an identifier of its *importance,* as Walt Disney states in his 1961 introduction to "The Title Makers," an *Adventureland* segment on his ABC program *Walt Disney Presents.* In explaining the social role for the title sequence, he emphasizes them as something more than simply being credits:

> Now time was you know when you could open a motion picture merely by flashing its title on the screen and listing the names of the people who helped put it together, but not anymore. We've reached the point where almost everybody wants to make a bid for the title as the "most ingenious" of the title makers. It has become a real challenge to devise a sequence that is fresh and interesting and entertaining. Also according to theory, it should also help to get the audience into the proper frame of mind.[17]

The "competition" among title designers is focused on prestige: an innovative title sequence becomes an indicator that the film that follows is also innovative. These concerns describe designs of the Early and Middle phase of the Designer Period, as well as some Contemporary designs such as both *Ça Ce Soigne?* and *Scott Pilgrim vs. the World.* The commercial and critical success of *The Man with the Golden Arm,* with its then-contemporary innovative title sequence of graphic lines and Modernist, twisted arm, established Bass and his approach to the title sequence as signifiers of prestige. The allegorical method that defines his choice of white line-needles that morph into a twisted, tortured arm were an innovative, Modernist design, new to title sequences. This association of innovation with prestige in title design has a historical basis apparent from Disney's introduction: the title sequence as an easing-into the narrative for the audience was proposed by Saul Bass, as he explained to Pamela Haskin in 1996, at the end of his career:

> "My initial thoughts about what a title can do was to set the mood and the prime underlying core of the films' story, to express the story in some metaphorical way."[18]

This allegorical mode Bass describes for the title sequence makes the narrative a prominent element, even as that connection emerges only in hindsight; as Disney's comments from 1961 suggest, Bass' proposal is closely related to the prestige of the Designer Period. It complicates the relationship of the opening title to the narrative through this rhetorical component—the metaphoric expression—so it is not just a statement of production information: by introducing an independent conception into the design, that design becomes a self-contained mediator between the interiority of the narrative and the exteriority lying outside the film.

The distinction between the paratextual design and the intertextual one is precisely the object of reference. The intertextuality characterizing both quotations and the artifact-character of established music challenges the integration of the title sequence. Even for Bass, the emphasis in these title sequences is on their relationship to the narrative, however independent the resulting design might be to the film that follows. Intertextual designs refer to absent, but already known works, while the paratextual design, as Jonathan Gray noted, always directs attention towards their linked text,[19] eliding the *independent* aspects of these designs, while simultaneously using their pseudo-independence as definitional. The role of historical visual music film in title sequences such as *Ça Ce Soigne? (Is It Treatable?* 2008) and *Scott Pilgrim vs. the World* (2010) provide intertextual references that complicate interpretations of their counterpoint synchronization, transforming the focus of these designs from immanent perception to memory, challenging the subordinate role by shifting meaning from the immediacy of both paratext and the sound::image connection, to other, parallel meanings evoked through the recognition of historical references via quotation (intertextuality).

The 1-minute, 45-second title sequence to the French comedy *Ça Ce Soigne?* (Figure 4.6) was designed by Julien Baret at Deubal, the French motion graphics studio founded by Stéphanie Lelong and Olivier Marquézy. It begins with the sound of an orchestra 'tuning up' paired with an animation of red squares arranged in a semi-circle. Their motion suggests they represent people finding their seats before a performance. As the music starts, a series of white lines appear on-screen. This initial opening is *not* an example of counterpoint: for each note played, a white line appears in an arc on-screen—an instance of direct synchronization that corresponds to designs in historical abstract films. This opening presents an immediate assertion of "visual music." These white lines are a visual quotation from the start of the Bach sequence in Walt Disney's 1940 feature *Fantasia*. This intertextual quotation gives the direct linkage

Figure 4.6 All the title cards in *Ça Ce Soigne?* (*Is It Treatable?* 2008).

of sound-to-form in *Ça Ce Soigne?* a second level of association with visual music that challenges the directness of the *illustrative* synchronization. It is an example of what semiotician Umberto Eco termed the "post-modern aesthetic solution" to intertextuality in his theorization of 'serial form':

> Aware of the quotation, the spectator is brought to elaborate ironically on the nature of such a device and to acknowledge the fact that one has been invited to play upon one's encyclopedic competence.[20]

Unlike "independent" design, this type of intertextual work anticipates the audience recognitions of its quotational basis. This "post-modern aesthetic solution" depends on the audience being aware of both the source for the quotation, and how the new context transforms the quotation.

The role of quotation in Eco's 'serial form' is systemic, but it must also be identified—recognized—by the audience: his theory of 'serial form' directs attention to how the audience apprehends the work, *which* intertextual references and quotations they identify and understand. His conception of the audience is specifically and explicitly as an actively engaged interrogator of what they encounter, anticipating and evaluating as the 'serial' work progresses. When the intertextual relationship is explicit (i.e., audience recognitions of quotations that blatantly play on intertextuality can be anticipated), the result draws attention to itself. In the titles for *Ça Ce Soigne?* these quotations render this design as a work of visual music about visual music. Quotational intertextuality is a redoubling of the already referential dimensions of title design generally.

The role of memory and past experience in recognizing counterpoint synchronization in *Ça Ce Soigne?* explicitly becomes a part of its design and formal organization as the sequence progresses. The film's narrative about a hypochondriac determines the representational character of the animated elements synchronized with the music: entirely a graphic animation, the "graphics" shift between recognition—as pills, drops of blood, the jagged plot of a heart monitor—and kinetic abstraction as the visual counterpoint to Camille Saint-Saëns' composition *Danse Macabre*. In visualizing this relationship to the narrative, the various "abstract" forms in the title sequence become representational. These images move between abstraction and representation, all evoking the film's title—"Is it treatable?"—through their connection to medicine and medical treatment. The doubling that intertextuality poses within the title sequence expands the recognitions specific to counterpoint synchronization beyond the typical dynamic that arises between the title sequence and the narrative that follows it. The intertextual references to *Fantasia* link this opening to visual music, but these references are not limited to the opening of the sequence. As it progresses, other quotations to the jagged and angular animations in Bute's film *Tarantella* (1940)—music that makes its own reference to the dance that supposedly could cure the "deadly bite of the tarantula"—provide an additional level of commentary that suggests the entire narrative about a depressed symphony conductor who may be suffering from nothing more than hypochondria.

Richard Kenworthy's title sequence design for *Scott Pilgrim vs. the World* (2010) (Figure 4.7) engages in the same play of intertextual quotation as *Ça Ce Soigne?* that divides its audience specifically into two groups: those who recognize and understand the intertextual quotations and those who do not. These divisions depend on an alternative, counter-interpretation submerged within the design—intertextual engagement requires interpretation through memory, necessitating a distancing from the immanent event to apprehend its organization as not an original

Figure 4.7 All the title cards in *Scott Pilgrim vs. the World* (2010).

invention, but a novel transformation of established and already-known form (past experience determines meaning). This division of audiences enables the title sequence to become an indicator of the film's importance (prestige), not simply through *who* the designer is, but as a formal part of the design itself. This intertextual approach is particular to title designs produced since the 1990s, a reflection of Eco's "post-modern aesthetic solution" to serial form becoming the dominant approach to intertextuality and design, challenging the paratextual relationship of title sequence to narrative by rendering the titles formally and conceptually distinct from their attachment to the primary text.

This secondary level of quotation reference—in excess to those proximately concerned with the narrative (the paratextual functions of the title sequence)—opens the interpretation of the title sequence beyond the confines of its pseudo-independence. Quotations necessarily divide the audience into those members who recognize and understand the references and those who do not; only the audience members who make the identification of source engage the serial aspects of the design. The intertextual reference is an excess in the literal sense: it is an addition that directs attention outwards, away from the narrative linkages that define titles as a paratext, challenging this subordination by drawing audience attention towards the (absent) sources. The "reward" for doing so is the establishment of the title as an *independent* entity, effectively separate from the narrative that follows and which is the *raisonne d'être* for the titles as such. In being appended to the narrative, the title sequence functions as a synecdoche that requires the decoding made possible only through the narrative as such. The intertextual quotation adds to this displacement a second level hidden from the narrative interpretation that changes the title sequence into a mediator between the proximate encounter with the motion picture and the cultural foundations of its production. By introducing this anteriority into the design, the quotations that organize and inform both *Ça Ce Soigne?* and *Scott Pilgrim vs. the World* demand that the ideological content manifested through counterpoint synchronization no longer remain invisible: the same 'artifact' character provided by using known, already-established music (Camille Saint-Saëns' *Danse Macabre*) must be extended to the animation, and potentially even the narrative itself. The audience recognition of familiar music (even when the composer and title remain unknown) always has this intertextual quality—*déjà entendu*—that finds its analogue in *visual* intertextuality. The challenge to the paratextual dimensions of the title sequence arise from this second level of reference that does not lie within the narrative: in directing attention away from the proximate towards the mnemonic, the title sequence assumes an independent existence separate from the narrative that follows.

Because *Scott Pilgrim vs. the World* imitates the appearance of traditional "direct animation"—painting, scratching, and drawing on clear film to create imagery on the film strip without using photography—its intertextuality is both formal and visual. This technique, in use since the Futurists created their first films in 1909, has a close association with the historical avant-garde. Both Len Lye and Norman McLaren worked extensively with this technique, and their films provide a referent for the digital animation in Kenworthy's design. "Direct animation" is a striking contrast to the sharp vector graphics embedded throughout *Scott Pilgrim vs. the World*: even though the film narrative is organized around and

through a wide range of animated typography and graphics resembling comic books and video games, the title sequence retains a distinct character that is not repeated elsewhere. Counterpoint synchronization separates these animated graphics from the other narrative graphics: flat and highly saturated, they are also gritty and scratched—their irregularity betrays their origins in handwork done directly on physical material.

The pseudo-independence that intertextuality offers the title sequence enables the design to be simultaneously *of* the main narrative *and* distinct from it, a parallel construction with its own internal structure, themes, and formal appearance. The shift from paratext to independently referential design inserts an additional level of signification into the interpretation of the title sequence, directing attention to the title design as a self-contained entity. The allegorical connection of title design to the production rhetorically masks this pseudo-independence, while the context of Kenworthy's design announces it as belonging to a separate realm than the narrative. Music anticipates narrative. As with Saul Bass' use of abstract, Modernist design, accompanied by equally Modern jazz music in *The Man with the Golden Arm*, the use of Saint-Saëns' *Danse Macabre* in *Ça Ce Soigne?* or indie rock in *Scott Pilgrim vs. the World* provides intertextual associations with particular 'subcultures' that informs the interpretation of the film/title. These designs all rely on established cultural hierarchies and values for their intertextual meaning, recalling art critic Russell Lynes' 1949 article for *Harper's Magazine,* "Highbrow, Lowbrow, Middlebrow":

> The highbrow enjoys aspects the lowbrow's art—jazz for instance— which he is likely to call a spontaneous expression of folk culture. [. . .] A creative lowbrow like the jazz musician is a prominent citizen in his own world, and the fact that he is taken by highbrows has very little effect on his social standing therein. He is tolerant of the highbrow, whom he regards as somewhat odd and out-of-place in a world in which people do things and enjoy them without analyzing why or worrying about their cultural implications.[21]

The tiering of cultural production that Lynes describes in his article is one where value—both significance and meaning—are exclusively granted to only two varieties of audience: the "highbrow" and the "lowbrow" whose distinction lies with whether they intellectualize the appreciation of the art or not; they are otherwise engaging with many of the same cultural productions; however, it is the "highbrow" selection of "lowbrow" productions that renders that work culturally significant, separating such work from what would otherwise be rejected as "kitsch." Cultural

values are *externalities* to title designs that precisely identify contents and direct their interpretation. Intertextuality inherently imposes values that limit and constrain the *desired* audience for the particular work: in Eco's "post-modern aesthetic solution,"[22] this audience is broad and informed by their knowledge of popular culture; for the Modernist Lynes, this audience is elite, reflective of a particular class. The only people financially capable of perusing the highbrow without also being members of the "upper middlebrow" are the independently wealthy. Lynes shrouds elitism in democratic egalitarianism through his claim that this highbrow group is focused on aesthetics in their everyday life, a claim that ignores the financial and material costs of such choices in terms of time and cultivated expertise.

The intertextual role of quotation in the Contemporary Title period reiterates these Modernist hierarchies of inclusion and exclusion: the elevation afforded by the "highbrow" made some works prestigious, revealed in the linkage of avant-garde Modernism (abstraction) and counterpoint synchronization that informs the intertextuality of *The Man with the Golden Arm;* later designs, such as *Ça Ce Soigne?* and *Scott Pilgrim vs. the World* are also informed by similar intertextual quotations from the same earlier avant-garde sources, their intertextuality functioning in precisely the same way—as a marker of distinction between the everyday mass audience and the "elite" audience who are able to "read" the intertextual references. Eco's "post-modern aesthetic solution" does not eliminate or even challenge this elitism—it is an inherent effect of intertextuality and quotation that only some audience members will recognize and understand.

Notes

1 Palmer, B. *Ben at the Beeb: Recollections of a Life in the BBC by Ben Palmer, 1947–1983* (spiral bound typescript, revised February 2005), p. 68.
2 Ruttmann, W. "Painting with the Medium of Light." *The German Avant-Garde Film of the 1920s*, edited by A. Leitner and U. Nitschke (Munich: Goethe Institute, 1989), p. 104.
3 Bresson, R. "Notes on Sound." *Film Sound,* edited by E. Weis and J. Belton (New York: Columbia University Press, 1985), p. 149.
4 Green, F. *The Film Finds Its Tongue* (New York: Putnam, 1929).
5 Clair, R. "The Art of Sound." *Film Sound,* edited by E. Weis and J. Belton (New York: Columbia University Press, 1985), pp. 92–94.
6 Eisenstein, S. *The Film Sense*, trans. Jay Leyda (New York: Harvest/HBJ, 1975), p. 163.
7 Eisenstein, S. *The Film Sense*, trans. Jay Leyda (New York: Harvest/HBJ, 1975), p. 74.
8 Eisenstein, S. *The Film Sense*, trans. Jay Leyda (New York: Harvest/HBJ, 1975), pp. 157–158.

94 *Counterpoint*

9 Afra, K. "'Vertical Montage' and Synaesthesia: Movement, Inner Synchronicity, and Music-Image Correlation in *Alexander Nevsky* (1938)." *Music, Sound, and the Moving Image*, Vol. 9, No. 1 (Spring 2015), p. 38.
10 Eisenstein, S. *The Film Sense*, trans. Jay Leyda (New York: Harvest/HBJ, 1975), p. 77.
11 Afra, K. "'Vertical Montage' and Synaesthesia: Movement, Inner Synchronicity and Music-Image Correlation in *Alexander Nevsky* (1938)." *Music, Sound, and the Moving Image*, Vol. 9, No. 1 (Spring 2015), pp. 33–61.
12 Afra, K. "'Vertical Montage' and Synaesthesia: Movement, Inner Synchronicity, and Music-Image Correlation in *Alexander Nevsky* (1938)." *Music, Sound, and the Moving Image*, Vol. 9, No. 1 (Spring 2015), pp. 33–61.
13 Foucault, M. *The Birth of the Clinic* (New York: Routledge, 1976), p. 60.
14 MacDonald, S. *Art in Cinema: Documents Towards a History of the Film Society* (Philadelphia: Temple University Press, 2006), p. 27.
15 MacDonald, S. *Art in Cinema: Documents Towards a History of the Film Society* (Philadelphia: Temple University Press, 2006), p. 70.
16 Gray, J. *Show Sold Separately: Promos, Spoilers, and Other Media Paratexts* (New York: NYU Press, 2010), pp. 23–46.
17 "Adventureland: The Title Makers," in *Walt Disney Presents* broadcast on ABC, June 11, 1961.
18 Haskin, P. "Saul, Can You Make Me a Title?" *Film Quarterly*, Vol. 50, No. 1 (Fall 1996).
19 Gray, J. *Show Sold Separately: Promos, Spoilers, and Other Media Paratexts* (New York: NYU Press, 2010).
20 Eco, U. "Interpreting Serials." *The Limits of Interpretation* (Bloomington: University of Indiana Press, 1994), p. 89.
21 Lynes, R. "Highbrow, Lowbrow, Middlebrow." *Harper's Magazine* (February 1949), p. 23.
22 Eco, U. *The Limits of Interpretation* (Bloomington: Indiana University Press, 1994), pp. 96–98.

5 Songs and Voice-Over

Synchronization of language—in the various forms of title song and voice-over narration—adds lexical connotations to the synchronization created by the sound::image *statement*. Quite apart from 'lip-sync,' the use of verbal language complicates the semiotics of sound::image synchronization, especially in the development and organization of title sequences. In synchronizing text-to-speech, this ideological content is explicit. In the uncredited title sequence for *The Big Broadcast of 1937* (Paramount, 1936) (Figure 5.1), the *statements* created through this linkage demonstrate how the connotative meanings associated with language entangle the relationship of *illustrative* and *naturalistic* synchronization precisely as described by Michel Foucault's observations about "enunciation" in *The Archaeology of Knowledge*. This simultaneous presentation of speech::text::image as a singular *statement* masks the arbitrariness of the synchronized associations. The illustrative linkage of the text *spoken* to the text *written* is simultaneously both an ideological demonstration and a natural connection of different modes of utterance, especially when it is coupled with 'lip-sync': speech becomes redundant with the text::image composite. This sequence begins with two brief shots of 'lip-sync' reflecting the central premise of the narrative in *The Big Broadcast of 1937*: the comic mayhem surrounding a major broadcast at a struggling radio station. Following the studio logo, the first shot presents a child dressed as an usher yelling at the audience through clenched teeth, "Quiet! Quiet! Quiet! We're on the air!" while straightening his jacket. Although the child's voice speaks, the concurrent image/performance creates the particular meaning of urgency, the insistence of his demand arising not only in the verbalization but through its synchronized behaviors.

The main title, appearing in the second shot, also employs 'lip-sync': a man's face in profile, close to a large condenser microphone says "The Big Broadcast of 1937!," each word appearing superimposed on-screen at the same time as he says it, progressively filling the screen to hide his face.

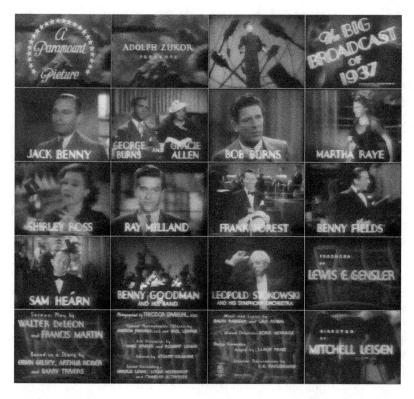

Figure 5.1 All the title cards in *The Big Broadcast of 1937* (1936).

The synchronization of text-to-speech functions as a direct analogue to the 'lip-sync' that accompanies this shot—it belongs to a different order of interpretation, one that depends on other semiotic recognitions than those of our everyday encounters: it is *illustrative* synchronization, even though the face is presented in 'lip-sync.' This simultaneous presentation demonstrates speech::text::image is a single *statement*—the typography is interchangeable with both the verbalization and the live action background. By linking the typographic with the spoken, each word of text synchronized through this emerging voice-over (the face becomes obscured) transforms the speech heard into a voice reading the words for the audience.

These opening shots are crucial for the development and organization of the title sequence as a whole: they establish the connections of voice-to-image while at the same time evoking a radio broadcast. After the first two shots of 'lip-sync,' the sequence continues to use voice-over to introduce each radio star appearing in the film, their name stated as

they appear on-screen while their written name appears superimposed as a text at the bottom of the screen (the calligram mode).[1] It is the familiar organization of text-to-speech that links text to image from past experiences originating with children's books where an image appears accompanied by the name of the thing shown. But these books that teach reading are not merely read silently. Children are encouraged to read aloud—the process of learning to read is vocalized—creating the same hierarchy of speech to image that is operative visually, as Foucault explained about the relationship of text to image in French Surrealist Rene Magritte's painted calligrams, discussed in his book on him, *This Is Not a Pipe*:

> The calligram aspires playfully to efface the oldest oppositions of our alphabetical civilization: to show and to name; to shape and to say; to reproduce and to articulate; to imitate and to signify; to look and to read.[2]

The dominance of language over image that Foucault describes is a product of the enculturation created in learning to read: children are trained to make these connections by the books that associate pictures with words. Synchronization develops this synergistic linked meaning through the *statement* made in synchronizing text and visuals with the soundtrack: the association of a picture with a textual label producing the calligram in *The Big Broadcast of 1937* is not only the combination of reading::seeing common to the calligram mode. The performative aspects of this process—that the child either reads aloud, or has an adult read to them—asserts the dominance of language over the images it accompanies, both as silent and audible speech. This connection of speech to written language renders them as equivalents, each asserting the dominance of language over the visual through the process of naming and identifying.

The subservience of image to sound in the earlier shot of the child is revealed in this title card. The disappearance of the speaking face behind the text establishes the dominance of written language literally over (or against) its verbalization: because the voice is coincident with the words, one can be substituted for the other; the dominance of typography is presented visually in this title card by *how* the words appear on-screen. This dominance recalls the dynamic contained by the calligram—Foucault's observation about how reading precedes seeing:

> The calligram never speaks and represents at the same moment. The very thing that is both seen and read is hushed in the vision, hidden in the reading.[3]

The calligram's redundancy of image-text becomes voice::text, assert-
ing a dual presentation of the same meaning: each is an interchangeable
cypher for the other. The immediacy of this connection, while entirely
an artificial construct, is for the audience a direct *fact* of the experien-
tial encounter. The direct synchronization of 'lip-sync' transforms the
less-than-direct relationships of text-to-speech into the same immediacy
of linkage, even though the audience is no longer seeing the same con-
junction of action-reaction. The semiotic process invoked in *The Big
Broadcast of 1937* provides a foundation for understanding the rest of the
design. As the voice shifts from being a simultaneously audio-visual link-
age of voice to subject, becomes a mode of address where the audience
reads::listens to a three-fold redundant presentation of verbal, textual,
and visual information where synchronization transforms the distinct
elements into a series of singular *statements,* one per title card.

Complex semiotic interpretations depend on these immanent deci-
sions about the relationship of sound::image. Each calligram title card
introduces the image of the actor with a simultaneous announcement of
each star's name as text and speech. Synchronizations of text-to-speech
in the rest of the sequence follow a more prosaic linkage of speech-to-
actor, invoking a foundational experience of everyday life, simultane-
ously anchoring the visual as a visualization of the audible sound. The
title sequence is a typical design of the 1930s at Paramount Pictures, but
the addition of the announcer "reading" each name is particular to this
sequence, distinguishing it from the otherwise commonplace calligram
mode title cards employed throughout.

The opening to *The Big Broadcast of 1937* develops three distinct types
of synchronized *statement*: the first is *naturalistic,* the direct synchroniza-
tion that produces a naturalistic effect, the 'lip-sync' of the child admon-
ishing the audience; the second is *illustrative,* specifically linking the
cultural knowledge presented as verbalized words tied to the appearance
of written words on-screen, an equally direct connection to that produced
by 'lip-sync,' but cultural rather than phenomenal; the third relation-
ship is *counterpoint,* depending on the same abstract, cultural linkages
employed in the graphic association of text-to-image learned in child-
hood that define the calligram. The shifts from one associative mode to
another are continuous and fluid; all are variations on the same immanent
sound::image link that defines all *statements* made by synchronization.

Music

Music is well theorized in cinema generally; a brief summary of its
approaches to synchronization are instructive. For title sequences,
music assumes one of two immediately apparent forms: as an abstract

musical performance, or as a "theme song." The various functions and roles for film music have been elaborately described and documented by many historians and critics; the extensive and well-documented catalogue of approaches/roles for film scoring that appear in the article by Jessica Green, "Understanding the Score: Film Music Communicating to and Influencing the Audience," provides multiple examples and typologies of musical accompaniment in the context of narrative films, yet fails to mention music in the title sequence or theme song; this neglect is typical.[4] The score has been handled as an intensifier and amplifier of the narrative, rather than an organizational source for its construction. Prior to the development and commercial adoption of optical sound in 1927, the so-called "silent era" in the United States, film scores would generally be produced after the film was made to facilitate synchronization and counterpoint of music and image.[5] The synchronization of music and title cards was narrowly restricted in its early implementation in the 1930s and 40s, but the potential for a more complex synchronization is present even in these early, minimal linkages created by aligning a trumpet fanfare with the producer's credit at the start of the sequence.

However, both direct (*naturalistic* and *illustrative*) and counterpoint approaches to synchronization offer complex potentials for the linkage of fanfare and individual credits. The illustrative synchronization that organizes the entire sequence in Walter Lantz's animated design for *My Man Godfrey* (1936) (Figure 5.2) simultaneously develops a counterpoint in the darker Hooverville built across the river from the bright lights of Manhattan. Set up as a continuous pan across a cartooned waterfront where the credits appear "in lights," the development of this two-minute "long take" concludes with optical printing to transform the animation into live action. The pauses written into the score correspond to the shifts of credit on-screen, each new sequence of "lights" going on in direct synchronization with the corresponding notes. This model of direct synchronization accompanied by counterpoint motion is a feature of the title sequences Lantz produced for Universal between 1935 and 1972 when he retired. Other designs, such as the counterpoint of animated run cycle and morphing ghost flying overhead for Abbott and Costello's film *Hold That Ghost* (1942), or the animated skeletons, werewolf, Dracula, monster, and

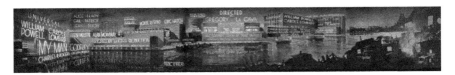

Figure 5.2 Panorama from the title sequence to *My Man Godfrey* (1936).

femme fatale in *Abbott and Costello Meet Frankenstein* (1948) reflects his better-known work with character animation on cartoons such as Woody Woodpecker.

In being composed for synchronization, the music becomes an element in a multi-sensory composite: it is not an external, appended form. A fanfare functions in title sequences as a demonstration of this on-going nature: it is a component, an internal element fused with the visuals to construct an ongoing whole. The simple use of a fanfare at the start of the titles in *My Man Godfrey* corresponds to the same role in the uncredited design for *The Trollenberg Terror* (aka *The Crawling Eye*, 1958) (Figure 3.4, page 60). In this two-minute sequence, each title card appears on-screen synchronized with a trumpet fanfare, giving the entire design the disconcerting character of a dramatic spectacle, even though the design itself is reductively Modernist, composed from minimally animated graphics: only the arrows that direct attention to the credits are in motion. Sound is dominated by the visuals specifically through synchronization; motion highlights the linguistic elements, reiterating the same language-vision-hearing hierarchy evident in other synchronizations. As musicologist Royal S. Brown's comments on the difference between film music scored specifically for use in motion pictures and other types of music belonging to the European tradition argues, film scores are part of an integrated *statement*, rather than an independent composition that runs parallel to the visual:

> Listen, for instance, to the way Bernard Herrmann's title music for Hitchcock's 1959 *North by Northwest* ends in the movie. That essential signifier of musical terminativity, the cadence that produces the expected closure of a return to the tonic, never shows up. The film, on the other hand, by closing the title sequence while moving directly into the film's opening shot showing Hitchcock missing a bus—it is likewise the nature of the cinema to be ongoing—has exactly the same narratological effect of, forgive me, terminative durativity found in the interior cadences mentioned above. Herrmann's score, on the other hand, rather than providing the unnecessary and superfluous doubling of that effect that would come with its own cadence, simply stops on a suspended chord in a state of almost pure durativity. By cutting off at this point, the music passes its particular dose of durativity into the verbal and visual texts of the film, whose durativity has been reinforced by the musical effect.[6]

In the concept of "durativity" Brown describes the shifts in compositional form required for music-as-component rather than as an independent composition, following the work of Eero Tarasti's *A Theory of Musical*

Semiotics that initially proposed it. The expectation of the composition *continuing* organizes the formal parameters of the musical statement— the audience listening employs their past experience to anticipate how the music heard will progress. The distinct narrative phases of a composition describe the internal 'sense' of the music as continuously developing. The three different sections he identifies—*inchoative* (beginning), *durative* (middle), and *terminative* (end)[7]—are structures internal to the music itself; once synchronized, these musical elements are no longer independent structures. The resulting *statement* is no longer only an audible form, but defers to the visual, as Foucault has noted. The direct connection of graphic animation to music establishes the hierarchy of visual-over-audio: the "durative" chord that concludes the title music in Saul Bass' design for *North by Northwest* simply describes the sense that the composition as a whole has not ended—but the title sequence has, a distinction that marks the conclusion of this opening *statement*.

The opening presents one *statement* made form a paired set of visual shifts, first from graphic animation to live action, then from an abstracted shot of the United Nations façade in New York to montage. These internal divisions, as between title sequence and opening dramatic scene in *North by Northwest*, function analogously to chapters in novels or themes within a larger composition: their "end" is transitory. Brown recognizes this audible suspension is contained through its synchronization with the final shot of Hitchcock missing the bus, a shift from a musically encoded conclusion to a visually terminated one; the end to the title sequence is not simultaneously heard in the composition. The hierarchy is the same one that Foucault described, but extended beyond just visuality: reading is dominant, then seeing, and finally hearing. The "essential signifier of musical terminativity" normally expected at the conclusion of a piece of music—the *terminative* conclusion musically—is missing from the opening theme, except in the automatic fashion by the performance coming to an end. This absence is appropriate precisely because the *film* is not over; there will be more music.

Title Songs

The initial development of sound recording with the Vitaphone system by Warner imposed technical constraints on the productions, dictating *how* the performances appeared in the finished films. Because the Vitaphone system recorded sound to a spinning disk, it did not *initially* allow for any editing of the performance; by 1929, the Warners had devised a complex mixing system that involved the synchronized playback and rerecording of multiple records to create a new, edited mixdown.[8] This initial limitation determined the style of presentation: the performances would last

eight to ten minutes—the length of a Vitaphone disk—and be the same as if done on stage for a live audience, filmed by cameras isolated in sound booths to muffle their noise. The initial inability to edit the sound meant that when these sequences appeared in the finished film they would run without interruptions. Historian Roy Prendergast's treatise *Film Music: A Neglected Art* described the aesthetic problem posed by the introduction of theme songs:

> For a short period of time during the early years of the sound film there existed what Kurt London characterizes as a "theme song craze." [. . .] There are, however, inherent aesthetic problems with films that use a theme-song approach to music. Generally, at some point in the film, the song itself must be stated in its entirety. This was usually accomplished by having someone sing the song, as Marlene Dietrich does in *The Blue Angel*. The problem was that the insertion of the song usually broke the dramatic tension at some of the more important points of the film because, as London points out, "it held up the action."[9]

This problem of characters stopping the narrative action during the theme song is specifically resolved by confining it to the opening credits. The paratextual nature of the title sequence enables the song to both appear in the film, but at the same time, the placement outside the narrative renders it *neutral* as the "dramatic tension" has yet to begin. The similarities between abstract musical performances and theme songs are tempered by the essential difference that adding lyrics imposes: synchronized images and language (lyrics) change the title sequence through the lexical structure of prescribed connotations language imposes on the visual.

While the fanfare aligns with the most basic function of credits to announce the title of the production, the most abbreviated designs, made as title-card-only, do little more than present the minimum required production credits and the main title, allowing the narrative to begin almost immediately. This elimination of the opening title sequence in the Logo Period is one of the striking developments of the "new Hollywood" that emerged from film school in the 1970s. Genette's distinctions between *peritexts* (such as title sequences, intertitles, and subtitles contained within the film itself) and *epitexts* (such as film stills, trailers, and advertising posters, as well as product-placement tie-ins, trading cards, and toys) are useful to acknowledge the paired functions of title songs both within and apart from their films.[10] These labels distinguish the possible internal and external encounters audiences have with title songs: "inside"

the film—as a *peritext*—or independently of it (for example, played on the radio or in a music video)—as an *epitext*—their distinctions determined by *context*. For a theme song, this parallel existence is masked by its common integration with the opening credits; Richard Greenberg's opening to *Ghostbusters* (1984) (Figure 5.3) is a highly abbreviated example of the Logo Period's approach to these issues surrounding the title song. The short clip extracted from Ray Parker, Jr.'s pseudo-advertising jingle ends in the same ambivalent way that Hermann's title theme for *North by Northwest* does. Although the main title card is only on-screen for a brief 12 seconds in a "sequence" whose music has been cut down to run only 45 seconds, it retains the synchronization of text-lyric, using the duration of the music to define the title sequence as a self-contained unit: yet, it is not musically terminated, opening instead into the next scene of the narrative. The "appearance" of the ghost character as the "O" of the film title makes this main title more than simply a superimposed title card over a shot looking across the street at the New York Public Library. The title card lasts approximately ten seconds, starting with a red iris-in from the startled librarian who sees a ghost that becomes the logo/"O", and concluding as a live action view outside the building; the music runs for a total of 45 seconds, ending with a shot of an office door where someone has written in blood (?) the words "VENKMAN BURN IN HELL."

Cutting the theme down to simply an opening fanfare and the vocalist announcing "Ghostbusters!" in sync with the opening title card almost entirely eliminates the title sequence as a recognizable "part" of the film, defining it only by the duration of the audio. This conjunction of sung title and title card appearing on-screen, however brief, is typical of the relationship between lyric music and title design, a *statement* that repeats

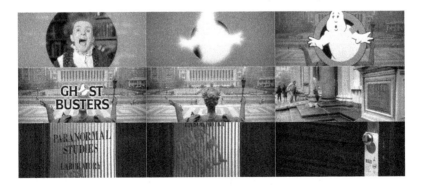

Figure 5.3 The title card only opening to *Ghostbusters* (1984).

the same redundancies—the composition passing some of its semiotic organization "into the verbal and visual texts of the film"—that appears in *The Big Broadcast of 1937* where the spoken/written text act as reiterations of each other: the resulting *statement* makes their connection explicit. The resulting audio-textual calligram is a common feature of how voice and text are linked in motion pictures, not simply in the production of title sequences. The calligram that connects title card to lyric in *Ghostbusters* affirms the association of the two, an important transactional linkage.[11]

The synchronization of the theme song and its role in the title sequence presents a complex structure of recognitions and past experience. Much like an advertising trailer, the music video for a theme song is an epitext that creates an additional understanding of the film quite apart from that offered by the title sequence, reflecting the same relational semiotics of anticipation and past experience in understanding its appearance within the film. It is not simply a part of the title sequence, but stands in parallel to it—popular music in fiction films has an identity and role equal to the visual, established as a parallel discrete and independent meaning in addition to its function within the narrative.[12] As an independent *song* this theme was a popular single the summer *Ghostbusters* was in theaters, debuting at number 68 on the *Billboard Hot 100* chart on June 16, it became number one on August 11, a reflection not only of the song's popularity, but its role in promoting the film, which was also a popular success that summer. The direct synchronization of the lyrics containing the film title and the main title card displaying that title on-screen is an essential assertion of their connection: the audience may already know the theme song without being aware of its connection-relationship to the film; their synchronization is an obvious means to establish this association.

Maurice Binder's title design for the tenth James Bond film, *The Spy Who Loved Me* (1977), is an elaborate counterpoint of title song and credit sequence (Figure 5.4). Like all of the Bond titles, it is a typical example of a Middle Phase Designer Period title design, even though this design was made at the end of the Late Phase. However, the synchronization of music-image is not complemented by the linkage of lyrics-credits: although the theme song does contain the film title, unlike the truncated title card for *Ghostbusters,* the appearance of the main title on-screen in Binder's design as superimposed text stating "THE SPY WHO LOVED ME" is not matched by Carly Simon singing that lyric. This deviation from the standard synchronization of the title card-theme song is unusual; of the Bond title sequences Binder designed, only *The Spy Who Loved Me* and *License to Kill* (1989) do not synchronize title card and

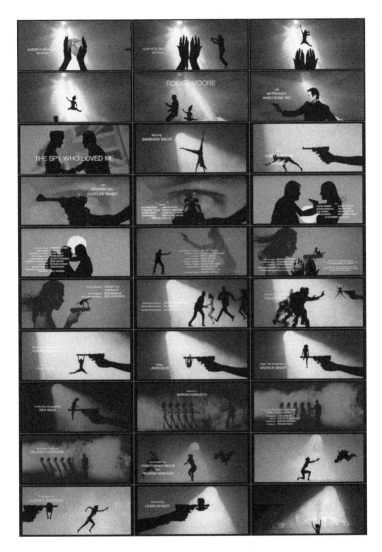

Figure 5.4 All the title cards in *The Spy Who Loved Me* (1977).

lyric (the theme song for *Octopussy,* the third exception, does not contain the film's title at all). The misalignment of the two reflects the placement of the film's title within the lyrics: for most of the other theme songs, the title comes early in the song, while for *The Spy Who Loved Me* it comes much later, and in *License to Kill* it is only contained by the refrains.

The *statements* that organize this title sequence are also not always aligned with *single* title cards. Instead, they create sub-sequences within the design—groups of credits superimposed over a singular composited background shot. There are 13 such sub-sequences in the design where visuals align with breaks in the music and its lyric contents, creating each particular *statement.* The libretto serves to anchor the meaning of the titles, allowing the visuals to create iconic combinations whose denota-tive—representational contents—are readily apparent. The *counterpoint synchronization* created around these iconic combinations[13] remains a constant feature of Binder's designs throughout the series as a whole. *The Spy Who Loved Me* theme song, "Nobody Does It Better," composed by Marvin Hamlisch, defines a "peritext" offering a fantasy of recipro-cal desire: the act of seduction, of *desire and being desired,* expressed by Carole Bayer Sager's lyrics. The iconography of this design presents a tripartite theme of *vision—gun—seduction* (sex) that depends on the lyric content for its lexical definition, making the design *not* an exercise in voyeurism *per se,* but rather a feminine "claiming" of the Bond figure through a reciprocation of desire expressed via the theme song: a fantasy of wanting *and* being wanted—seduction—that challenges any critique of this sequence as necessarily presenting the female body as threat, sex object, or victim of violence.[14]

As with Binder's other designs for the "James Bond films," *The Spy Who Loved Me* reused optical elements (masks, typography, imagery) in the films starring Roger Moore (Figure 5.5), thus maintaining a

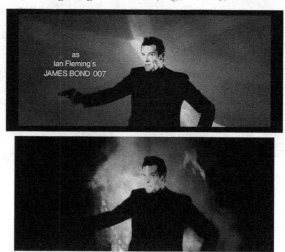

Figure 5.5 Selected stills showing identical mask used in *The Spy Who Loved Me* (top, 1977) and *A View to A Kill* (bottom, 1985).

consistent "look and feel." All the films starring Moore have common, recurring elements, but the three films that directly follow *The Spy Who Loved Me* also contain variations on the same iconic imagery: eye, gun, woman, and "James Bond" (Roger Moore). Composed from 13 discrete sequences, these repeating materials are arranged and composited using an optical printer. The hold frame of a gun in the background of the first title card in *The Spy Who Loved Me* is from the previous film, *The Man with the Golden Gun* (1974); a silhouetted dancing girl reappears from *You Only Live Twice* (1967); and the rippling kinetic typography was first used in *Thunderball* (1965). The pervasive female nudity common to all of Binder's James Bond title sequences invites a consideration of them via Laura Mulvey's theorization of the gaze as a vehicle for masculine heterosexual desire, which she identifies as an *innate* feature of commercial cinema as a whole:

> In their traditional exhibitionist role women are simultaneously looked at and displayed, with their appearance coded for strong visual and erotic impact so they can be said to connote *to-be-looked-at-ness*. Women displayed as a sexual object is the leit-motif of erotic spectacle: from pin-ups to strip-tease, from Ziegfeld to Busy Berkeley, she holds the look, plays to and signifies male desire.[15]

The *on-displayness* typical of eroticized imagery as a signifier of masculine heterosexual desire (what she terms "male desire") is complicated by the specifically *feminine* point-of-view expressed through the lyrics. While the desire '*to see*' characterizes the dominant engagement with erotic spectacle in a reiteration of Foucault's link between sight and the establishment of hierarchy, Mulvey's analysis is not a purely descriptive account of the power relations developing within Binder's design. The "plays to and signifies male desire" does not necessarily mean a disempowered position, as the theme song for *The Spy Who Loved Me* suggests—in embodying masculine heterosexual desire, the female figure *gains* power through the potential to channel and *redirect* this desire—seduction of the male—complicating and challenging the meaning Mulvey's theory anticipates *for* the images shown, an alternative conception stated *through* the song. Instead of being silent, a feminine desire *for* Bond is expressed via the lyrics and their synchronization, organizing and dominating the *statements* created in this sequence.

The semiotics of synchronized *statements* challenge the proximate meaning of this visualized, gendered hierarchy without necessarily eliminating its implication in the dominant power relations she discusses.

This subverts Mulvey's conceptions about the gaze that reappears in film historian Janet Woollacott's discussion of these designs:

> While women are represented as erotic spectacle, the audience is led to identify with the male hero, the active performer.[16]

In treating Binder's designs as a uniform series without individual potentials for difference or complexity, the critique comes in advance of the evidence: audience identification is neither simple nor one-sided; as Tony Bennett and Woollacott suggest in their 1987 study of the Bond series, the "Bond girl" provided a "liberated" sexuality compared to other representations of the period, offering *female* viewers an identification that was not automatically passive, disempowered.[17] This complexity is reflected by the title song's role in determining the range of expected meanings for the images, demonstrating the importance of *who* sings in directing the audience's identifications. The hierarchy of language-image-sound that determines meaning also establishes point-of-view and constrains identification: *in non-diegetic narration (such as the theme song) the audience conventionally identifies with the person speaking.* Thus, in the title to *The Spy Who Loved Me*, the identification is with Carly Simon's breathless expression of a feminine desire for Bond. This lyrical positioning complicates Mulvey's critique, undermining its monolithic conception of the audience as *necessarily* only identifying with the camera/male protagonist. The *illustrative synchronization* of images and theme song in Binder's design sublimates these voyeuristic interpretations of the nudity via the meaning of the iconic triad *vision—gun—seduction* that structures the composited montage. Lexical ambiguities develop a second set of double meanings through the synchronized lyrics-imagery:

> Nobody does it better
> Makes me feel sad for the rest
> Nobody does it half as good as you
> Baby, you're the best![18]

The question these lyrics raise is obvious: what is the "it" that nobody does better?—this question, while implied, but never answered by the song, is simultaneously resolved through a visual metaphor presented twice: first in sub-sequence 12, imagery accompanying the credits for Claude Renoir (cinematography)/John Glenn (editing)/Maurice Binder (title design), and then in a second variation as the background for Albert Broccoli (producer)/Lewis Gilbert (director) in sub-sequence 13. Synchronization sublimates the song's meaning through the imagery of

a nude female acrobat spinning around a giant gun barrel. What Mulvey theorizes becomes a programmatic account of the seduction being presented symbolically on-screen, rather than an autonomous playing-out of exhibitionist display; this title sequence employs it as a vehicle for attracting and 'capturing' the male (James Bond). Rather than an objectifying gaze, Mulvey's "male gaze," here linked to the gun—the phallus—is a symbolic activity that is undergoing semiosis during the sequence; its meaning and 'power' are in question. The dominant gender-role (normative) binary opposition that is central in this construction, male::female/masculine::feminine, and that inheres in Mulvey's theory, is revealed by a reversibility for roles: the fixity of subject::object dominance (and its linkage to normative gender roles for masculine and feminine) assumed by her theoretical critique become unstable in this process, conclusions rather than starting-points of signification. Desire and the voyeuristic aspects of this design become a trap for Mulvey's "male gaze" conceived along normative lines. It is a structure where the desiring feminine viewpoint dominates the sequence, revealing the repressive actions implicit *within* Mulvey's negation of subjectivity and desire for the 'object' of another's gaze, denying reciprocity, that the audience can engage in a reading-against dominant power relations.

The opening to these titles inaugurates a space of fantasy—but fantasy requires both an object-of-reverie and subject-who-desires. For *The Spy Who Loved Me* it is the woman who desires, and "James Bond" who is the object of that desire: a reversal of what Mulvey's theory explicitly assumes about film spectatorship. This structure is apparent from the very beginning of this title sequence. Synchronized with the start of the music, silhouettes of female hands cup the Union Jack parachute Bond uses at the end of the prologue, as it dissolves into a blue tinted still frame of light glinting off a gun. These cupping hands that 'catch' the falling Bond are accompanied by a series of other 'falls'—a full length silhouette of Bond (Roger Moore) enters the frame, while a nude woman holding a gun rises from between the cupped hands, pointing a gun and falling back, synchronized with the rise and fall of a male silhouette in the center of the frame while a man (Bond) tumbles up 'head over heels' on the right. It is a complex of entrances, actions, and exits. The lyrics "I wasn't lookin' but somehow you found me / I tried to hide from your love light / But like heaven above me / The Spy Who Loved Me" make the meaning of these composites explicitly a part of the synchronization of the title sequence as a whole.

The central element of this opening composited sequence, *the cupping hands*, evokes not a *masculine* fantasy of domination, but rather—due to the synchronization with the *female* vocalist—a specifically feminine

claiming of desire for the masculine Bond in an embrace of what this character represents—an outwards-directed, dominant heterosexual masculinity. This opening for the title sequence in particular works to assert the dynamic in action is one where guns are a metaphor for desire, represented as belonging *to* Bond, and as the desire of the various women and female silhouettes *for* Bond, reiterated by the song lyrics "And nobody does it better / Though sometimes I wish someone could / Nobody does it quite the way you do / Why'd you have to be so good?" The lyrics present this metaphoric desire as being specifically *reciprocal*: in this design it is not an objectifying gaze that these images present, but rather a literal translation of the metaphor "being laid bare" as nudity. This collection of elements will reappear at the end of the sequence in a reiteration of its importance as the mediator of what is happening on-screen: the various falls imply a "falling for" or "falling into" love, rendered visually.

The symbolic structure of the images demonstrates a feminine heterosexual desire for the masculine Bond, a claim reinforced by the lyrics themselves. By playing to the dominant "male gaze," these figures subvert its association of sex and violence. This subversion undermines the conception of these titles as a voyeuristic fantasy because role reversals and mutual exchange/surrender organize the imagery: the play invoked is seduction, not voyeurism. Nudity is not disempowering, as Mulvey's criticism presumes, but a technique for role-reversal to gain power over the gaze. This logic of *seduction* is specifically initiated, not by Bond (the only male shown), but by an (unseen) female presence who may or may not correspond to any of the various women appearing in this sequence, but whose *voice* synchronizes with all the actions shown; that the designer is a man, Maurice Binder, does not alter these symbolic feints and transfers.

Seduction emerges in *The Spy Who Loved Me* title sequence from the reversal of powerful/less roles, developed not in the imagery, but through its synchronization with the theme song: creating an inversion of roles and expected positions that Mulvey assumes in her conception of "male gaze." It follows from the ambivalence of signs and signification—their relationships are always contingent, contextual. The immanent transformation of roles played out in this title sequence present exactly the conversion of positions that theorist Jean Baudrillard describes in his book *Seduction*:

> To seduce then is to make both the figures and the signs—the latter held by their own illusions—play amongst themselves. Seduction is never the result of physical attraction, a conjunction of affects or an economy of desire. For seduction to occur an illusion must intervene and mix up the images; a stroke has to bring disconnected things together, as if in a dream, suddenly disconnect undivided things.[19]

The reversals of Mulvey's relationships of erotic gazes and desire render this seduction—and the ambiguity of these images—throughout Binder's design; to take them as merely reflections of a voyeuristic male gaze is to deny half of the experience in watching these titles: the mediating role of music and lyric in establishing the symbolic forms on display. This reversibility of power relationships and transformations of meaning reveals the convergence of Baudrillard's proposal of *seduction* and other post-modern critical theory, such as Jean-Francois Lyotard's proposal of 'paralogy' as a critical strategy for challenging established power in *The Postmodern Condition*:

> Paralogy must be distinguished from innovation: the latter is under the command of the system, or at the very least used by it to improve its efficiency; the former is a move (the importance of which is often not recognized until later) played in the pragmatics of knowledge. The fact that it is in reality frequently, but not necessarily, the case that one is transformed into the other presents no difficulties for this hypothesis.[20]

The fact that guns figure prominently throughout these titles (as a graphic background element, wielded by the figures shown on-screen, and in a distinctly iconic fashion) renders this shifting power an ironic reversal of Mulvey's dynamics. The phallic power of the gun becomes instead a dispersal, subverted by its dominance as the "male gaze": subverted by the very objectifying role Mulvey describes for it. At the end of sub-sequence 2 (immediately before the main title, sub-sequence 3), there is a medium shot of Roger Moore rising into view, turning, and pointing his gun towards the audience. It is an ambiguous action since his expression does not suggest a threat: the "violence" implied by the gun is not *literal* violence, but the dynamic interplay of seduction: implied, but false threat, countered by an equally "false" surrendering—this is the play of signs that Baudrillard's seduction, and Lyotard's paralogy, identify. The reversal of meaning and dominant roles traditionally assigned to female nudity is precisely neutralized by their symbolic dominance. In being presented as silhouettes and through the alienating effects of compositing without concern for scale, the resulting iconic forms can be read directly as both assertions of voyeuristic power dynamics, and discursively against this interpretation, as a dominance and "dancing circles around" the dominant view.

The lyrics are a mediator of the sequence's signification; the music seduces as much as the images, affirming the paralogy of the nudity. The active/passive roles commonly assumed for the genders are belied by title

card—the text "THE SPY WHO LOVED ME" superimposed over a couple ("James Bond"/female) where the woman leans in, pushing Bond to lie back—resolving any lingering doubts about what the theme song alludes to, and which the rest of the imagery suggests: that the 'action' of this sequence is seduction of Bond. However, in contrast to the opening silhouettes, this section begins with a close-up of a woman's hand pointing a gun to the right, a male hand enters the frame, pushing the gun aside as the red background dissolves into a Union Jack flag fluttering in the wind; simultaneously, the words "THE SPY WHO LOVED ME" appear one word at a time starting over her hand in silhouette, pulling back to reveal that she is dressed in stereotypical "Russian" clothing— a military uniform and fur hat—while the man is clearly Roger Moore (Bond); he leans in and they lie back, as if about to kiss. These women are not passive figures; they are highly active, literally armed, not immobile, passive objects *only* to be looked at. This title card reveals the song is directly about Bond, that the refrain "Baby, you're the best" refers not to Bond the spy, but instead as lover/playboy. The gun functions symbolically as a metaphor for desire—Bond taking her hand in the main title card becomes a gesture of acquiescence to her, their lying back together a joint surrender, revealing the end point of this seduction.

Voyeurism and objectification go together in Mulvey's theory. The singularity of film spectatorship accompanied by the inherent one-sidedness of the act of watching makes the audience's position in the movie theater naturally appear voyeuristic. However, such a conception necessarily renders all film spectatorship as a pathological gazing because "voyeurism and scopophilia" in her theory is specifically drawn from psychoanalytic descriptions of pathology. This relationship depends on an entrapment of the 'object' that denies its consciousness, those human capacities for feeling, desire, and action. In contrast, Baudrillard conceived this surrender as happening through *seduction*, not a reflection of pathology, but a product of interpersonal power dynamics that are in flux, metastable, rather than locked into an eternal hierarchy:

> The feminine is not just seduction; it also suggests a challenge to the male to be the sex, to monopolize sex and sexual pleasure, a challenge to go to the limits of its hegemony and exercise it to death. [. . .] Love is a challenge and a prize: a challenge to the other to return the love. And to be seduced is to challenge the other to be seduced in turn (there is no finer argument than to accuse a woman of being incapable of being seduced). Perversion, from this perspective takes on a somewhat different meaning: it is *to pretend to be seduced* without being seduced, without being capable of being seduced.[21]

Female desire employs *seduction* as a tactic to negate the patriarchal order Mulvey critiques—but does so by deflecting its dominance through a subversive re-presentation of its own established codes. This 'role play' appears in Binder's design. Passivity and objectification are closely linked in seduction as reversible, each capable of instantly becoming the other. The culturally coded nature of nude::naked[22] with its conception of implicit erotica expressed as voyeurism seemingly applies to cinema precisely because those being viewed are unaware of the viewing, unaware of the gaze which incapacitates (traps) the object without any potential for reciprocal viewing. For in this linkage of voyeurism and motion pictures that renders all depictions of nudity as erotic, *seduction* is as an opposing force, one that requires nuanced consideration of context; in the case of Binder's title sequence, the voyeuristic designation that appears inevitable is complicated by the seduction shown in the relationship of lyrics to imagery. The voyeuristic aspects accruing to nudity are challenged, their meaning redirected via the title songs' lyrical content, undermining any reductive interpretation based *only* in the title sequences' imagery. The lyrics are central to the meaning of the sequence, established through the synchronization and synaesthetic effects produced by its counterpoint of lyric-to-shot, making the verbal content the true dominant, not the visual.

Title songs direct the apparent meaning and contents of title sequences: the synchronization of audio-visual materials is a second level of meanings to those already contained by and established through the purely visual devices of montage and composition, affirming Foucault's recognition of language dominating vision. This organization of meaning is typical of title designs employing what historian Solange Landau described as a variation on the "Mosaik-Intro" (Mosaic Intro), the "epic narrator": "cut-scenes" shown in the title sequence are accompanied by voice-over narrative or theme song that explains the premises of what the television program is about.[23] In Robert Schaeffer's design for the Hanna-Barbera mystery/comedy half-hour cartoon *Scooby-Doo, Where Are You!* (1969) (Figure 5.6), the song, written David Mook and Ben Raleigh and performed by Larry Marks and Paul Costello, overlays a montage of encounters with "apparently" supernatural forces the "meddling kids" flee—ghosts, aliens, robots, and other monsters. The song is linked to these shots only through the rhythmic montage; the lyrics do not align with the imagery. The informational dimension of this opening sequence—the voice actors and other animation credits do *not* appear in the opening title—are suppressed, allowing the montage to provide an explanation of the premise for the program, an approach shared by a range

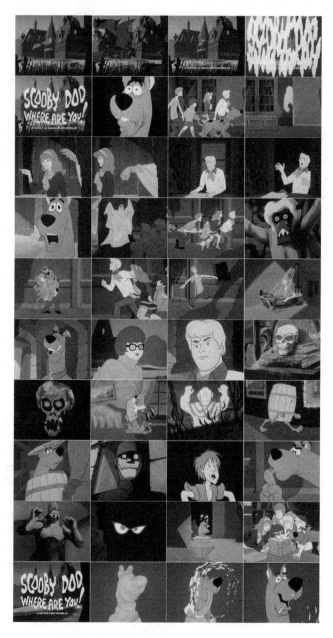

Figure 5.6 All the title cards in *Scooby-Doo, Where Are You!* (1969).

of other comedies from *The Flintstones* (1960) to *WKRP in Cincinnati* (1978). In both *Scooby-Doo, Where Are You!* and *The Flintstones*, narrative information is conveyed, not just in the song, but through the particular clips and their arrangement, while in *WKRP in Cincinnati*, the imagery for this opening is composed from shots of the city, while the actor-stars do not appear.

The theme song's main purpose is to explain the premise of the series: a group of meddling kids and their dog solve "supernatural" mysteries. These foes are all ultimately revealed to be mundane humans wearing costumes and rubber masks because *"there's no such thing as _____."* The cut scenes are arranged into a specifically rhythmic montage subordinated to the counterpoint of *actions::lyrics* that allows the dominance of language over image. Their coherence depends on the counterpoint *statements* made through rhythmic montage rather than the connection of associated lyrics to imagery. As is typical for television show openers using cut-scenes, every shot is drawn from some episode of this first season, offering a glimpse into future events while at the same time subordinating them to the informational demands imposed by the lyrics:

> Scooby-Dooby-Doo, where are you? [*aligned with the main title card*]
> We got some work to do now.
> Scooby-Dooby-Doo, where are you?
> We need some help from you now.[24]

Schaffer's design begins with the main title appearing as floating, ghostly letters stating "Scooby-Doo, Where Are You!" over a Queen Anne-style Victorian façade; there are no other title cards in the sequence. The main title card's appearance is synchronized with the same lyrics heard in the theme song, even though this theme song has no other existence *beyond* the television program as Ray Parker Jr.'s theme song for *Ghostbusters* or Carly Simon's theme for *The Spy Who Loved Me*, "Nobody Does It Better," do. Each individual episode's title appears as a still using a standard composition presented at the conclusion of the title sequence. However, even though there are no actor/voice credits on-screen after the main title, each shot has been selected to highlight particular characters—Fred, Daphne, Velma, Shaggy, or the dog, Scooby-Doo—in a series where they encounter "monsters" of various types. This structure is typical of television program openings that present a series of "cut scenes" that reveal dramatic moments for the various character/actors in the program. In the case of Schaefer's design, these isolated moments are also orchestrated in a vaguely narrative progression from the exterior

of a "spooky" house to a series of interior shots that culminate in an encounter with a stereotypical ghost that the "meddling kids" flee from, only to (literally) run into other terrors, identified by each episode's individual title card (Figure 5.7). These encounters are all drawn from the various episodes of the series; they act as an anticipatory exposition for the individual episodes' narratives where the "monster" is always a villain in a mask usually motivated by greed, but are not directly related to either the imagery being shown or the fragmentary narratives of encountering danger and the supernatural (a ghostly hand swiping at Daphne, a seated Fred falling backwards through a secret door behind him, all four meddling kids and the dog running away).

In contrast to the dislocations of lyrics and images in *Scooby-Doo, Where Are You!*, the 60-second theme song written and composed by Vic Mizzy for the "Mosaik-Intro" to *The Addams Family* (1964) combines *naturalistic* and *counterpoint synchronization* to create a design that is made from cut-scenes, but produces the affect of being an independent title sequence (Figure 5.8), much like the designs for *Gilligan's Island* (1964) and *The Beverly Hillbillies* (1962). All four of *The Addams Family's*

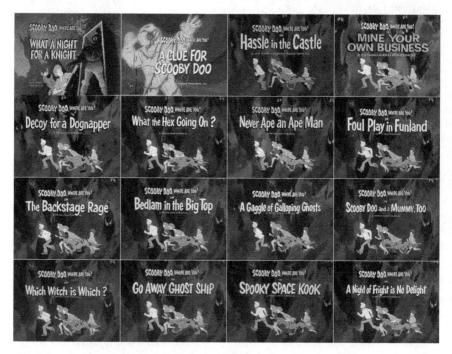

Figure 5.7 The first 16 episode title cards for *Scooby-Doo, Where Are You!* (1969–1970).

title cards employ the calligram mode: the first and second title cards repeat the same text, first as the main title, and then as an identifier for a 'family portrait.' The other two cards credit the only actors who are individually named: Carolyn Jones, who plays "Morticia" and John Astin, who plays "Gomez"; there are no other texts on-screen. Instead, the rest of the title sequence uses the lyrics from the theme song to explain who the "Addams Family" is.

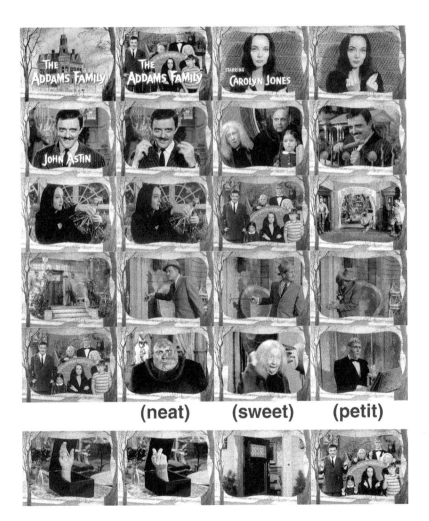

Figure 5.8 All the title cards in *The Addams Family* (1964).

The rhythmic montage in *The Addams Family*, unlike *Scooby-Doo, Where Are You!*, has not been designed to appear to be a series of cut-scenes, an affect created by two elements in this design: (1) around all the images in the title sequence is a mask that suggests an antique picture album where the exterior of the house is a mat around each photo; (2) part of this sequence is specifically shot for the titles—the actors snap their fingers to punctuate the harpsichord melody, and image that returns as a refrain placed in-between all the cut-scene shots that 'illustrate' the lyrics; however, the singing stops for three words/shots, each introduced with the harpsichord fanfare-leitmotif that runs throughout the theme song: *"neat, sweet, petit."* Each of these statements is contradicted by the accompanying image. In creating a contradiction between the voice-over and image, this design recalls the problematics that were the focus of Michel Foucault's discussion in *This Is Not a Pipe*, but with an essential difference. In *The Addams Family*, the contradiction emerges not between a text-label and its associated image, but between the voice-that-speaks and the synchronized object of that (apparent) discussion. The contradiction that "neat, sweet, petit" creates specifically requires the audience watching to object to the speaking voice, to challenge its dominance and imposed order. In making this objection (which can happen simply by laughing at the juxtaposition) the audience becomes aware that these labels are arbitrary, a social construction, and the nature of the program that follows these titles will also challenge these social conventions. The reversal of typical expectations for the "American" family—as well as the comic nature of these reversals—is apparent throughout the entire title sequence, but reaches its most dramatic demonstration through this momentary counterpoint of voice/image.

Title songs act as framing devices that instruct the audience about the *nature* of the drama and the significance for the visuals in the title sequence itself. The lyrics establish the appropriate boundaries for interpreting the images: what and how these isolated moments presented during the title sequence should be considered. Lyrics constrain the available interpretations in advance, directing the engagement towards specific meanings that may not be otherwise present in the visuals. This mutually supporting meaning is especially apparent in the counterpoint of song and montage appearing in Schaefer's design for *Scooby-Doo, Where Are You!* The fusion of audio-visual form is synthetic, suggesting and developing conceptual aspects of the title design independently of either soundtrack or visuals alone. The juxtapositions that create these additional meanings depend on the *un*real nature of the sequence—its suspension of dramatic realism to develop meaning using techniques normally absent from the realist drama. Because the illusion of "continuity" employed

in dramatic realism rarely applies to these designs, the independence of the title sequence is at the same time its guarantee of aesthetic consistency. Meaning developed in the self-contained formal unit of the title sequence allows it to comment and reflect upon the dramatic narrative without the necessity for an explicitly *linear* narrative in the title design itself, coherence emerges in the "epic Mosaik-Intro" from the support provided by the dominance of language in defining *how* to understand the images shown.

Narrated Montages

Musical lyrics and voice-over narration constrain the understanding of the images in similar ways: the distinction between them comes from the ambiguities developing around lyric music that do not apply to voice-over. Montage is central to this presentation, but its meaning is prescribed by the limits imposed through the narration. The editing of motion pictures—montage—has been a major part of film theories throughout the history of cinema; however, the range of theories created to describe these effects, while they all differ in both degree of detail and conception of their medium, do converge on a single idea: that the juxtaposition of imagery via editing could create meanings not present when the shots were considered in isolation. Concern with these relationships was a focus of heuristic film theories of the 1920s and 1930s as synchronous sound recording emerged technologically. These title sequences function as both credit listing and preamble to the narrative using the same combination of voice-over and cut-scenes common to Landau's epic "Mosaik-Intro" (Mosaic Intro) in television title designs; whether the "epic" explanation of past events is provided by song or narration, the effect is the same.

Television title sequences have employed a narrative voice-over to explain and present a prologue since the earliest commercial broadcasts in United States in the 1940s. The need for a narrative explanation for programs whose premise or backstory is not immediately apparent, such as science-fiction and horror programs like *The Twilight Zone* (1959, 1985), *The Outer Limits* (1963, 1995), or *The Incredible Hulk* (1978), makes these programs of particular interest when considering the synchronization of sound-text-image. The DuMont children's program *Captain Video* (1949)[25] is typical of the structure of these narrations (Figure 5.9). This early design does not correspond to any of Landau's typologies: there is only one image in the entire sequence, combined with two superimposed title cards. The visuals are highly restricted technologically by the need to perform them live and the primitive state of television broadcasting.

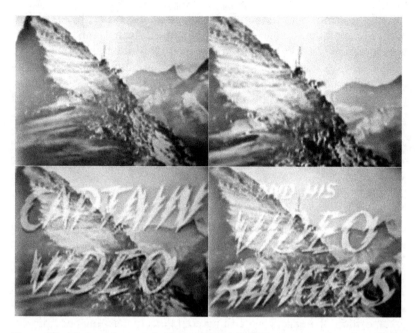

Figure 5.9 All the title cards in *Captain Video* (1949).

Announcer Fred Scott's narration[26] overlays this superimposed text-still composite, accompanied by a trumpet fanfare, explaining the premise of the program:

> Captain Video! Captain Video! Electronic Wizard! Master of Time and Space! Guardian of the Safety of the World! Fighting for law and order Captain Video operates from a mountain retreat with secret agents at all points of the globe. Possessing scientific secrets and scientific weapons, Captain Video asks no quarter, and gives none to the forces of evil. Stand by for *Captain Video and his Video Rangers*!

The affect of this combination of voice-over and visuals in *Captain Video* closely resembles a radio program that includes pictures; however, there is a rudimentary level of synchronization between the narration and the imagery: a still image of a tower stands on a mountain plateau—as the narration continues, the shot zooms in on this picture, stopping at the conclusion, as the narrator says "Captain Video and his Video Rangers!" The superimposed title cards appear synchronized with the narrator saying

the words: the text CAPTAIN VIDEO folds down, revealing the next card AND HIS VIDEO RANGERS in the same lightning-bolt typeface. This clear association of the narration with the title card text demonstrates that this sequence, primitive as it is, still retains an awareness of how the audio-visual construct *statements* of connection through the synchronization of sound::image. It is not marked different than the presentation of narration-text in *The Big Broadcast of 1937*.

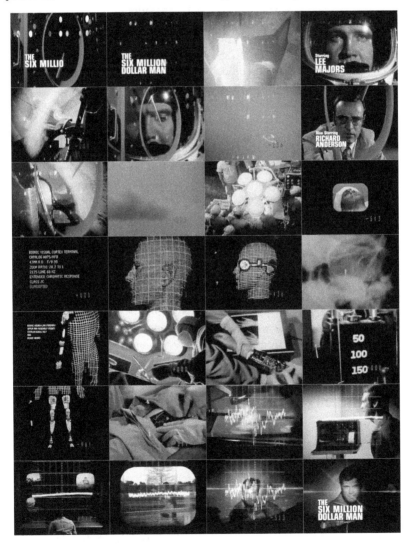

Figure 5.10 All the title cards in *The Six Million Dollar Man* (1974).

The synchronization of voice-over with imagery in Jack Cole's title design for the television program *The Six Million Dollar Man* (1974) (Figure 5.10) develops the synchronization evident in *Captain Video*. Cole's design transforms the historical documentary footage of the May 10, 1967 crash of the Northrop M2-F2 that nearly killed test pilot Bruce Peterson, and flights made by the HL-10 (the next generation lifting body aircraft that replaced it and was visually almost identical), combined with staged scenes to create a narrative introduction for the television program.[27] This title sequence is 90 seconds long, organized into three distinct sections: the accident, the surgery, and the recovery. The voice-over narration presents the program's backstory in encapsulated form: everything needed to understand the premise of "bionics" (cybernetics) and the scope of this fictional word is contained in this show opener.

The titles condense a complex backstory into a 90-second opening broken into three overlapping, equal-sized sections: the accident, the operation, the new man. Each part has its own dominant audible and visual character that build to a climax at the conclusion of the title. Each section tells a distinct part of the origin story for "Steve Austin." This narrative content is the most important part of the design, conveyed through a collection of direct synchronization and counterpoint voice-over organized into *statements* by the background music. The prologue this opening creates through the combination of narration and montage tells the 'origin story' for "Steve Austin" (Lee Majors), explaining how he became a cyborg as a result of an aerospace test flight accident. The organization is specifically counterpoint synchronization: while functioning as a "show-and-tell," the relationship between the images and the narrative is highly abstract, requiring the audience to recognize/invent the links between voice-over and imagery.

The 90-second opening begins with a composite of the show title typing out on-screen, each letter accompanied by a clicking sound of keys being pressed while blocks of light progress in abstract lines suggesting 1970s-era computers in action. As the sequence continues, compositing a radar sweep moving in a circle paired with kettle drums and voices that sound like they are coming through the radio—saying scientistic things such as "Touchdown at NASA-ONE"—while the music and voices are not definitively synchronized with the images, the keystroke-typography connection establishes their direct linkage before either element appears. A voice says "We have separation," accompanied by a hissing sound of wind shear as a flat aircraft moves down, dropping away. The compositing never entirely stops throughout the sequence, fusing the stock footage of the NASA/USAF test flights for the M2-F2 and HL-10 planes with other materials prepared for the title sequence,

including footage of Lee Majors dressed as the pilot and seated in the real HL-10 cockpit.

This visual change from compositing to live action is matched by the direct synchronization of the voice-over and the narrative action shown through the montage. Each shot acts as a precise summary of key narrative information: there was a test flight, something went wrong, there was a crash, the pilot was severely injured, and healed using high technology that made him into a super-human cyborg. This prologue is dramatized through an audio montage of the pilot's narrative telemetry, sound effects, and footage of the *real* M2-F2 crash landing (including over the shoulder footage as the pilot Bruce Peterson brings the plane down). Through the combination of stock footage, audio montage, and careful editing, the first 30 seconds form a *statement* about the factual 'accuracy' of the science-fictional narrative that dominates the next 60 seconds in the titles. The voice-over begins with the M2-F2 crash landing and continues throughout the rest of the sequence:

> Steven Austin, astronaut, a man barely alive.
> Gentlemen, we can rebuild him. We have the technology. We have the capability to make the world's first bionic man. Steve Austin will be that man.
> Better than he was before.
> Better, stronger, faster.

The same show-and-tell approach continues, but with a key difference: instead of using stock footage, the images are cut-scenes from the show itself, close-ups of props that look like advanced technology. A shot of a computer readout (again accompanied by the sound of a computer teletype and the squeal of a low-baud phone modem) then continues without interruption with the statement, "Gentlemen, we can rebuild him. . . ." With the voice-over statement "Better, stronger, faster," the music shifts to accompany a montage of "Steve Austin" (Lee Majors) running on a treadmill, across a field while being watched on a series of TV monitors in a control room, and then along the side of the road. The music crescendos during this 30-second finale, culminating in a fanfare for the main title at the end of the sequence as "Steve Austin" runs towards the camera in slow motion while shots of scenery flash at high speed around him, suggesting he is traveling at inhumanly great speed.

Narration is central to the structure and organization of this design, performing the same informational role as the theme songs in both *Scooby-Doo, Where Are You!* and *The Addams Family* titles. Without this

narration, what is happening becomes much less clear, but not entirely uncertain, as the stills (Figure 5.9) from Cole's design clearly demonstrate: it is the level of specific detail the narration provides that makes the voice-over more than just an appendage to the imagery, even though its *narrative* functions are redundant with the narrative character of the montage. This narrative is *visual*, enhanced and expanded by the voice-over that makes the story implied in the pictures an explicit part of the design.

The formal organization of the titles as a montage synchronized by/ through either voice-over or theme song is a common feature of title sequences designed for television programs since the 1950s; the distinctions between an early program such as DuMont's *Captain Video* (1949–1955) and Jack Cole's design for *The Six Million Dollar Man* are specifically aesthetic—the role of voice-over as the material organizer for the sequence remains constant. There is only marginal similarity of these designs to the occasional use of narration in feature film title sequences—*The Big Broadcast of 1937* is an exception that reveals the historical continuity between radio program's use of narration and its use in television: the narration in this film title appears there as a reference to the setting of the show (a radio station) rather than as the formal design choice commonly employed in television title sequences.

Figure 5.11 Selected stills from the title sequence to *Blade II* (2002).

The 90-second opening to the feature film *Blade II* (2002) designed by Kyle Cooper (Figure 5.11) does not resemble the title sequences of feature films; its use of narration to organize a series of illustrative images more closely resembles the structure of television show openers for programs such as *The Six Million Dollar Man*. His design for *Blade II* is a translation of Landau's (epic) "Mosaik-Intro." This title sequence presents an edited montage that retells the narrative from first film, *Blade* (1998), as a "highlights reel" that illustrates the various lines of narration in exactly the same way that the combination of voice-over and cut-scenes would in a television program. This shift from television to feature film is not unprecedented—Cooper's design for *Mission Impossible* (1996) directly adapts the opening from the 1964 TV program. His designs have actively engaged in conforming the approaches used to design feature film titles to the standards developed/produced in/for other media, such as television programs and video games.

Unlike the re-presentation of the entire narrative (in sequence) from the 1978 *Superman* in Richard Greenberg's design for the film *Superman II* (that also lacks a voice-over narration), *Blade II* is not a direct retelling of the earlier film, but follows Wesley Snipes' voice-over as a television opener would, drawing appropriate shots from *Blade* to match/illustrate the words. As in *The Six Million Dollar Man,* this sequence tells the backstory to the narrative in a prologue. The titles change the exposition in the first *Blade* film into a short, summary sequence. The result has the same effect as in Greenberg's design for *Superman II* (1980)—the important details of the first film are re-presented, making that film entirely redundant to the second. The accompanying narration by "Blade" (Wesley Snipes) employs the same show-and-tell approach used for television openers to synchronize images with both narrative theme songs and voice-over narration. The voice-over is illustrated by the images, while the music adds flourishes in-between its declarations, affirming the dominance of language over vision and hearing:

Forget what you think you know.
Vampires exist.
My name . . . is Blade. I was born half-human, half-vampire. They call me the "Daywalker."
I have all their strengths, none of their weaknesses. 'Cept for the thirst. Twenty years ago I met a man that changed that. Whistler. Taught me how to hold the thirst at bay, taught me the rules, gave me the weapons to hunt with: silver, garlic, sunlight.
Two years ago he was attacked. They took him and turned him into the thing I hate the most. I should have finished him off, now I'm hunting him. I will find him, and nothing will stand in my way.

The narration breaks the sequence into distinct sections based on the content: the "gaps" in the narration show silver bullets being cast, sharpening weapons, getting dressed to go hunting. These images glide across the screen right-to-left—the result is a continuous pan from the left—producing a highly kinetic effect, even for relatively static individual shots. This directional motion matches the direction that English reads, a reminder of the lexical dominance over vision. The text for the credits wipes-and-fades on left-to-right, further reinforcing the lexical dimension of this "pan." Each part of this narrative is paired with appropriate shots (in desaturated color) that align with its contents: when "Blade" (Snipes) talks about his birth, those shots appear on-screen.

The music, composed from a highly rhythmic, repeating series of low-key fanfares is not synchronized. Neither the background images nor the composited title card texts align with the music, forcing attention away from the rhythmic aspects of the sound to the relationship of voice-over to cut-scenes. This structure results in the design creating the effect of show-and-tell as its primary *statement*: the opening is about the relationship of narration to cut-scenes. Their clear distinction from the rest of the footage through a combination of tonal reversals (that look like film negatives) and desaturated color (except for red, which remains bright, but muted) allow these shots to signify "memory" or "past," in contrast with the full-color shots. Each shift between negative and positive marks the start and end of these "flashback" sub-sequences. The flashback narrative that begins with Snipes saying "Whistler" is directly synchronized with a full-color hand picking up a metal block to reveal a photocopied photograph showing "Whistler" (Kris Kristofferson). Again the cut-scenes are drawn from the first film, illustrating Whistler catching Blade and holding him in the sunlight while looking at his vampire fangs. The sequence ends with a return to full-color images. As the title develops, this distinction between 'flashback' and 'present' is specifically defined by the "now I'm hunting him" narrative which synchronizes shots of a curved knife with "weapons to hunt with."

As an example of Landau's (epic) "Mosaik-Intro" the design for *Blade II* is entirely typical, concluding with a kinetic logo graphic, much like the (epic) "Mosaik-Intro" used for season two of the television program *Castle* (2010) that follows a similar progression of introductory narration concluding with kinetic logo reveal. But *Blade II* is innovative: it transposes a design approach from television to feature films, blurring the distinction between them; in the process it reveals a uniformity of narrated designs between what historically have been antithetical media. In designing this title to match the same aesthetic and formal organization of a television program, Cooper has demonstrated the consistency of the

semiotic organization of title designs employing narrated montages. The synchronized *statement* that results from this construction prioritizes the lexical order over the tradition of "visual music," an instance of the language-vision-hearing hierarchy operating at all levels of the design, even the direction of the 'pan' through the various images that form the montage.

The differences between the title song and the narrated montage lie with the role of music in the construction of the title sequence. The synchronization of music-image informs the structure and emergence of the *statement*, linking the song to the organization of the sequence as a whole. The rhythmic montage apparent in *The Spy Who Loved Me, Scooby-Doo, Where Are You!* and *The Addams Family* unites their approach to music in the same way that the dominance of narration over both music and image in the designs for *Blade II, Captain Video,* and *The Six Million Dollar Man* renders the associated theme music as an asynchronized accompaniment whose function is simply to mark the distinction between title sequence and narrative (the standard, most basic role for music during a title sequence). The consistency of synchronization in these designs, no matter what medium they have been produced for, allows the recognition of the semiotics informing these *statements* as an independent structure, not connected to particular media, but rather a common form shared by motion pictures generally.

Notes

1 Betancourt, M. *Semiotics and Title Sequences: Text-Image Composites in Motion Graphics* (New York: Routledge Focus, 2017), pp. 52–74.
2 Foucault, M. *This Is Not a Pipe* (Berkeley: University of California Press, 1982), p. 21.
3 Foucault, M. *This Is Not a Pipe* (Berkeley: University of California Press, 1982), p. 25.
4 Green, J. "Understanding the Score: Film Music Communicating to and Influencing the Audience." *The Journal of Aesthetic Education,* Vol. 44, No. 4 (Winter 2010), pp. 81–94.
5 Winkler, M. "The Origin of Film Music." *Films in Review,* Vol. 11, No. 10 (December 1951), pp. 34–42.
6 Brown, R. "How Not to Think Film Music." *Music and the Moving Image,* Vol. 1, No. 1 (Spring 2008), p. 3.
7 Tarasti, E. *A Theory of Musical Semiotics* (Bloomington: Indiana University Press, 1994), pp. 16–58.
8 Eyman, S. *The Speed of Sound* (New York: Simon & Schuster, 1997), p. 204.
9 Prendergast, R. *Film Music: A Neglected Art, Second Edition* (New York: Norton, 1993), p. 25.
10 Genette, G. *Paratexts: Thresholds of Interpretation* (New York: Cambridge University Press, 2001), pp. 4–7.

11 Lapedis, H. "Popping the Question: The Function and Effect of Popular Music in Cinema." *Popular Music,* Vol. 18, No. 3 (Oct. 1999), pp. 368–370.
12 Lapedis, H. "Popping the Question: The Function and Effect of Popular Music in Cinema." *Popular Music,* Vol. 18, No. 3 (Oct. 1999), pp. 367–379.
13 Betancourt, M. *Beyond Spatial Montage* (New York: Focal Press, 2016), pp. 98–104.
14 Woollacott, J. "The James Bond Films: Conditions of Production." *The James Bond Phenomenon: A Critical Reader,* edited by C. Lindner (Manchester: Manchester University Press, 2003), pp. 99–117.
15 Mulvey, L. "Visual Pleasure and Narrative Cinema." *Film Theory and Criticism: Introductory Readings,* edited by L. Braudy and M. Cohen (New York: Oxford University Press, 1999), p. 837.
16 Woollacott, J. "The James Bond Films: Conditions of Production." *The James Bond Phenomenon: A Critical Reader,* edited by C. Lindner (Manchester: Manchester University Press, 2003), p. 110.
17 Bennett, T. and Woollacott, J. *Bond and Beyond: The Political Career of a Popular Hero* (New York: Palgrave Macmillan, 1987).
18 "Nobody Does It Better" lyrics written by Carole Bayer Sager, Sony/ATV Music Publishing LLC, 1977.
19 Baudrillard, J. *Seduction* (New York: St. Martin's Press, 1990), p. 103.
20 Lyotard, J. *The Postmodern Condition: A Report on Knowledge* (Minneapolis: University of Minnesota Press, 1993), p. 61.
21 Baudrillard, J. *Seduction* (New York: St. Martin's Press, 1990), pp. 21–22.
22 Clark, K. *The Nude: A Study in Ideal Form* (Princeton: Bollinger, 1972), p. 3.
23 Landau, S. "Das Intro als eigenständige Erzählform. Eine Typologie." *Journal of Serial Narration on Television,* Vol. 1, No. 1 (Spring 2013), pp. 35–36.
24 "Scooby-Doo, Where Are You!" lyrics written by David Mook and Ben Raleigh, copyright Warner/Chappell Music, Inc. 1969.
25 Weinstein, D. *The Forgotten Network: DuMont and the Birth of American Television* (Philadelphia: Temple University Press, 2004), pp. 69–92.
26 Weinstein, D. *The Forgotten Network: DuMont and the Birth of American Television* (Philadelphia: Temple University Press, 2004), p. 70.
27 Perkins, W. "*The Six Million Dollar Man* (1974)." *Art of the Title Sequence,* posted September 16, 2014, retrieved December 12, 2016. http://www.artofthetitle.com/title/the-six-million-dollar-man.

6 Conclusions

The *Statement* of Synchronization

Audience interpretations of motion pictures depend on the syntactic organization provided by past experiences with synchronization. The two variables that define this audio-visual syntax are *what* provides the sync-point, and *when* that sync-point occurs in relation to earlier/later sync-points in both sound and image tracks (Figure 6.1). Direct and counterpoint synchronization are distinguished by the variable proximity and distance between visual sync-points of motion on-screen, duration of the shot/music, chiaroscuro dynamics within the frame (or a combination of all three), correlated with audible sync-points, the most basic being the appearance of a sound (as in the 'lip-sync' of direct synchronization). The others used in counterpoint synchronization all emerge from the soundtrack over time, rather than being an immediately apparent connection: the beat, musical phrasing, and/or instrumental performance. These emergent, audible sync-points connect with the same set of visual sync-points, enabling the audience to identify the *statement* of counterpoint as part of a continuum of synchronized links of sound::image that orients the soundtrack and the visuals.

This framework demonstrates the entangled and overlapping connections between the varieties of direct synchronization and the higher-level interpretations emerging as counterpoint synchronization. It describes all the various approaches to "visual music" employed historically in abstract films of all types; the shift away from direct synchronization (with its resemblance to 'lip-sync') and towards less immediate connections of counterpoint. The assignment of particular animated forms to match particular instruments in Len Lye's 1935 film *A Colour Box* comes as an antithetical, but equally recognizable, *statement* to any direct synchronization. Anything that appears on-screen potentially offers a sync-point: variable motion

SYNCHRONIZATION OF SOUND::IMAGE

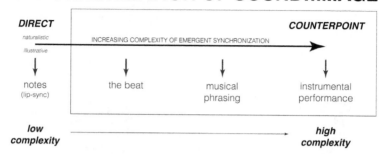

Figure 6.1 The range of sync points formally distinguishes direct (*naturalistic and illustrative*) from counterpoint synchronization, a reflection of the syntactic function the *statements* created by synchronization have for interpreting motion pictures.

of elements (or within them), the appearance/disappearance of forms, and the 'cut' where the entire image changes. The motion of elements includes any motion, even stationary (rotation, pulsation, vibration, and color changes, as well as animorphs). What is significant about these transformations is that the audience must recognize them as changing—provided the audience recognizes the change, that element can be used as a sync-point.

What is typically called "visual music" is only synchronization at the lowest level of audio-visual structuring (*illustrative synchronization*). The sync-points used for this proximate connection between individual notes and accompanying visual elements within the image allow for a range of associations between a sound and a form (motion, chiaroscuro [color], appearance/disappearance).[1] The distinctions between direct and counterpoint are entirely dependent on *when* the sync-point appears: proximity and distance differentiate between counterpoint and direct synchronization. Counterpoint's reliance on the emergent connections apparent in the development over time renders its formal character fundamentally different from direct synchronization. The immediacy of a form synchronized to a note heard creates the illustrative linkages common to visual music films, but this directness of connection is only part of the range described in Figure 6.1—as the distance (in time) between sync-points increases, the shift from direct to counterpoint synchronization happens. The appearance of direct synchronization and counterpoint within the same work is not unusual. The distance between a note as sync-point and the beat, measure, or melodic phrase is simply a matter of degree, rather

than an absolute distinction; only the apperception of synchronization creates the illusion of their radical difference.

Synchronization renders the audible subservient to the visual, reflecting the hierarchy of language-vision-hearing described by Michel Foucault's discussion of the gaze as an ordering approach to the world. Because motion pictures have a phenomenal basis that employs the same senses we use to understand the world, our interpretations of motion pictures inevitably employ these same frameworks to understand their constructed artifice. The experiential overlap in interpretations allows the audience to glean the basic knowledge required for making the identifications of synchronization—the structural link created by identifying sound and image as forming a *statement*—in and from their encounter with the film itself, giving all associations of sound::image an immediacy that hides their arbitrary nature. The *statement* created by perceived synchronization occupies a position of great importance in relation to interpretation, since the indivisibility of the interpretation from its subject shows the movement of interpretation is from 'lower' to 'higher.' These distinctions are important for what they suggest about the typical understanding of perception-as-semiosis, as semiotician Umberto Eco noted in his book *Kant and the Platypus*:

> if we accept that even perception is a semiosis phenomenon, discriminating between perception and signification gets a little tricky. . . . We speak of perceptual semiosis not when *something stands for something else* but when from something, by an inferential process, we come to pronounce a perceptual judgment *on that same something* and not on anything else. . . . The fact that a perception may be successful precisely because we are guided by the notion that the phenomenon is hypothetically understood as a sign . . . does not eliminate the problem of how we perceive it.[2]

Understanding perception-as-semiosis conceptualizes the interpretative process in a series of conscious decisions (often made semi-autonomously) about what in perception has value and needs to be attended to—an action anterior to linguistic engagement, as semiotician Christian Metz's theory of "aural objects" demonstrates, the attachment of a name to the sound is a semiotic procedure dependent on the audience's "past experience" that is parallel to, but independent of, the relationships that comprise the identification of the apparently immanent link that is *synchronization*. Foucault's identification of the *statement* as the fundamental unit of enunciation (i.e., the vehicle for semiosis) develops on these related, but independent levels within the title sequence: first as the synchronization of sound::image, emergent in

its organization over time; then, at a higher level of interpretation, as the title sequence itself—its comprehension as pseudo-independent enables the identification of titles as a distinct component within the film. This foundational interpretation is an identification that exceeds mere simultaneous sensory encounter: it forms these encounters into *statements* that then build into the more familiar and elaborate networks of relationship, indexicality, and narrative. The same *already-cultural* foundation that defines "music" for Levi-Strauss applies to the synchronization of sound::image: as a meaningful structure, synchronization is therefore dependent on the recognition/ invocation of the same interpretative expertise that establishes meaning for other types of semiosis. In making the identification of the 'title sequence' in a particular grouping of these statements, the centrality of synchronization for the unity and punctuation in many of these designs becomes obvious: the alignments of sound::image::text that compose the title design are definitive not just of its formal character, but instrumental in the identification of signification within those arrangements. 'Cinematic form' does not depend on isolated signs, but rather emerges from the audience's conventional interpretations centered around these *statements* and their development into sequences.

These shifting levels of interpretation are a function of how the *statement* structures and organizes the otherwise disparate phenomenal encounters with sound and image. Their mere presentational simultaneity is not enough to guarantee their comprehension as meaningfully correlated, synchronized statements. Transformation happens at different levels of complexity and immediacy in the title sequence, reflecting the role of audience interpretation through the language-vision-hearing hierarchy as a constraint on the identification and conception of the whole.

The Immanence of Ideology

Synchronization implicitly expresses an ideological conception of reality through its apparent resemblance to our everyday experiences: it renders whatever appears on-screen as a 'neutral' fact. The apparently autonomous connection of sound::image::text in both varieties of direct synchronization, *naturalistic* and *illustrative,* acts as a demonstration that transfigures underlying ideo-cultural belief into immanence. Realist construction descends from *naturalistic synchronization.* This recreation of the appearance of everyday life (re)produces the phenomenal world as it appears to our senses; the realism created seems to lack articulation and construction, instead offering itself as an *artifact,* similar to the idea of the "trace" or "footprint" that define the photographic image

for theorists such as André Bazin or Stanley Cavell. The experiences of everyday life are the foundational reference point for all varieties of synchronization, but the two direct varieties explicitly create claims about the "true" nature of the world—whatever that might mean—at its most basic the immediate construction of "reality" through formal *statements* of audio-visual linkage, of voice to an image of someone speaking, creates the *statement* that the voice heard belongs to the person speaking; 'lip-sync' is the underlying formal relationship for all *statements* emergent in synchronization and their superficially autonomous realism.

Naturalism, foundational to the realism of commercial cinema, presents a direct association of sound::image that is essential to the emotional impact in Lardani's design for the Western *For a Few Dollars More* (1965) (Figure 6.2). The combination of long take, theme music, and direct synchronization makes the immediacy of connection between the gunshots and the 'responses' by the typography appear entirely natural. This three-minute sequence begins with a distant rider gradually coming closer, while on the soundtrack, someone is whistling, then they load a rifle. It is unclear *where* this sound comes from; only faint wisps of smoke drifting in front of the camera imply an off-screen presence. The entire title sequence is a long take; what the audience *waits* for is this distant rider to approach. Once the rider comes in range, the unseen whistler shoots them, another wisp of smoke drifting across the shot—the view is placed to approximate this sniper's point-of-view on

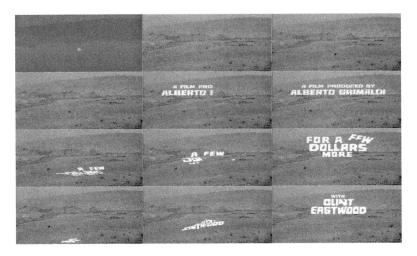

Figure 6.2 Selected stills from the title sequence to *For a Few Dollars More* (1965).

the landscape below. A moment later, as the music starts, the titles begin flowing over the landscape like the shadows of clouds, their connection to the live action background an apparently integral part of the design. As they approach the top of the screen, the text "pops" up, like in an arcade game where players shoot at small targets (the titles) to win prizes: each title card exits when it has been "hit" by the same marksman who can be heard, but not seen, as the sequence starts. The initial live action moment's apparent use of *naturalistic synchronization* renders the connections of gunshot to title card an apparently autonomous linkage, even though it is *illustrative synchronization*. The realism of both *statements* is related to the same apparently direct action-effect shown in the typography; however, what is particularly notable about this design is the artificiality of these associations—the film is a "spaghetti western": all the sounds are Foley performances, added in post-production. The construction of direct synchronization in this title hides this fabricated nature through its proximate associations with the imagetrack that create these *statements*.

Direct synchronization fabricates the immanent connection of sound::image. Where *naturalistic synchronization* creates the appearance of everyday reality, *illustrative synchronization* constructs its relationships as a demonstration of ideo-cultural beliefs about the way the world really *is*, rather to offer an approximation of how the world appears. In place of invoking everyday sensory experience, the realism of *illustrative synchronization* creates a phenomenal encounter—but it is one that only resembles the familiar appearance of the world—the link of gunshot to reaction on-screen is clearly an invention particular to the title sequence no matter how much it seems recognizable. These effects are even more essential for documentary productions than they are in fiction films. In designing the sound::image relationship, direct synchronization creates *statements* about both the observable world of "surface reality" and the "true reality" of the world that is normally hidden from our senses.

These different conceptions of "realism" unite in direct synchronization as the immediately understood association of image and sound. In persuading its audience of the inherent link, the realism becomes that much more secure in its organization of the materials on-screen. Synchronization renders the realist ideologies employed in its construction as an apparently material feature of the work, unquestionable and beyond challenge. This unity makes the title sequence into a singular component within the larger drama, even when it presents essential narrative events and is otherwise integrated into that story. Understanding realism-as-ideology derives implicitly from the particulars of *which* depictions compose the "mere appearances" as with

the choices of sounds to present in *naturalistic synchronization,* but it becomes explicit through the organizational role it plays in *illustrative synchronization,* and the determinate function it has in constructing and rearranging those appearances to create *counterpoint synchronization.*

Once the *statement* of synchronization moves away from the literal connections of naturalistic synchronizations such as 'lip-sync,' the model that informs the production shifts away from a reproduction of the "mere" appearances of the world to a revelation of its unseen organization. The "visual musical" interpretation and organization common to the title sequence makes this ideological content both immanent and unacknowledged. Its invisibility as an ideological construct (apparent even in Eisenstein's references to it in his chromo-phonic montage) originates with its ancient, even foundational role in European culture. Recognizing it as artificial demystifies this belief, enabling its consideration as an ideology that informs the conception and organization of these *statements* in motion graphics.

Illustrative synchronization and *counterpoint* both depend on higher-level recognitions of ideo-cultural belief in their organization; the difference between them demonstrates their different modes of *statement*—as immanent encounter versus emergent organization. The meaning each develops reflects the same complexities of their production. The ubiquity and transparency of the connections created by the illustrative synchronization, no less than the emergent counterpoint, makes the determinant role of ideology in synchronization an implicit meaning for title sequences. In demonstrating an unseen order in the world, these *statements* affirm the ideo-cultural beliefs that are shown by and through the synchronization itself. Their status as ideology follows precisely from their *real*ization of that ideology as the formal, phenomenal encounter itself.

Counterpoint approaches to synchronization depend on this ideological relationship, rather than the proximate (direct) identification of an immanent linkage. The emergent synchronization is a higher-level interpretation about the structure and meaning of the title sequence as a whole, subsuming any lower-level direct synchronizations. The parallels between the identification of a series of sounds as belonging to the domain of music and the identification of a title sequence as counterpoint synchronization both depend on the same references to past experience and established expertise. Much like the identification "music," counterpoint synchronization has a cultural foundation that appears as a natural organization of its materials (it is a *statement* of synchronous relationship). As with *illustrative synchronization,* the results are demonstrative

of an unseen order to the world—a variety of realism that reveals this "true reality."

The Role of Music and Theme Songs

Synchronization dominates intertextual media (such as pre-existing popular music and theme songs) by linking their promotional role for the motion picture with the actual production. The 'theme song' written specifically for, and used in, the title sequence removed the need to otherwise include it in the production, thus avoiding the stoppage of narrative action for the song's performance. However, the use of these songs *beyond* and outside of their context *in* the motion picture presents specific problems for their use, issues that become more apparent in the case of pre-existing music repurposed in a motion picture design: intertextuality challenges the conventional paratextual status of the title sequence by shifting audience interpretation from the immediacy of the title sequence to what is evoked in the quotation of absent referents, undermining the link of opening-narrative by directing attention outwards. The commonplace practice of aligning the lyrics containing the film's title with their appearance on-screen in the main title card is an attempt to address the intertextual opening of the title sequence to other influences that are not a direct part of the film narrative.

Popular music theme songs function in a way analogous to the use of established music *not* written for the film: they have an existence independent from their role in the film, making their presence always potentially an intertextual encounter for the audience that evokes emotions and meanings separate from whatever appears on-screen: the independence and familiarity of the music challenge its incorporation into the title sequence, leaving an excess that remains apart from the 'film as a whole.'

The duplicity of the theme song created by synchronizing the lyrics containing the film's title with the main title card creates a subservience of image to sound that reveals that reading dominates seeing: the hierarchy Foucault's theory proposes is explicitly a progression down from the dominant *language* to *vision* then *hearing*. The semiotic process invoked as human voices shift from being a simultaneously audio-visual linkage of voice to subject into a counterpoint created by sung lyrics or voice-over, the distinct narrative phases of musical composition—*inchoative* (beginning), *durative* (middle), and *terminative* (end)[3]—establish the hierarchy of visual-over-audio through the *statement* that defers to the visual. Synchronization entails a shift from a musically encoded conclusion to the audible sequence to a visual one

where the various sync-points used to create the *statement* also defines its scope.

Lyrics and voice-over narration constrain the title sequence's signification; they also provide an essential redirection of the apparent meaning and contents of the shots themselves. The direct show-and-tell synchronization of voice/lyrics with image places the images in the same 'labeling' role as the text in a calligram: the image becomes a depiction of what the connotative statement of language claims. In those rare cases that construct juxtaposed meanings *between* lyric and image—as when the image 'disproves' the linguistic—the apparent rupture still introduces a specifically lexical dimension into the interpretation of the images, one that affirms the dominance of language over vision.

The synchronization of audio-visual elements does not diminish this ordering role for sight, it demonstrates it by making the audible see-able: by turning, through synchronization, the audible realm into a subordinate visuality. The suppression or suspension of sight in a motion picture does not eliminate its dominance; a film without pictures does not become "radio"—the meaning and form assumed in constructing audio-visual *statements* is always one that prioritizes and demands the visual as demonstrative accompaniment, even when (as in Dan Perri's design for *All the President's Men*) the synchronized visuals are elided or highly reduced. In denying the visual, the blackened screen becomes that much more important; the images that do appear become more powerful limitations on the audible. The semiotic function of synchronization is always organized by and through its relationship to *what* appears in the visuals: these statements always descend through the same encultured hierarchy of *language—image—sound* that the audience uses in creating meaning.

The *statement* that synchronization enables for title sequences, motion graphics, and all motion pictures is specifically grammatical in nature: it unites and separates the continuous flow of imagery into discrete units that can then be considered in relation to one another. This formal organization only emerges through the parsing of the whole by an audience familiar and experienced with the interpretation of motion picture narratives. The specific segmentation that identifies the pseudo-independence of the title sequence uses the same lexical expertise that allows the recognition of visual narratives without the intervention of narration. The addition of language—via title songs or voice-over narration—to these designs anchors the abstracting character of sound::image to the connotative overdetermination of lexia, whether sung, spoken, or written. Initial interpretations created by

synchronization enable higher-level meanings to emerge, including the identification of a title sequence as being separate (or integrated) to the narrative that follows, in the process disguising the ideo-cultural foundations of that work as an obvious, necessary visuality that appears entirely natural, unquestionable.

Notes

1 Collopy, F. "Color, Form, and Motion: Dimensions of a Musical Art of Light." *Leonardo,* Vol. 33, No. 5 (2000), pp. 355–360.
2 Eco, U. *Kant and the Platypus* (New York: Harvest Books, 2000), pp. 125–126.
3 Tarasti, E. *A Theory of Musical Semiotics* (Bloomington: Indiana University Press, 1994), pp. 16–58.

Index

A Colour Box 129
Abbott and Costello Meet Frankenstein 100
absolute films 60
Addams Family, The 116–19, 123, 127
Adventures of Baron Munchausen, The 42–4
Afra, Kia 76–7
Alexander Nevsky 77–8
All the President's Men 63–7, 137–8
Altman, Rick 2–3
Antheil, George 60
Arabesque 70–2
Archaeology of Knowledge, The 27–8, 95
Art in Cinema 82
Astin, John 117
Attali, Jacques 4, 7, 18–19
aural objects 14–17, 31, 59, 75, 131–2
avant-garde: in art 1–4; film 2–3, 11–12, 60, 79–80, 91, 93; and visual music 49–50

Baret, Julien 87
Bass, Saul 8, 10–12, 49, 61–2, 86–7, 92, 101
Baudrillard, Jean 110–13
Bazin, André 15, 24–5, 33–4, 37, 41, 132–3
Beat the Devil 39–41
Belle de Jour 32–6, 41
Ben at the Beeb 70–1
Bennett, Tony 108
Bernstein, Carl 65; *see also All the President's Men*
Besant, Anne 51–2

Beverly Hillbillies, The 116
Big Broadcast of 1937, The 63, 95–8, 104, 121, 124
Big Chill, The 37–9, 41
Binder, Maurice 10, 11, 61, 70–2, 104–13
Birth of the Clinic, The 80–1
Blade 125
Blade II 124–7
Bleus de Ramville, Les 70, 79–81, 84
Bold Ones, The 62–3
Bolton, John 2
"Bond girl" 107–8; *see also* James Bond films
Bond, Jay 79–81
Boyd, Rutherford 83; *see also* Bute, Mary Ellen
Bresson, Robert 73
Bright Colors, Falsely Seen 58–9
Brown, Julie 6
Brown, Royal S. 100–1
Bute, Mary Ellen 12–13, 52, 82–4, 89
Butting, Max 72

Ça Ce Soigne? 12–13, 86–9, 91–3
calligram 38, 87–9, 104, 117, 137; definition 97–8
Captain Video 119–21, 122, 124, 127
Cavell, Stanley 24, 133
Chomsky, Noam 28
Clair, Rene 73–6, 78, 79
Clowes, Simon 12
Cole, Jack 122–4
Concerning the Spiritual in Art 51
Contemporary Designer Period 9, 11–13, 86; and intertextuality 92–3

Cooke, Mervyn 3
Cooper, Kyle 46–8, 54, 125–7
Corra, Bruno 51
Costello, Paul 113
cut-scene 63, 113–16, 118, 119–20,
 123, 125–6

Dann, Kevin 58–9
Danse Macabre 89–91, 94
déjà entendu 39, 91
Der Gelbe Klang 51
Designer Period 9–11, 61, 66; the
 Middle Phase 10–11, 86–7, 104
Die Walküre 41
diegetic 17, 36–44, 46–8, 66
direct animation 91–2
Disney (company) 4–5
Disney, Walt 86–7
docudrama 63–6
documentary 32–3, 66–7, 122, 134
Dog Problem, The 84–5
Dracula: as character 99;
 as feature film 8

Eco, Umberto 88–9, 131–2
Eggeling, Viking 52
Eisenstein, Sergei 4–6, 74–7, 135
enunciative function 27–8; *see also*
 sync-points
epitext 102–4; *see also* Genette, Gérard

Fantasia 19, 87, 89
Ferro, Pablo 11
Film Language 13–14
Film Music: A Neglected Art 102
Fischinger, Oskar 3, 52
Fitzgerald, Wayne 10, 11, 34–6, 63, 66–7
Flintstones, The 115
foley sound 75, 134
For a Few Dollars More 133–4
Foucault, Michel 27–31, 39–41, 53,
 54, 55–6, 58, 59, 75–6, 80–1, 85,
 95–101, 107, 113, 118, 131–2, 136
Futurism 18, 51, 91

gaze 32, 55, 58, 75, 80–1, 85, 107–13, 131
Genette, Gérard 31–2, 86, 102;
 see also paratext, *Paratexts:
 Thresholds of Interpretation*
Ghostbusters 103–4, 115

Gilligan's Island 116
Ginna, Arnolda 51
Goldblum, Jeff 38
Gray, Jonathan 8, 31, 87
Green, Jessica 7–8, 99
Greenberg, Richard 103, 125

Heroes 54–7, 59
Herrmann, Bernard 100–1; *see also*
 Bass, Saul
hierarchy *see* language—image—
 sound hierarchy
HL-10 plane 122–3
Hold That Ghost 99
Houston, John 39

*I Heard It Through the
 Grapevine* 37–41
Incredible Hulk, The 119
*International Music Festival at
 Baden-Baden* 60
intertextuality 32, 41, 83, 87–93, 136

James Bond films 10, 104–13
Jazz Singer, The 6, 32, 73–4
Jones, Carolyn 117

Kahn, Douglas 4–5, 16–17, 20
Kandinsky, Vassily 51–2
Kant and the Platypus 131–2
Kenworthy, Richard 89–92
Kircher, Athanasius 56–7
kitsch 92–3
Klein, Kevin 38
Klüver, Heinrich 52

La Creation Du Monde 83
Landau, Solange 63, 113, 119, 125–7
language—image—sound hierarchy
 107–8, 136–7; as language—
 vision—hearing 13, 57, 73, 100,
 127, 131–2; as speech over image
 84, 97, 101
langue 27
Lantz, Walter 99
Lapedis, Hillary 6, 37–9
Lardani, Iginio 133–4
Leadbetter, Charles 52
Les Echanges 18–20, 29, 82
Levi-Strauss, Claude 18–19, 132

License to Kill 104–5
Lichtspiel 60, 72, 75
Liebermann, Rolf 18, 29, 30, 80
Light Moving in Time 57–8
lip-sync 2, 5–7, 13, 22, 25, 32–6, 46, 56, 59–60, 63, 70, 72–4, 78, 95–8, 129–30, 133, 135
Logo Period 9, 11, 102–3; *see also* Designer Period
Lustig, Alvin 10
Lye, Len 52, 93, 133
Lynes, Russell 92–3
Lyotard, Jean-Francois 111

M2-F2 plane 122–3
McLaren, Norman 52, 91
Majors, Lee 122, 123
Man with the Golden Arm, The 9, 48–50, 53, 61, 86, 92, 93
Man with the Golden Gun, The 107
Marks, Larry 113
Marx, Groucho 59
Metz, Christian 7–9, 13–17, 28–9, 59, 75–6, 131–2
Mickey Mousing 4–5, 46
Milhaud, Darius 83
Mission Impossible 125
montage 1, 4–6, 17, 29, 37–41, 43, 63–4, 70, 74–83, 101, 108, 113–16, 118, 119–27, 135
Mook, David 113
Moore, Roger 106–7, 109, 111–12
Moritz, William 3–4, 51, 58–9
Mosaik-Intro (mosaic intro) 63, 113, 119
Mulvey, Laura 107–13
Mummy, The 8
My Man Godfrey 99–100

NASA 122
Nixon, Richard 65–6
Nobody Does It Better 106–10, 115
Noise, Water, Meat 4–5, 16
non-diegetic 17, 36–44, 108
North by Northwest 100–1, 103
Nourmand, Howard 84

Octopussy 105
One Flew Over the Cuckoo's Nest 34–6, 41–4
Outer Limits, The 119

Palmer, Ben 70–2
Parabola 82–6; *see also* Bute, Mary Ellen
paralogy 111–12
paratext 2, 9–11, 31–2, 42–4, 85–92, 102, 136; *see also* Genette, Gérard
Paratexts: Thresholds of Interpretation 31–2; *see also* Genette, Gérard
Parker, Jr., Ray 103, 115
parole 27
peritext 102–3, 106; *see also* Genette, Gérard
Perri, Dan 25–6, 63–5, 137
Peterson, Bruce 122–3
Player, The 25–7, 44
popular music 6–7, 37–41, 93, 104, 136–7
Postmodern Condition, The 111–12
Prendergast, Roy 102
primary recognition 13–17, 20–2, 29, 32, 75

quotation *see* intertextuality

Rand, Paul 10
realism 6–7, 15, 24–6, 29, 31, 32–5, 36–7, 41, 46–8, 53–9, 63, 66–7, 74, 81, 118–19, 132–6; *see also* Bazin, André
Realism and the Cinema 24–5
Richter, Hans 52
Rossini, Gioachino 41
Rumba 8–9
Rushton, Richard 24–5, 57
Russolo, Luigi 18–19
Ruttmann, Walther 12, 52, 60, 72, 75

Sager, Carole Bayer 106
Saint-Saëns, Camille 89, 91, 92
Satie, Eric 60
Schaefer, Robert 115–18
Schnapp, Jeffrey T. 52–3
Scooby Doo, Where are You! 113–19, 123, 127
Scott Pilgrim vs. The World 86–93
Seduction 110–12
serial form 88–91; *see also* intertextuality
Set-Up, The 36–7, 41, 43–4
Seven Year Itch, The 61–2

Show Sold Separately see Gray, Jonathan
Signs and Meaning in the Cinema 13
Simon, Carly 104–5, 108, 115
Six Million Dollar Man, The 121–4, 125, 127
Snipes, Wesley 125
speech dominating image *see* language—image—sound hierarchy
Spy Who Loved Me, The 104–13, 115, 127
Stanitzek, Georg 42
statement *see* enunciative function
Superman 125
Superman II 125
Swan Lake 8
synaesthetic 12–13, 22, 50–2, 55–63, 80, 113
sync points: for counterpoint synchronization 73, 82–3, 129–30; definition 25, 129; for naturalistic synchronization 25, 72–3, 129–30; and visual music 72; *see also* enunciative function

Talkies 2, 4–5, 7, 73–81, 82
Tarantella 12, 82, 89; *see also* Bute, Mary Ellen
Tarasti, Eero 19–22, 100–1
Theory of Musical Semiotics, A see Tarasti, Eero
This is Not a Pipe 39–40, 97, 118
Thought Forms 52
Thunderball 107
Touch of Evil 10, 25–6, 66–7
Trollenberg Terror, The 60–1, 100
Twilight Zone, The 119

Universelle Sprache 52
"unseen truth" 58

Vertigo 12
Vertov, Dziga 4
visual music 1–2, 3–4, 7, 10–12, 22, 25, 49–59, 60, 61, 70, 72, 76–7, 79–81, 82, 87–90, 127, 129–30, 135
Vitaphone 73, 101–2
voyeurism 106–7, 110, 112–13

Wagner, Richard 41
Warner Brothers 73–4
Washington Post 65; *see also All the President's Men*
Watergate hotel 65, 66; *see also All the President's Men*
Wees, William C. 57–8, 60
Weis, Elizabeth 2
Welles, Orson 2, 10, 25; *see also Touch of Evil*
Whitney, John 7, 11, 82
William Tell Overture 41
Williams, Christopher 24–5
Willis, Frank 66
Wimbledon 46–8, 50, 53, 55
Winkler, Max 3
WKRP in Cincinnati 115
Woodward, Bob 65; *see also All the President's Men*
Woollacott, Janet 108

X-Men: First Class 12–13

You Only Live Twice 107

CPSIA information can be obtained
at www.ICGtesting.com
Printed in the USA
BVHW08*0231200618
519464BV00006B/105/P